Leon Underwood's periodic [...]ances as sculptor, painter and [...]maker since 1920 have frequently shown him to be in the forefront of developments, yet for long periods his refreshing distaste for galleries and critics has allowed him to be almost forgotten.

In the 1920s and 1930s his work, like that of his contemporaries, was concerned with the evolution of the formal language of sculpture but, characteristically independent, he refused to develop it into the area of total abstraction. His early belief in the importance of significant subject matter was reinforced by his travels in Poland, Iceland, Spain and Mexico, and later in Africa where he developed his interest in its primitive art on which he is an authority.

His vigorous late bronzes, an economical expression of form and content, are the most recent manifestation of his aggressively independent philosophy of art.

This, the first biographical and critical study of Underwood, should establish him as a much underrated talent in British art of the last fifty years.

On the jacket: *Venus in Kensington Gardens* 1921 (detail).

Leon Underwood

For the reader's guidance, the artist has provided the following list indicating the approximate height of each work:

1 = 27″	32 = 5″	62 = 20″	92 = 13″	122 = 12″	151 = 13″
3 = 40″	33 = 5″	63 = 30″	93 = 21″	123 = 25″	152 = 24″
4 = 12″	34 = 16″	64 = 24″	94 = 25″	124 = 40″	153 = 22″
5 = 40″	35 = 9″	65 = 24″	95 = 43″	125 = 41″	154 = 22″
6 = 20″	36 = 16″	66 = 24″	96 = 20″	126 = 10″	155 = 25″
7 = 37″	37 = 30″	67 = 14″	97 = 33″	127 = 7″	156 = 6″
8 = 15″	38 = 30″	68 = 14″	98 = 21″	128 = 7″	157 = 6″
9 = 22″	39 = 40″	69 = 17″	99 = 7″	129 = 32″	158 = 16″
10 = 10″	40 = 22″	70 = 16″	100 = 5″	130 = 22″	159 = 180″
11 = 20″	41 = 9″	71 = 16″	101 = 12″	131 = 16″	160 = 192″
12 = 24″	42 = 5″	72 = 12″	102 = 21″	132 = 11″	161 = 216″
13 = 40″	43 = 4″	73 = 30″	103 = 13″	133 = 15″	162 = 54″
14 = 20″	44 = 6″	74 = 40″	104 = 30″	134 = 15″	163 = 15″
15 = 15″	45 = 3″	75 = 12″	105 = 22″	135 = 15″	164 = 15″
16 = 11″	46 = 8″	76 = 24″	106 = 22″	136 = 15″	165 = 19″
17 = 15″	47 = 11″	77 = 14″	107 = 25½″	137 = 12″	166 = 19″
18 = 40″	48 = 15″	78 = 20″	108 = 36″	138 = 27″	167 = 16″
20 = 36″	49 = 48″	79 = 36″	109 = 24″	139 = 14″	168 = 30″
21 = 8″	50 = 34″	80 = 36″	110 = 24″	140 = 16″	169 = 24″
22 = 8″	51 = 19″	81 = 6″	111 = 10″	141 = 30″	170 = 10½″
23 = 12″	52 = 12″	82 = 6″	112 = 22″	142 = 18″	171 = 24″
24 = 9″	53 = 8″	83 = 4″	113 = 40″	143 = 24″	172 = 5″
25 = 12″	54 = 7″	84 = 14″	114 = 13″	144 = 13″	173 = 18″
26 = 11″	55 = 20″	85 = 36″	115 = 9″	145 = 24″	174 = 20″
27 = 5″	56 = 15″	86 = 25″	116 = 17″	146 = 20″	175 = 13½″
28 = 8″	57 = 20″	88 = 24″	117 = 19″	147 = 14″	176 = 53″
29 = 26″	58 = 63″	89 = 24″	118 = 22″	148 = 20″	177 = 31″
30 = 25″	59 = 5″	90 = 24″	119 = 27″	149 = 25″	178 = 11″
31 = 5″	60 = 6″	91 = 16″	120 = 43½″	150 = 33″	179 = 20″
	61 = 30″		121 = 51″		180 = 20″

LEON UNDERWOOD

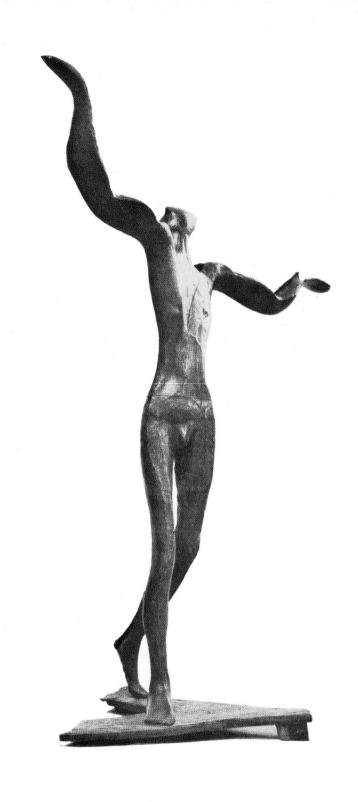

Christopher Neve

LEON UNDERWOOD

with an introduction by
John Rothenstein

THAMES AND HUDSON · LONDON

Frontispiece:
1 *I Believe* 1957. Bronze (cast by the artist)

© 1974 Christopher Neve

Filmset by Keyspools Ltd, Golborne, Lancs.
Printed in Great Britain by
Lund Humphries Ltd, Bradford, England.

ISBN 0 500 09099 8

Contents

Introduction

'For many years', observed a critic some ten years ago, 'Underwood allowed himself to be half-forgotten'. No artist of his generation of remotely comparable achievement has been so little honoured; indeed so neglected. One reason is that he has never treated art as a career and, indifferent to their consequences, he has pursued his highly individual aims with extraordinary tenacity. This has not been the sole, or even the chief, cause of his neglect, for other artists have followed a similar course. Personal ambition is indeed a help to an artist's career, but the absence of it from Underwood's character is a relatively minor reason for the lack of the success that he has deserved so abundantly, and for so long. The disposition – prevalent in this age of specialization – to underrate the versatile man has also played a part, and Underwood has been a novelist, poet, scholar, editor, teacher, maker of stained glass and a philosopher engaged for forty years on a book on the Cycle of Styles in the arts, besides, of course, a painter, draughtsman, engraver and sculptor.

The basic cause of his relative neglect is more complex, namely the ambiguous relation of his art to the prevailing attitudes. It is not remotely 'academic', or abstract – geometric or expressionist – or in the generally accepted sense 'progressive'. Yet the acute intelligence it expresses, the awareness of contemporary problems and the admiration of younger sculptors, Henry Moore among them – besides his outstanding quality – have caused critics to refer to him as 'the father of modern sculpture in Britain'. According to his theory of the Cycle of Styles certain Greek and Renaissance art, for example, represents its highest points, modern art represents its lowest possible. In the present volume he is quoted as saying, in 1961, 'Modern art is decadence. Of course you must cut away the old crops and compost them, but you must also grow something new. We have produced a generation of iconoclasts'. (This does not imply lack of admiration for such contemporaries as Brancusi, Gaudier, Zadkine, Archipenko and Moore, but he believes that their achievements would have been greater still had they worked at a high point in the Cycle of Styles instead of in an age of decadence.)

The basic reason for his sense of alienation from the art of his own age is the widely prevailing conviction that form is more important than subject; even – as is the case in abstract art – that subject should be excluded altogether. Although he admires the work of several abstract artists, he has dismissed that of

most as 'artfully making emptiness less conspicuous'. But for him subject, simply as subject, is not sufficient. 'No significant artist of today', he wrote in his pamphlet *Art for Heaven's Sake*, 'can work without a definite idea about the reconstruction of the world he and his fellows live in'. This idealistic objective does not involve sympathy with the rejection, by William Morris and his followers, of the machine, with which, he believes, artists should come to terms – but their own terms. The imagination, he believes, is continually modified by science, but the artist must always look beyond it. 'I do not consider intuition [a synonym, I think, for imagination] to be better for being independent of reason [science]. The ideal is a synthesis of the faculties, as Blake implied by *The Marriage of Heaven and Hell*'. Underwood's ideal is an art not primarily for connoisseurs and fellow artists, but for people as a whole. 'Art and Life', he has regretfully written, 'have drifted apart'.

Underwood's belief about the absence of content in the art of today is expressed in a paragraph of his forthcoming book. 'Man's intellectual advances in his sciences,' it runs, 'have abrogated his intuitive judgment on many material affairs of life . . . a strip of printed linoleum has proved more economical and practical than a Persian carpet for the entrance hall. But the abstract laws of aesthetics have provided "the Moderns" with no new subject-matter – no religious expression . . .' For Underwood subject, which for him means spiritual content, is all-important.

If Underwood repudiates the paternity of modern sculpture in Britain he was undeniably its precursor, and he has been a source of inspiration to his successors, however opposed to their own were his basic convictions.

In the first decades of the century serious sculpture, long moribund, scarcely existed in Britain. There were indeed two major sculptors at work, Epstein, a New Yorker by birth who settled in England in 1905 but whose rare gifts, though they always had ardent admirers, did not win wide recognition, nor exercise substantial influence, until relatively late in his life, and Gaudier-Brzeska, who although he spent his creative years in England died tragically young and, in spite of Ezra Pound's tribute, published in 1916, and the recognition of other perceptive friends, exerted little influence on his academically orientated fellow sculptors. Unlike Underwood neither was a teacher, and neither had evolved an aesthetic philosophy. Although, therefore, Underwood's theories were mostly in sharp contradiction to those most widely held, by their impressiveness, by the application of an acute intelligence to the study, not primarily in museums, but in the actual places in Africa, Latin America and elsewhere, often remote, where the sculpture of most interest to his contemporaries had actually been made, they in fact exercised an inspiring influence. The title 'father of modern sculpture in Britain' is therefore by no means so wide of the mark as it appears to him.

Henry Moore, for one, has spoken to me on more than one occasion of his indebtedness to the teaching of Underwood. He remains – whatever his opinion

of it – a participant (and, as far as Britain is concerned, a pioneering participant) in 'the modern movement'. It is scarcely possible to imagine his sculpture being made even a few decades earlier. But to attach undue importance to this aspect of his achievement is to misunderstand its essential character. The art of Underwood is as nonconformist as it could well be, and in two crucial respects. First, as already noted, because subject is for him of paramount importance. 'I have never been able to drift along', he wrote, 'with the present spate of subjectless art'. Second – however optimistic the spirit of his work – he does not believe that art is progressing. Indeed the most optimistic tenet of his belief about the present condition of art is that its eclipse is imminent, and that whatever transforms or replaces it cannot but be superior. Such an opinion on the part of some self-styled 'traditionalist' would not be worthy of notice, academic tradition having long since withered away. Coming from someone who has himself made a substantial contribution to the pioneering movement, it is an opinion to be taken into serious account.

On a visit to Florence in 1925 he happened to see, in an English newspaper, an illustrated account of the paintings in the caves at Altamira. Abandoning his various plans he went there straight away, spending long hours on his back to study the paintings – which though discovered in 1879 were then relatively little known by artists – by lamplight. For a man who had always been aware of an affinity with primitive art, the visit was a transforming experience. 'My "New Philosophy" blossomed', he wrote to me, 'when I first saw the Magdalenian drawings of Bison . . . The quality of these drawings was so high that it made the anthropological explanation of "magic purpose" unacceptable. Like technology, art depends upon a cyclic awakening of the artist to the appraisal of technical evaluation. Science, technology and religion spring from the same stem . . . the human mind in its progressive attempt to comprehend nature by science and art.'

This experience was a prime cause for the concentration of a mind, always analytical and fascinated by the contemplation of the long perspective of art's history, upon the creation of a comprehensive aesthetic theory. This is not the occasion for a summary of what will be elaborated in Underwood's book, which he has worked on over four decades, but a further quotation will give an indication of his attitude. 'A strange fact in the history of drawing revealed by archaeology, that cannot be accounted for by science, is not merely that the Sumerians drew consistently better than the Assyrians, and the Greeks than the Romans, but that this sequence of meaning and emptiness is constantly repeated in history whenever man's intellectual science abrogates the authority of his intuitive and divine confidence. Periods of equipoise between intuitive and intellectual knowledge in a whole culture are short – 250 years from the "archaic" to the "classical" Greek draughtsmanship.'

There is one feature of his philosophy that calls for emphasis: namely that it is based not primarily on theory, and not on the exclusive study of the finished

product in public or private collections, but on the study of the works with reference to where they were made and in terms of the way in which they were made, by constant experiment with the relevant techniques, especially bronze-casting, and making replicas of Bronze Age and prehistoric tools, and using them as they were used by their original makers. 'All judgment', he wrote, 'derives from doing.'

The time is long overdue for such a book as this, as it is for a major retrospective exhibition of the work of this masterly and many-sided creator, so long overlooked.

JOHN ROTHENSTEIN

ACKNOWLEDGMENTS

Many of the works in this book are now in untraced collections in Europe and the United States and are reproduced here from photographs taken before their initial sale. The author is deeply indebted to all those who allowed him to examine their collections or who supplied photographs, as well as those who were parted from their possessions while they were being photographed. Without patient and constant help – and the prolonged searching of memories, diaries and papers – by the artist, his wife, Mary, and their late son, John (who took all but one of the colour photographs and many of the black and white), the book could not have been completed. Among those who provided invaluable information or whose works have been illustrated are: Gertrude Hermes, Mr and Mrs Stuart Johnstone, Helen Lessore, Henry Moore, Kay Murphy, Sir John Rothenstein, Warren J. Vinton, Margaret Wells, Col. and Mrs Peter White, the secretary of the Rome Prize committee, the Slade School, Regent Street Polytechnic, the Royal College of Art, Hampton Gurney School, the Public Records Office, and the Directors and Trustees of the British Museum, the Tate Gallery and the Imperial War Museum. John Webb specially photographed illustrations number: *96*, *116*, *117*, *119*, *126*, *128*, *167*, *168*, *170*, *175*, *176*, and Anne Mason was responsible for the faultless and rapid typing of the manuscript.

1 An alternative philosophy

It is as unproductive to approach Leon Underwood's work, in any medium, without some idea of his alternative philosophy as it would be to examine Blake's outside the aesthetic context of revolution. What he has done runs so often in opposition to the mainstream of art in Europe and the United States since 1925 that there is a temptation to say that if Underwood is right everyone else is wrong. The distinction originates in his reaction to technology, and the over-riding belief he has developed, in a period of fundamentally analytical aesthetics, that subject – or spiritual content – is all-important.

It is not a fashionable view. As Archipenko complained, the Egyptian style lasted five thousand years, the Gothic five hundred, Cubism ten, but art now is a seasonal performance. But these rapid stylistic changes are closely linked, as of course they should be, to the philosophy of rationalism, the intellectual framework produced by our scientific culture. As Gottfried Semper pointed out in the eighteen-sixties, art must be viewed as a reflection of the economic, technical and social relationships that form any society. Technology now is on such a scale, and so vastly pervasive, that it must be taken into account. Since the 1920s art historians have been taught to shun technology in favour of the traditional scholarly techniques of formal analysis, investigations of historical context, comparisons of style, influence and so on. It no longer works.

In the 1880s and '90s, with the rise of psychiatry, the Viennese art historian Alois Riegl suggested that art stems from ideal, rather than material, sources; and it is this attitude that underlies Bergson and his *élan vital* and comes almost up to date with Herbert Read's struggle with the schism, in sculpture, between the organic or vital, based in nature, and its antithesis – constructivism, abstraction, what Read called 'a scribble in the air'.

'To what extent,' he asked in 1964, 'does sculpture remain in any semantic sense *sculpture*?' From prehistoric times it was conceived as mass, for twenty-five centuries its potency has been directly related with an obsession for the free-standing human form and its life-emitting properties, and now, with technology the metaphysics of the twentieth century, those very qualities of mass and stability have been deflected towards a dynamism and transience totally at odds with its traditional function. In the struggle to reflect technology, its energy is dissipated.

The search for alternatives has reached a dizzying speed. It shows up as clearly in our attitudes to the art of the last hundred years as it does in what is being produced in London and New York now. In the last few years we have seen appetites rediscovered on an enormous scale for Pre-Raphaelitism, Jugendstil and Art Nouveau, Surrealism and, perhaps most interesting of all, though not as sinister, the increasing enthusiasm for between-wars Kitsch, the more joyous and ludicrous reaches of Art Deco and deliberate bad taste as an alternative to the rationalism and hair-shirt austerity of good Bauhaus design. This even extends now to the Festival of Britain style of the '50s. The reaction that any or all of these represent is against a mainstream tradition that is based ultimately on visual analysis. It is no longer enough, we suddenly discover: even sacred principles like truth to materials are seen as less important than truth to self. As Moreau put it: 'I believe only in what I do not see, and solely in what I feel.' The Symbolists were concerned exclusively with finding a valid visual equivalent of an emotional experience, and in the process, within the terms of a profound painter of the opposing school like Cézanne, they were capable of atrocious pictures.

Somewhere between, there is the balance of these extremes that in themselves serve to reflect the duality of human nature. Worringer saw in 1910 that abstraction was a necessary corrective to the realism, the deliberate simulation of biological appearances, that meant sculpture had reached its apogee in the Renaissance, with the triumph of human anatomy. Sculpture in this sense is carving and modelling with the purpose of transforming an idea into an object, what Karl Marx called *Verdinglichung*, with the implication of a stable and permanent presence and at least some reference to recognizable form. But where is a direction? And is there any suggestion that, having revolved so hectically, the compass needle will settle down to imply a considered magnetic field of theory and behaviour?

'The modern sculptor', said Gaudier-Brzeska, 'is a man who works with instinct as his inspiring force.' There *does* seem to be a direction that might prove capable of escaping such a confused period and of recovering some kind of upward impetus. It has nothing to do with exhausted academism but it is in a tradition of classical solutions. It is traceable in sculpture to the beginning of the modern movement, with Archipenko and Zadkine and with the brief, brilliant development of Gaudier, and it is linked with the harmony that Brancusi saw as vital between man and nature, the union which his own sculptures were intended to reflect. It has to do, essentially, with a quality that is not much in evidence in the twentieth century: belief. And, strangest of all, it is optimistic.

An artist who subscribes to such an idea in the present circumstances is, it goes without saying, lonely. But painters and sculptors do not always hunt in packs, and there will always, one hopes, be individualists who evolve their own philosophy where necessary in opposition to what goes on around them. As Caspar David Friedrich, one of the most solitary but vital figures of the

Romantic movement, put it: 'I am not so weak as to submit to the demands of the age when they go against my convictions.' But it is a dangerous stance, quite apart from any practical difficulties of survival, because, unless there is a very deliberate development, reaction can turn into a form of overcompensation and the individualism can become a self-defeating cult. There is no point in disagreeing with your period unless you can offer a properly reasoned alternative, and more paranoia is counterproductive.

Such a sense of separateness can all too easily look like aggressiveness, contrariness or eccentricity. It made men like Hogarth, Blake and Cézanne impossible in the eyes of most of their contemporaries. Yet, on the other hand, such loneliness can quite often be emphasized by a purely rational desire to get on with some work without pausing to slog it out with galleries and critics. In an artist who is truly onto something, the two very often go together, but such apparent disinterestedness can too quickly be mistaken for a pose. The personality cult has often enough confused mere obsessions with originality.

Leon Underwood is a name familiar to many people since the '20s. His periodic appearances, primarily as a sculptor, have frequently shown him to be at the forefront of developments but he has always taken an independent line – in particular in the face of abstraction – and his work has left him little time for courting the dealers. He is an innovator who discovered the potential of primitive art shortly before Henry Moore, who is eight years younger, and experimented with it with at least as much daring and originality but less publicity. He was the first important artist to visit Altamira, in 1925, and three years later he was making his way by pack-mule and canoe across Mexico, from El Progreso to Tehuantepec, studying the art of the Mayas and Aztecs. He was in Poland in 1913 and in Iceland (illicitly, on a Prix de Rome premium) in 1923. He has worked as painter, illustrator and printmaker as well as sculptor with endless ingenuity and inventiveness; he has published, among much else, his own book of verse, a novel, and is still at work on a complicated philosophical and historical volume to do with his theory of the cycle of styles in art; he has made stained glass, executed commissioned murals, and is an expert, not only in theory but in practice, on bronze casting techniques; he has founded and run a magazine, and for many years taught in his own school of drawing.

All this has left little time for what is called getting one's work across. He has scant respect for commercial galleries and their inhibiting influence, although I think there is much to indicate that he recognizes a responsibility towards his public. He has never asked for an exhibition, and, although Eric Newton for one was quick to recognize his importance and to write about him, there has never been an attempt at a serious assessment of his position and significance. He has always been where he thinks the artist ought to be, busy with the next idea. In his *Art For Heaven's Sake*, of 1934, he wrote: 'The artist is the sower who at the harvest time is over the horizon – on his way to sow new ground.'

Apart from the tendency of a naturally independent nature to cross swords with many people who might otherwise have helped him, if there is one aspect

of Underwood that has not gone in his favour it is his sheer diversity. In a period of specialization, it makes critics uneasy. How can a man be so active in so many directions at once? The answer is that the direction is a unity and all the separate activities are parts of it. 'Art', Underwood points out, 'is not like Selfridges, with departments'. If you have a glimpse of the truth you go after it with every available weapon, if you have the ability. It is his conspicuous talent at this that makes Underwood's contribution all the more interesting and which adds immeasurably to its reasoned and deliberate development along a firm line.

It may look firm, but of course it is easy to over-simplify. There must have been moments when he was uncertain which way to go, and when experiments failed. He admits to having taken a wrong turn in 1929–30 when he temporarily adopted Surrealism. But he was sustained, from quite early on, by his suspicion that there was a link between the social stimuli of prehistoric, Bronze Age, Greek and Renaissance art that had to do with function and content rather than first and foremost with form. Over the years, and as a result of his travels, that suspicion became a conviction. He sensed that in each case it was the same cycle, inspired by technological change and constantly expanding, extending its range, when the old technology became exhausted. Significant form, in Fry and Bell's sense, was to Underwood no more than a tool. The hard-won geometry of Cézanne's pictorial language to him is a means and not an end and therefore misses the point, its own point. This notion about spiritual content has been strengthened, from Altamira onwards (when Underwood, having examined the paintings, rejected pointblank Obermeir's objective interpretation of their significance) and it has led him to what, in the second half of the twentieth century, is one of the most apparently untenable aesthetic conclusions of all: a belief in subject, and, not just subject, but in the spiritual and optimistic expressiveness of the human figure.

At once it is important to point out that this is not because of any built-in prejudice against intellectual abstraction in itself, especially as an expression of a spiritual ideal, but because from long experience he knows its limitations. He has described much abstract art as 'artfully making emptiness less conspicuous', and believes that the simplification mistaken for abstraction in much primitive art is not so much the result of intellectually determined logic as of inspired belief. This is what de Kooning meant in the 1950s when he said that it was absurd to paint the human figure but more absurd not to. Its pursuit has meant that Underwood remains firmly within the humanist tradition resurrected in the nineteenth century by Rodin and defended by Henri Bergson and Herbert Read, the tradition that saw the sculptural treatment of the human form enter the hostile period of abstraction promoted by Worringer in the early years of the century which meant, for instance, that many of Matisse's figure sculptures (notably the Tate *Backs*) are such ruthless investigations of form and mass that any sign of an emotional reaction to the human shape itself is eliminated.

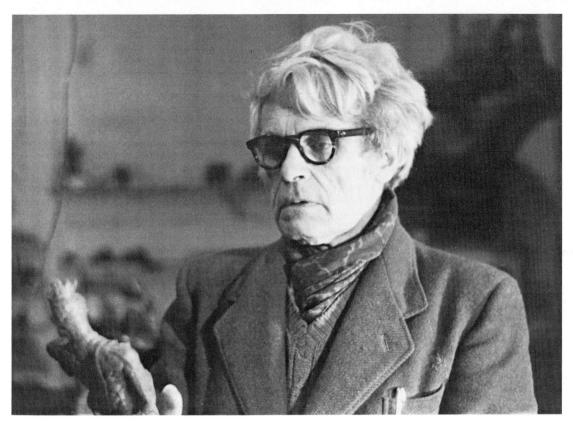

2 Leon Underwood in 1961

Underwood is frequently on the edge of abstraction himself. There are similarities, in this area, between him and Zadkine, who was born the same year, 1890. The bronze skin of many sculptures, slit and peeled back to show the hollow interior, as well as the powerful upward gesture, is comparable with the gutted shapes of the *Destruction of Rotterdam* monument. Some of his solutions to problems of movement and space are not far from Boccioni, and at one stage there are signs of an attempt to apply Cubist principles to sculpture, not far from Lipchitz. But none of these similarities are more than distant approaches to the work of other men inevitably concerned with the same problems in the same period, who on occasion came up with similar answers. His rejection of abstraction in a period that saw it as a new solution and a brave new world is a central theme of what follows. And now that the impetus is lost, and so many abstract artists are looking for a way out, his conclusions are all the more worth studying.

Finally, it may help to regard him essentially as painter turned sculptor, again a transition directly in line with some notable examples – Géricault, Daumier, Degas and Gauguin were all painters with a natural inclination to sculpture who, had they had the opportunity, would have done much more – and a

tendency that emphasizes Underwood's proclivity for the classical attributes of sculpture, its permanence and mass. Not only that, but the unwillingness to persevere with illusion in two dimensions in favour of realizing a truthful, actual object in three: the reification of Marx referred to earlier, the transfer of ideas to existing objects. As a sculptor he was self-taught, out of necessity, because he felt the need, when already an extremely alert and accomplished draughtsman and painter within what is really a Slade tradition, of the release into a third dimension.

By the early 'thirties this release has become an amazing, flickering weight-lessness in the bronzes as they threaten to leave their bases and go soaring into the air, and yet, paradoxically, it is a condition arrived at via a thorough understanding of structure and bulk, worked out in the life class and in his own teaching, that initially was a strong influence on Henry Moore. The evolution of Underwood's own highly original solution to the problems of life drawing is the partly intellectual, partly instinctive, journey of discovery of an artist who sees the figure as a supreme expression rather than as pure form. His drawings, which are hardly known, are among the supreme life drawings of his period, comparable with Rodin's and close in spirit to Gaudier's.

Through all this runs a mystical element, sceptics would say a literary streak, though it is in no sense anecdotal, that allows him a conscious affinity with Blake. It is the right to exercise his imagination entirely as he thinks fit, which includes, like Blake, rewriting the Bible in his mind. The result is a host of vital and surprising biblical images, like the Ruth who bends down to glean, not corn, but the tiny gesticulating figure of her future husband Boaz. And equally, the result of an avid enthusiasm for primitive cultures seen at first hand. Much of his work is taken up with an idealistic but unsentimental view of human relationships in Utopian surroundings, usually as the reflection of a static tribal society uncontaminated by western technology. Some of the most perfectly optimistic images are in the Mexican colour prints, where the *mestizas* are beautiful, the crops heavy and the songs are always about love.

But it is a difficult journey, if only because the time in which it has been made is confused beyond any understanding, a period of transition in which a paramount belief in subject and spirituality is out of tune. It is a time when the biomorphic vocabulary of sculpture, the pursuit of formal imitations for their own sake, found their logical conclusion in Wilenski's philosophy when Sam Goodman exhibited twenty-three stone castings of excretions at the Gallery Gertude Stein in 1964. Underwood is an innovator who, in a subjectless period, believes passionately in subject. He feels very strongly, and from his own experiments, that subjectless art is disastrous and that, because of it, the present situation in the arts cannot get very much worse. It is hardly a popular stance, but one that to some degree is summed up by an idea he wrote on his studio wall in the '30s, apropos art and technology: 'If necessary, sink a mine shaft in your front garden, but keep a corner in your back garden into which you can retire from its noise and listen to the song of the thrush.'

16

2 Beginnings: Glad Day

George Claude Leon Underwood was born on Christmas Day, 1890, in Askew Road, Shepherds Bush, and christened at the Church of St Paul, Hammersmith, in February 1891. His father was an antiquary and numismatist who had owned a shop on Ebury Street until shortly before Leon was born, and now had a shop in Praed Street, on the corner of Sale Street. He came from a family of antiquaries, his own father in turn having kept a shop in Holborn directly opposite the old Vienna Tearooms in the 'sixties.

Leon's father, Theodore George Black Underwood, had an erratic career, perhaps partly attributable to the fact that Leon's grandfather had married a second time in middle age, and George's stepmother, presumably jealous of him, had treated him badly. The grandfather had seriously undermined the family finances by investing heavily in a process of champlevé enamel casting that failed, and by the time Leon and his two younger brothers, Alec and Horace, were in their late 'teens, George had suffered a similar setback with the Praed Street shop and become, to his disappointment, a travelling salesman for polyphones. It was a job that involved tedious journeys into the suburbs by horse and trap to demonstrate the machines, and a certain amount of compensatory drinking – enough to turn Leon to life-long near-teetotalism – while his wife, Leon's mother, Rose (née Vesey) was forced to set up at home as a dressmaker in order to make ends meet. Rose was Irish, and George of Scottish and English parentage, with a grandfather who, at least in appearance, was distinctly Jewish. His mother's work as a dressmaker fascinated Leon as a child, and she and the several part-time assistants she employed are the subject of one of the earliest surviving paintings.

Leon's education up to 1906, when he left school to serve in the Praed Street shop, was rudimentary, and mostly he ran wild in the streets. In theory at least, he attended first a small primary school a stone's throw from Praed Street, St Michael's – in St Michael's Street which, to a child, was always busy and interesting because it served as an approach to the Great Western Station at one end. Far more influential, though, was his attendance at Hampden Gurney, a Church of England school founded in 1863 in a dog-leg street in the angle between Upper Berkeley Street and Seymour Place, just north of Marble Arch. Underwood enrolled, according to the register, on 13 January 1904, and left just before Christmas 1906, but his three years there made a deep impression on him.

3

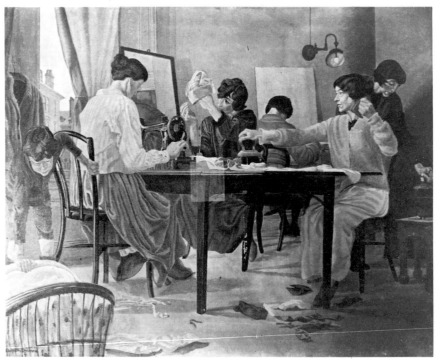

3 *Dressmakers* 1919. Oil

The building, erected in memory of John Hampden Gurney, M A, rector of St Mary's, Marylebone, was obviously by an ecclesiastical architect. The rooms, 22 feet high and freezing cold in winter in spite of large coal fires, are thronged now with a macabre selection of limbs and bodies; they are used as a warehouse for shop-fitting and display equipment and are scheduled for demolition in 1978 when the neighbouring leases expire. Underwood made his first drawings here, in an atmosphere the social and period implications of which are clear from contemporary inspectors' reports. The school had been private until May 1904, and after that was administered by the parish. L. H. Pritchard arrived as headmaster at the beginning of 1903 and, being paid according to attendance, had quickly set about increasing it. Numbers in the boys' school had gone up to 200 in February 1905 compared with the 149 when Underwood arrived the previous year. Nevertheless, his problem, and that of his assistant masters, Saxby and Powell, was to keep pupils there. In September 1904, for instance, he closed Hampden Gurney in despair because there was a spell of hot weather and all the children went to the country for hop-picking.

Underwood was impressed, or oppressed, by the great amount of church attendance he had to endure – which included long services every day during

Lent – and the tedious copying that constituted the drawing lessons. Far more attention was paid to games, in particular to cricket in Regent's Park, than to scholastic effort. The hero of the prize distribution held at the Portman Rooms on 21 December 1904, despite the densest fog of the year, was a boy called Antony Andas who had somehow taken forty wickets for sixty runs in the previous cricket season, while Underwood was denied his art prize ostensibly as a punishment for having been caught talking during prayers.

There emerges from this the first glimmer of what was not long in developing into an enduring suspicion of the official line. Though hardly paranoiac, Underwood sensed a hostility to his talent, already emerging in his precocious drawing, that aggravated him beyond endurance. Peter Ustinov has described how his report from Westminster once included the observation that he showed signs of originality and that these should be stamped out, and Underwood felt rather the same way. The drawing that would have won him the prize in 1904, before it was withdrawn, was an imitation in pencil of a sentimental engraving, cut out of a newspaper by Pritchard for the class to copy, of kittens playing with a ball of wool.

Underwood's own earliest subjects, infinitely more interesting, included Welford's Asses Dairy, which occupied the stables directly over the street and provided endless amusement for him and his friends (ass's milk was thought nourishing and was much in demand by the Edwardians); or, like all schoolboys, he drew his masters in margins and on exercise books, in particular the pugnacious Pritchard, and his contemporaries, all of them wearing the strange mediaeval cap that was part of the uniform, with a fish embroidered on it – to symbolize faith because the motto was *Fide et Labore*.

All in all, he was not a successful student at Hampden Gurney, and his performance is listed in the ledger as 'Average' without further comment. From an environment that included a good deal of hardship, especially in winter when the LCC health inspector for March 1906 found a high incidence of squints, rickets and ringworm, he took away with him chiefly the idea that he must be content to go against the grain because the standards within which he was supposed to succeed had little or no relationship to his own ambitions. A boy called Hoggett, for instance, received top marks in French because of his prowess at cricket. This kind of thing disgusted Underwood; and strangely enough these small beginnings at Hampden Gurney repeat themselves with marked similarity several times during his art education, both at the Regent Street Polytechnic and at the Royal College of Art. Already he was beginning to feel himself at odds with the system.

Having been forced into the habit of copying at Hampden Gurney, Underwood began his adult career as an artist, like Blake, by repairing and copying prints. He was surrounded by them at home. It was a time when any shop like his father's would have specialized in London views and colour prints by artists like Havell, with still a strong turn-over in historical portraits and steel en-

gravings after the best-selling painters of thirty years before. Engraved land-scapes after Benjamin Leader were still more popular with those who shopped on Praed Street than the newer things by Whistler and the Scottish artists like Cameron and Bone, and Stacpoole's engraving of *The Shadow of Death* continued, as it had done since the mid 'seventies, to outsell the later products of the Aesthetic movement and the related taste for Japanese. A stock-in-trade were tiny but meticulously detailed colour lithographs by Joseph Nash (1809–78), great feats of ingenuity, showing for instance the interior of the Crystal Palace at its opening, and from Underwood's point of view extremely difficult to touch up or repair.

But most important of all, it was here that he first came into contact with Hogarth and Blake, both of whom at once affected him more strongly, perhaps, than any other subsequent influences – including the traumatic encounter, that changed the course of his whole student generation, with Roger Fry's first Post-Impressionist exhibition in 1910.

It is significant that in sharp contrast to the predominantly literary view of these artists generally taken in the years up to the First World War, he was fascinated by the emotional impact and expressiveness of their line. In individual figures which he copied attentively, he sensed the highly-charged drawing as having a quality sadly lacking in most of the rest of the stock, a meaning beyond straightforward appearances – what he later described as 'a romantic denial of the actual'. He had glimpsed this in a book illustrating Flaxman's line drawings given him by his father in 1905, but the impact of Blake was so strong that there is a valid sense in which Underwood learnt at one stroke the first of his own artistic vocabulary when he came across a coloured engraving of *The Dance of Albion*, usually known as '*Glad Day*', in the autumn of 1907, shortly before he entered the Polytechnic.

An optimistic image if ever there was one, it is impossible to underestimate its significance as a latent idea, and spiritual source, throughout the whole range of Underwood's subsequent work. Based on a vision of Albion rising from the mill where he worked with slaves, Blake first engraved it in 1780. (The Washington, Rosenwald Collection version dates from much later, about 1794–95.) With his arms spread wide and an ecstatic expression on his face, Albion steps forward in a great burst of light, the figure entirely alone and completely naked.

Alerted simultaneously by what he had seen of Samuel Palmer's wood engravings and reproductions of works by El Greco, an artist rediscovered only in the '90s and then at a great pitch of popularity despite theories about an astigmatism, Underwood began to look around for means within his own reach to draw this magical flickering movement of the single figure. On the good authority of Sickert, or more probably of the café-concerts of his European equivalents, he went with his sketchbook to the Old Metropolitan Music Hall, on the Edgware Road. There he made a succession of drawings, none of which survive, of a man on a ball, jumping on and off it and controlling

its direction and speed with his feet. It is interesting that he tried to draw this figure by indicating its movement in sequence, like Muybridge's sequential photographs first produced in California in the 1870s which show up clearly, for instance, as an influence on Degas's studies of movement in dancers. Such experiments were common in the '80s and '90s, amounting almost to a craze, but already Underwood was showing considerable initiative and originality in seeking to use the balance of the figure not as a basis for anatomical information but in order rather to express an idea.

Eager for technique, and an avid visitor to the Victoria and Albert Museum to make drawings during holidays from Hampden Gurney and at weekends, he was already beginning to think about technical expertise as he saw it in the print stock in his father's shop in relation to what an artist actually had to express. Ironically, one of the brightest stars of Underwood's boyhood and the high point of two generations before his own at the Slade, Augustus John, was a case in point. During his own student years, Underwood was to struggle constantly towards a similar facility in life drawing while concluding that neither John, nor Tonks for that matter, had any real purpose to which it could be applied.

At the age of fifteen and sixteen Underwood can have had no more than an inkling of all this, but a suspicion of technique as an end in itself was evidently beginning to take shape in his mind, and he sensed, or was about to sense from his natural inclination towards a particular kind of drawing and particular draughtsmen, a truth behind physical appearances. It was many years before he came to read Hogarth's thesis and analysis of the Serpentine Line, but it was nevertheless an aspect of the engravings that he had noted for himself, without fully understanding it, and tried to imitate as a boy.

As happens with precocious children, such lofty aims were not much nourished by the kind of drawings expected of him by his parents and at Hampden Gurney, let alone at St Michael's. His first commission, at eight, arose when a customer of his father, a woman who lived in Sussex Gardens, took him home with her to draw her pet poodle in the summer of 1898. Underwood may or may not have known at the time about the boy Landseer's first success with the fighting dogs for Sir George Beaumont, but he accepted the task only on sufferance.

On 21 December 1906, he paid his sixpence for the week's tuition at Hampden Gurney for the last time, to Pritchard seated in the little front office by the door. By Christmas he was free: free, at any rate, to go to work at Praed Street and to plan how he could turn himself into a professional artist. In the event he worked spasmodically for almost three years in the shop, which dealt in stamps, medals and coins as well as engravings. He drew assiduously and it soon became clear that his determination to become some sort of artist was very much at odds with his father's own aspirations for him. He was discouraged from any such idea. There was already a three-generation tradition of antiquarians and print-dealers in the family, and George Underwood's own finances were quite shaky enough without the additional strain of his eldest son embarking on a notori-

ously risky career. Besides, an artist's training cost money. It gradually became clear that if Leon was to have his way he must leave home.

Fortunately for him, a friend of the family called William Goody, a publican who lived in Dulwich and who managed The Poppy in the Edgware Road, almost opposite Underwood's favourite the Metropolitan Music Hall (both now demolished), saw fit to become his patron. He not only took him into his own house but entered him for the Regent Street Polytechnic and paid his fees. The reason for such an act of kindness, apart from Goody's evident belief in the boy's ability, must have been at least partly that he was an amateur artist and a clever cabinet maker who had wished for just such an opportunity himself. And he had no son of his own.

Underwood moved into Goody's house overlooking Goose Green, Dulwich, in September 1907 and began to travel up from there to the Polytechnic every day. Having been accustomed to a dominating father and two brothers in Praed Street he now found himself in a predominantly female household which included Mrs Goody and three daughters, an environment that must have been altogether more sympathetic to his ego and encouraging towards his work compared with the hostility at home. He became confident enough, over the following three years, to take an independent line not always approved by the principal Percival Gaskel, a situation that culminated in Underwood's selection of subjects for his scholarship examination for entrance to the Royal College of Art in 1910.

Without informing Gaskel, he chose to ignore the areas of study specified on the application form and decided instead to concentrate on the Fairford Church stained glass in the Victoria and Albert and to make a freely interpreted copy of a Florentine quattrocento coffer painting. For his third subject he preferred to bypass antique drawing from casts but went to the Natural History Museum on the Cromwell Road and made very careful studies of animal anatomy with a close investigation of fur and feather patterns. Gaskel was appalled and at first refused to submit the work to the examiners under his signed approval. He must have felt duly humiliated when an enlightened board, evidently appreciative of some signs of originality, awarded Underwood an entrance scholarship and, what was more, wrote two months later asking to purchase the studies for demonstration purposes so that other students could see examples of the kind of work expected of them. Again Underwood felt himself justifiably at odds with authority in the form of Gaskel while his talents were more fully appreciated by his fellow students and contemporaries, notably a friend who was to play an important part in his travels later, Edward Armitage, whose father, also Edward, was an Academician and had been professor of painting in the Royal Academy schools from 1875 to 1882. Armitage was with him at the Polytechnic and stayed on there for an extra year after Underwood moved to the RCA in October 1910.

It is worth noting Underwood's choice for this examination, and the thinking behind it. In the first place, he was concerned very much with structure and

method as opposed to straight copying. He chose the Fairford Glass not so much because of its colour, though he appreciated that it was one of the few kinds of exhibit that could be drawn with complete clarity and without distracting reflections, but because of the conventionàl restraint of the leading in its construction, which divided colour and shape quite ruthlessly into small enclosed pieces that in themselves were an important element of the design. Equally, it was the method and quality in the tempera panel that excited him, particularly the surface of an egg-based medium on wood, so that in trying to imitate it he experimented in the preparation of his own panel and tempera by mixing a series of combinations of Newman's materials. He took an immediate liking to painting in tempera on wood which he thought was often far preferable to oil on canvas. And, thirdly, he drew animals at the museum because at that stage the practical difficulties of working at the zoo were too much for him, and he wanted to have a thorough grasp of anatomy before attempting to draw it in motion. All three choices suggest an enquiring mind that was already eager to explore in all directions to find a usable grammar and technique before starting to put them to work.

Such ideas were not easy to pursue at the Royal College in 1910, and the somewhat confusing entries in the copperplate of the college register reflect the tug of war that went on between Underwood and the professors of the painting department over the next three years. He was not an easy student to contain. He is shown as having entered in October 1910 and left officially in July 1913, with a note to say that he nevertheless wished still to sit for the painting diploma in July 1914. He attended etching classes after the war in October 1918, and much later applied to re-join the etching class in March 1921.

One of the first difficulties that he encountered on his arrival was that Augustus Spencer, the principal, was unsympathetic towards him, being, as Underwood considered, a man employed more for his administrative abilities than for his prowess as a teacher. Spencer evidently infuriated him from the beginning, but Alston, who taught life drawing, and Gerald Moira, who took the painting school, although academic in approach, were at least prepared to allow him some latitude and had a working knowledge of French painting via the new English Art Club. Most of those with him in the autumn intake of 1910 were 'fundamentally academic and included, for example, Jagger who was subsequently to distinguish himself with the monument to the Royal Artillery at Hyde Park Corner. Of the academics Underwood mostly steered clear, his chief interest, and the area in which he succeeded best, being the sketch club, which was administered entirely by the students for themselves without the outside intervention of the staff.

In fairness to the college authorities, it must have been – rather as it is today – an extremely difficult period in which to retain students' attention within a prescribed course of study when there were so many heretical outside influences. Pandemonium was engendered in the London art schools by the Grafton

Galleries exhibition in November, and, at the Slade, Tonks forbade his students to attend it for fear they would be led astray by the dependence on colour and what must have seemed to him an almost complete absence of drawing. The show, which ran until January 1911, incensed the public, gave the New English Art Club violent indigestion and generally aroused bitter antagonism while succeeding in changing, very quickly, the whole direction of English painting – an effect similar to that of the Amory show in New York two years later.

Underwood's reaction, considering that he had been at the Royal College for only six weeks when it opened, was evidently remarkably objective. Confronted for the first time in the flesh with van Gogh, Gauguin and Cézanne, he was dazzled by their colour but at once set about trying to analyze the content of the paintings as distinct from their method. It was Cézanne, the most important and at once the principal foundation of the whole atmosphere and attitude of criticism against which Underwood reacted throughout the '20s and '30s, who troubled him most. His student reaction has much in common, in a less coherent way, with D. H. Lawrence's criticism of Cézanne in 1929, and it is already typical of Underwood that he should have come to the conclusion that an extremely skilful and highly original kind of visual analysis had been evolved as what appeared to be an end in itself.

Exciting at a purely pictorial level as a language, it did not seem to him to progress sufficiently beyond an essentially optical sensation. His reaction is summed up by his remark that it was 'science, but not religion' – an extraordinarily mature judgement that is a pointer towards his own attitudes and symptomatic of a change in critical approach to Cézanne that was not to surface until long afterwards.

Nevertheless, at a purely technical level which, as a twenty-year-old, he was much concerned with, he saw the advantages of Cézanne's style as a vehicle to be studied and perhaps even used – always assuming that one first had something of value to express – but he wished to know much more about advanced colour theory first. He certainly did not feel able to adopt Post-Impressionist colour wholesale until he had some practical grasp of the light principles of Impressionism, in particular as they affected his own observations when painting out of doors. That he was thinking at this period about the scientific principles of colour harmony, with reference both to Chevreul and to Ogden Rood (*Modern Chromatics*, 1879), is suggested by the fact that he spent a good deal of time and trouble in constructing himself a portable sketching easel with a screen on it attached to a folding arm that enabled him to cut out halation while looking at the canvas. On sketching trips with Armitage in Staffordshire or the Lake District, he concentrated especially on trying to suggest subtle tonal or colour values at dusk or early morning using this device. It was slow work because each time the arm and screen were moved back after a scrutiny of the subject he had to wait for his eyes to adjust to the different values on the canvas. He concerned himself, especially during one prolonged stay at Walthwaite in 1911, in studying the effects of light on water.

The results of these experiments he exhibited in the holiday competitions adjudicated by the sketch club, with spectacular success. He won all sketch club prizes in both 1911 and 1912; but he was far from happy. He was nauseated by the teaching at the college and did not hesitate to say so, finding himself, as at the Polytechnic, in the position of being something of a hero among the more advanced students but distrusted and misunderstood by the principal. The situation was borne out entirely when with a shock he found he had been failed his painting diploma in September 1913.

The time had come, at almost twenty-three, to spread his wings. His only visit abroad to date had been for a few weeks in the Hague in 1911 when, firmly accompanied by his mother, he went as a first-year student to design a lunette for the Peace Palace. He felt himself thoroughly tired now of academic theory and bureaucratic in-fighting. (There had been a suggestion that he stay on a further year at the Royal College because Augustus Spencer wanted more grant students from the LCC.) Underwood by this time had a sound understanding of technique, the beginnings of his own ideas about life drawing and the first stirrings of a desire to use the human form as a vehicle for the expression of a spiritual ideal. But he needed time to think, and space – most of all, space, to escape the everlasting jostle of new influences promoted by Roger Fry, Clive Bell and the devotees of significant form on the one hand, and the academic strictures he had endured at the Polytechnic and the RCA on the other.

His friend Armitage, who had remained behind at the Polytechnic in 1910, had gone to Vilna, Poland (now Russia) in the summer of 1913 to teach English, and he wrote suggesting Underwood join him. He had a studio in a modern block in the centre of Vilna which he was using to paint portraits in his spare time – and, he maintained, there was no lack of patrons. His only stipulation was that Underwood should not steal his. What was more, there was also plenty of cheap accommodation. To Underwood, who was badly in need of a change and disgruntled at having been failed his diploma by Spencer, the opportunity seemed too good to miss.

3 To War

Having celebrated his twenty-third birthday with Goody and his own family at Dulwich, Underwood embarked for Poland on 26 December 1913. He was in fact to make two visits, the first lasting until mid-June 1914, and the second from July of the same year for only a few weeks when he and Armitage had to make a tortuous journey back via Finland on the outbreak of war. The only reason for his return to England in the summer was that he wished to resit his diploma. It was typical of him that, having hurried reluctantly from Poland for the purpose, he stopped briefly in South Kensington to equip himself with pencils and brushes on the way to the college and was refused admittance on the grounds that he was half an hour late. After some difficulty he was permitted to sit the examination, and this time duly passed.

Much more important, however, is the transforming effect that these journeys to Poland had on him. For reasons which will become clear later, almost nothing from the period survives – not only from the Polish period but from the war as well – but in order to understand his development as an artist it is crucial to look at the early travels.

He left England first on Boxing Day, 1913, met Armitage in Dresden and went with him to Vilna. By the Polish Christmas, thirteen days later than that in the western calendar, they were already on the estate of a family called Slotvinski, at Ravanica in the province of Minsk, a place that in the sinister atmosphere of impending war was to make a deep impression on Underwood who subsequently spent much of his time there. Slotvinski both paid him to copy decaying imitations of Italian renaissance murals in the local churches and bought his drawings; but he spent more time painting in the open air, continuing his colour experiments, and more particularly using the broad horizons of the surrounding landscape to explore changes of definition and focus of the kind he had first noticed in Barbizon paintings to convey recession.

The only oil to survive as an example is a small panel painted at Ravanica in the spring of 1914. It is a sketch-club picture of the kind that would not much have appealed to August Spencer, and there is no discernable suggestion in it of the encounter with Post-Impressionism three years before. Its soft definition and rapid recession from the bottom edge of the composition – a sensation almost suggesting to the viewer that he has no lower eye-lid – shows that Underwood was luxuriating in the emptiness of the scene, and no doubt

4

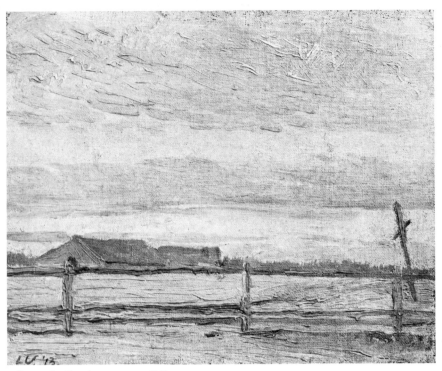

4 *Ravanica Landscape* 1914. Oil

luxuriating, too, in the absence of aesthetic dogma. He experimented, when needing to paint figure compositions, with church interiors in which it was possible to catch the colourful movement forwards and upwards, towards the altar, of a congregation. An organist he knew in Vilna was happy to allow Underwood to paint quick sketches in the organ loft rather than working-up a painting later from drawings. For the rest, in order to pay for his room and food he painted portraits in Armitage's studio overlooking the River Vilenka.

It is tantalizing not to be able to see the drawings from this period. Always armed with a sketchbook, Underwood drew constantly, beginning with the train journey to Borisov and the arrival by troika at Ravanica that first Christmas. Up until the 1930s when they were lost, never having been photographed, Underwood had some drawings of the Christmas festivities, and in particular of a group of peasant musicians who stood on a balustraded parterre in front of the house in heavy snow to sing and play violins. Ravanica, an imposing imitation of French eighteenth-century *gentilhommerie* architecture, was a constant subject, but there were more sinister elements too. Following the Austrian attack on Serbia and the Sarajevo assassination in June, a macabre

poster began to appear with three figures on a gibbet as an indication of what happened to anyone resisting conscription or the compulsory purchase of horses – at a fraction of their market value and at exactly the moment they were most needed for harvesting. Underwood continued to draw the effects of this on the Ravanica estate. The situation was symbolized for him in July in a way that exactly suited his poetic imagination: there was a total eclipse of the sun which panicked the remaining estate workers and horses so that they ran away, but with the gradual reappearance of light the cocks in the countryside around Ravanica mistook it for a new sunrise and crowed lustily.

While Underwood was trying to draw the atmosphere of impending disaster, his host clearly had little grasp of the situation. Slotvinski and his wife, both of whom were killed subsequently in the bombing, pressed him and Armitage to join them on a motor tour of Siberia in the autumn. With war declared on 4 August, they were leaving their departure perilously late. Peasants attacked and killed a neighbouring landowner in Minsk, and from Vilna at night, when the breeze was in the right direction, guns on the front were plainly audible.

There were other reasons apart from pressing political ones why Underwood should leave Ravanica. He had argued with a member of the Slotvinski family who took exception to the frequent presence of two English artists as guests, and whom Underwood discovered searching his room. The quarrel came to a head with a brawl in the snow during a hunting party, made all the more dangerous by the presence of firearms. Uncertain what form any retaliation might take, Underwood and Armitage left Ravanica unceremoniously for the last time with their baggage concealed in a cartload of hay driven by the estate manager, prepared at any time to hide in the hay themselves. At Borisov they had to wait while a train full of German prisoners was unloaded. They never saw Slotvinski and his wife again.

Unable by this time to move in any direction except east, they hurried by train to Pskov and Leningrad to try to see the British consul. It was soon obvious that it was already too late to cross the Baltic and that they must begin at once to head round it through Finland, via Viipuri and up the Gulf of Bothnia to Tornio on the Swedish border. This journey is the reason why none of the work from the period survives. They found themselves in a stampede of desperate travellers with the same idea as their own. Overcrowding on the trains was bad enough but at the Finnish-Swedish border there was a break in the line between Tornio and Haparanda, with almost no alternative transport, and it was necessary to walk many miles in bitter weather. Neither Armitage nor Underwood had anything to carry, having sold any spare clothes to pay the exorbitant sums demanded for fares, but any remaining canvases and sketchbooks were either lost or left behind.

Having reached Sweden they were forced to go still further north to the Norwegian coast at Tromso but did not succeed in getting a boat until moving down to Bergen a fortnight later, and finally reached Newcastle after a journey of almost six weeks. Underwood had long since stopped sketching but, not

least, the North Sea crossing made a deep impression on him when the ship leaving Bergen in front of theirs was sunk, and probably only heavy seas inhibited enemy activity in their direction as well. He began to think for the first time about sea pictures and a kind of northern sea imagery that was to contribute a vivid period in his work when the war was over.

Like anyone else at work in the same period, Underwood lost almost a decade of his career to world war. In both 1916 and 1939 he was seconded to the camouflage department, a situation in which he was the more frustrated for being surrounded by other artists of all kinds, whose talents, it was assumed, should suit them to the job but who mostly felt they would be better occupied elsewhere. At Wymereux in 1916 the potentially explosive combination included the French academician, Girond de Sevolat, who commanded the section (an appointment exactly equivalent to that of the British camouflage section under the auspices of Solomon J. Solomon), André Matin and André Mare, with Walter Russell and the scene painter and stage designer, Oliver Bernard. The method Underwood developed of staying sane was to submit any official plans and drawings in whichever current idiom he felt most appropriate – usually that of Marinetti or Wyndham Lewis.

The only small compensations were the opportunities to make (unofficial) drawings from the air, both in aircraft and balloons, but unlike Nevinson and Sydney and Richard Carline he had no proper facilities for putting the experience to use. Frequent flying impressed him with the astonishing depth it was possible to see into the Channel under certain conditions, when locating submarines, and he was at three thousand feet behind the lines at Mount Kemmel when he saw, and later tried to draw, the spectacle of nine barrage balloons simultaneously machine-gunned and destroyed. His only war work to reach any size of audience were drawings sent home for publication in the *Graphic* and the *Illustrated London News* and mostly he had to content himself with posters for concert parties in France, and, later, the commissions that came his way via Muirhead Bone and the Ministry of Information, for the Imperial War Museum.

Despite the initiation of official war artists, beginning with Bone and Orpen in 1916, unclassified drawing was a difficult undertaking, and one that landed Underwood in a good deal of unpleasantness even before he was seconded to camouflage. He and Armitage, on their return from Poland, had enlisted with the Royal Horse Artillery, Underwood nursing romantic notions about spending the war on horseback having passed much of his time at Ravanica riding a horse called Castanka. After training with horses for two months at Albany Barracks and in Regent's Park, their section was transferred to the cheaper and less vulnerable bicycle, so they both resigned and, still in search of horses, joined artillery regiments. Underwood was commissioned a first lieutenant in what in peacetime had been a territorial regiment, the 2nd London Field Battery, at Woolwich. They trained at Elton Palace and went to France

just after New Year 1916, but were kept waiting for six weeks in the wagon line at St Omer.

He moved up to Gommecourt at the end of February where he was supposed to instruct in the operation of a new mortar that never arrived, and he was re-called to report at Wymereux almost immediately. A small oil painting of three officers giving range orders in a slit trench, just their faces showing, must date from drawings made at this time. Unfortunately for Underwood, his instructions to return to the coast arrived the night before a scheduled offensive and there was a certain amount of bad feeling about his departure. This, and the unreal nightmare quality of France even behind the lines, may have heightened his attitude when that night, having first been denied the use of a battery cart to get him to the station, he had a strange encounter that was reflected in a novel he published in 1928. On its way to the station the cart had to pull off the lane to let a company march past. Underwood recognized the London Scottish, his brother's regiment, and saw his brother Horace, heavily bandaged, in the ranks. Horace, too, recognized him, but it took so long for the request to fall out to reach an officer at the front of the column that by the time Horace retraced his steps Underwood had given up waiting and left.

The new camouflage section at Wymereux, then a pleasant seaside resort, quickly came to seem to Underwood a total waste of time. He believed that, up to a point, disruptive camouflage might be useful on a very small scale but that on anything much larger than a single gun emplacement it was quite futile. Nevertheless, the services of the section were much in demand and camouflage was clearly an important psychological palliative that had far-reaching effects on morale. Occupants of a factory or hospital that had not received the atten-tions of the department felt themselves vulnerable and exposed.

Apart from his work in the air, Underwood's chief responsibility was the unpleasant task of going up to the front by truck at night or in the very early morning, crawling forward and recording the enemy field of fire by sitting with his back to their lines and sketching the view. Such drawings were then used to alter various landscape features, usually trees, to upset the German machine-gun profiles. A tree would be cut down and an armoured replica, constructed of mild steel by the camouflage section, substituted in a slightly different position to confuse the enemy's datum points and trigonometry. The substitute often had a seat in the top surrounded by gauze and could be used as an observation post.

In 1919, when Underwood was commissioned by Bone's committee to produce an official painting on the subject of camouflage he chose to show some figures working on just such an artificial tree. His brother Horace was the model for all of them. However, the picture has a contrived documentary air about it that makes it less than a success and puts one at once in mind of the similar difficulties of official war artists at work some time after the event, which produced stilted pictures like Bomberg's for the Canadian War Memorial commission.

5

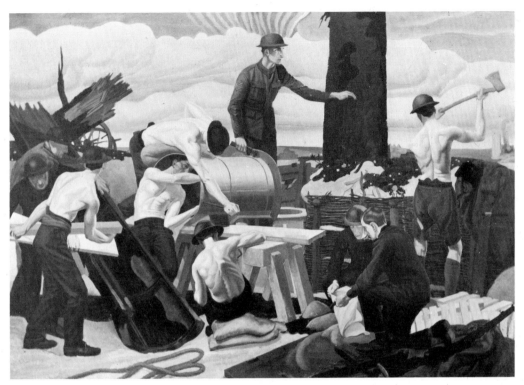

5 *Erecting a Camouflage Tree* 1919. Oil

That Underwood should do some work for what was then the Pictorial Propaganda Section of the Ministry of Information was first suggested in June 1918, and his file at the Imperial War Museum shows that he submitted sketches for the committee's approval from M Ward, London General Hospital, Wandsworth, in August. By October the commission had become the responsibility of A. Yockney, secretary of the newly formed art section at the museum, who suggested he go ahead with the camouflage picture with a view to its eventual purchase for one hundred pounds, with a twenty-five pound advance to buy materials. On 14 February 1919, Muirhead Bone came to Underwood's studio to inspect the picture's progress, advise him on detail, and perhaps to inhibit him still further with the kind of directive Yockney gave to all war artists. His memo to Underwood (October, 1918) ran, in part: 'For style I would like you to bear in mind the necessity of propaganda, and for this reason the design should be within the grasp of the public rather than a purely aesthetic composition.'

Yockney and his committee were sufficiently enthusiastic about the outcome that in November 1919 they volunteered to buy *French Girls Making Camouflage Screens*, but for some reason the sale did not take place and the only other

6

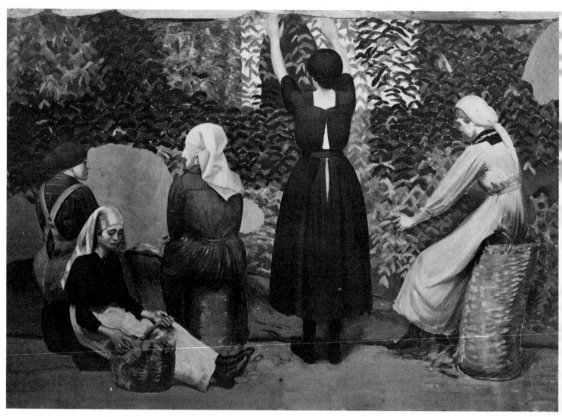

6 French Girls Making Camouflage Screens 1919. Oil

commissioned picture by Underwood in the War Museum is a portrait of
Captain G. B. McKean, V C, M M, of the Fourteenth Battalion Canadian Infan-
try, begun on the last day of April 1919. McKean by that time was working
at the Headquarters of the Khaki University of Canada in Bedford Square,
but in June 1918 he is cited in the London Gazette for an action described as
'beyond praise'. In quick succession he had captured two enemy machine-gun
positions single-handed by flinging himself over wire trench-blocks and en-
gaging the enemy at close quarters, in the second case when he was already out
of ammunition. The portrait shows a shy face and what looks like a very gentle
disposition.

At the time, it is indicative of Underwood's turn of mind that he should have
been more concerned with practical aspects of warfare than of making pictures.
He envied Gaudier his ability to carve (rifle butts) in the trenches but, unable
to concentrate on his own work, he concerned himself instead with the con-
stantly accelerating technology of the fighting, and twice he found himself
in trouble as a result of his over-enthusiasm in this direction.

7

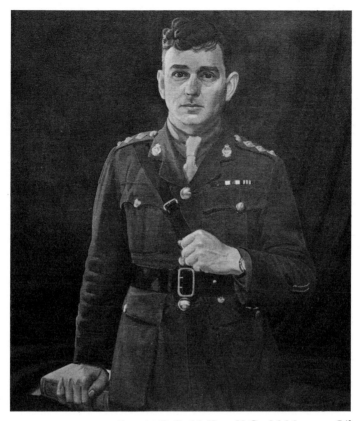

7 *Captain G. B. McKean V.C., M.M.* 1919. Oil

Remembering his experience at Gommecourt with the mortar that never came, and thinking how unnecessarily cumbersome and inefficient was the front-loading of the conventional Stokes, he designed an alternative. The principle of the scale model which he made in wood, and which worked by winding a handle, was that it loaded from underneath so that each shell constituted a breach for the following one. Theoretically it would fire as an automatic weapon, repeating fast enough to spray the enemy. His own tactical mistake was that he submitted his designs direct to the War Office instead of first to his commanding officer. In January 1917 he went home to be married, to Mary Coleman whom he had first met at the Royal College in 1911. They had been engaged for a year. His leave, after a brief honeymoon, was extended by ten days to enable him to talk to the War Office about his mortar designs.

They caused a good deal of initial enthusiasm and excitement but it was decided at length that production was already too heavily committed to the conventional mortar and that the complications of tooling-up would take too long. Underwood became quite accustomed to this sort of decision when

the same thing happened to a considerably more complicated invention of his in 1943. The kudos that attached to his proposals in 1917, however, seemed to irritate his commanding officer who would have preferred that the whole exercise had been carried out via him, and life was made difficult for Underwood on his return. He was evidently not slow to relate this to similar situations in the past, most notably Gaskell's loss of face over the entrance papers to the R C A.

A second instance was confusing in that Underwood's name was muddled by the security department with the American photographic firm, who had recently succeeded in publishing some photographs of British tanks still on the secret list in an American magazine. Leon Underwood's only offence was to have made some drawings of tanks, among the first in action in 1917, and to have submitted them, through Mary, quite legally to the censor in London with a view to their being published in the *Illustrated London News*. At the time, he was advising on camouflaging gun emplacements at Arras, and while touring emplacements in a car with his colonel they were overtaken by a sinister bearded security man on a motor bicycle who was only convinced of Underwood's innocence after a protracted interview in a brick cellar in the flattened town.

Underwood finally left France when he was invalided home with a bad attack of gastro-enteritis in June 1918, and put in Lady Mountgarrett's hospital in Cadogan Square, later going to Ilfracombe to convalesce. Although he was still by no means well, the fact that he was not idle is borne out by a large etching, of the view from his room across the rooftops to a single ship, that must date from this period. Its final state is so dark as to be almost overworked and it may be that he continued with it too long for lack of anything else to do, though it was also at Ilfracombe that he wrote, for his own amusement, a ballet about the war, making use of contemporary songs for the score. Called *Rickets*, it was subsequently danced with some success by an amateur company at the Barnstaple Theatre, Devon.

By the time the war was over in November he had been transferred as an outpatient to the system of nissen huts that served for a hospital at Wandsworth and it was there that he became seriously ill in the influenza epidemic of 1919.

There is little indication, in the paintings he worked up for the Camouflage Artists' Show at Burlington House in October 1919, of what he really felt about the war. They indicated in more or less conventional language only where he had been and what he had seen. Among the nine pictures he showed were *A Bathing Place Behind the Lines* and a watercolour of an R.E. dump in winter, as well as portraits of an Australian pioneer and Lt Col. J. P. Rhodes, RE, DSO. Rhodes's faulty map reading had once saved both their lives at Ypres, and the portrait showed him wearing the flamboyant sideburns that he and Underwood both agreed to grow to commemorate their escape.

The exhibition was intended to put conscripted artists, who might have spent anything up to five years in the camouflage section, in touch with their public again, and reviewers in the dailies generally concentrated more on the ingenuity

of camouflage subjects than on the quality of the paintings themselves. The critic in the *Manchester Guardian*, however, singled Underwood out without hesitation. 'An artist of very great talent and originality' he wrote (7 October 1919): 'His painting, *French Girls Making Camouflage*, with its fine picture sense, simplified, beautifully controlled and delicately related, is one of the most notable things we have seen on the Academy walls; and his other works, more experimental and amusing, show the same large, vivid grip.' 6

That these pictures were fresher and more direct than the official work he did for Muirhead Bone is clearly because they were either made on the spot in France or worked up from drawings at home in Underwood's own time and according to his own lights, instead of being painted specifically for public consumption in the War Museum. Good as they are, they nevertheless give little idea of what he was really thinking, and as a reaction to all that he had seen they hardly go very far. If he had decided anything about his work during the war it was that, more than ever, he wanted to make newly optimistic images in the spirit of *Glad Day*, but initially the sheer size of what he saw and felt made him want to express himself on a colossal scale. Nevinson, whom he already knew and would come to know better through the Slade and his membership of the National Society after the war, Wyndham Lewis, William Roberts and Paul Nash all had an advantage, in painting about the war, from their varying degrees of commitment to a style relating to Marinetti's Futurism and hardened by the philosophy of T. E. Hulme, but Underwood had always felt himself unable to subscribe to this.

In the first place it seemed important to him to make pictures or sculpture that were about war but not *of* war, and, secondly, that what was needed was to depict not individual incidents or activities but to make a forceful and coherent general statement. Of course, individual incidents done supremely well, like Goya's *Disasters of War* etchings or *The Third of May*, will quickly expand in the subconscious into comments on the futility and waste of all war always. *Guernica* works in the same way, and has something approaching Underwood's desire for size, but shows war and is therefore, in one sense, specific. An example along the lines that he was turning over in his mind would be Mark Gertler's *Merry-Go-Round*, not strictly a war picture at all but infinitely eloquent about war nonetheless. But for him this kind of solution was hardly expansive enough, and he began to think in terms, prompted by the scale of human and natural desolation that he had seen around him, of physically changing the face of the landscape in some way. The first inkling of this grandiose idea belongs to the First World War, and derives from his frequent flights along the Channel coast, although it was not to find its logical outcome in drawings and watercolours for an architectural scheme until 1939–45.

He began to think in terms of a gigantic figure, related to English hill figures like the Cerne Giant or the chalk horses that proliferated in the eighteenth century. Essentially it would be an optimistic image, a figure suggesting resurgence, renewal and peace, cut into the grassy cliff top above Dover, with a

clenched fist raised into the air on a colossal arm of Portland stone laid in courses and carved. The fist would symbolize non-aggression by having its thumb tucked inside the closed fingers in a gesture of strength rather than war. It was a conception intended to adapt a whole area of natural phenomena to a work of art, changing its mood with the weather, in much the same way that Claes Oldenburg planned to do, for instance, in his Thames 'Ball' schemes of 1967. At least to some extent it would reflect in a poetic way, and with some personal validity, what he had felt about the enormity of war, both a warning in Wilfred Owen's sense and an affirmation of his own belief in the resilience of human nature.

He had ended the war as a captain, on the point of a promotion to major that he did not want, after long spells of operating by lorry from the second line of trenches up to the front on camouflage assignments, and very often obliged to complete a job, sick with fear, under the kind of machine-gun fire that nipped branches off the hedge behind which he was sheltering and rained them in his face. He needed now to express the scale of his ideas intensified by this kind of stress. He was impatient, like everyone else, to begin building again instead of destroying. The first brilliant stirrings of the English abstract movement subsequently turned out to be on the list of war dead, and Underwood's idea for an anti-war memorial is really an inventive extension of the heroic tradition of nineteenth-century monumental sculpture, of which Bartholdi's *Statue of Liberty* of the 1880s is the most extreme example. The message is embodied in an enormous rhetorical gesture, obviating any need for the significant inscription on an architectural pedestal, and yet going much further. It is not just the weather and the landscape that becomes part of his conception, but the emotions and history of that landscape too, the complete landscape. A project on this scale is not dependent on any of the normal laws of monumental sculpture, even to the extent of Rodin's technical limitations in the *Monument to Balzac*. What is important, in an astonishingly modern way, is not so much the sculptural form as its idea. Today this would be called conceptual, though at the time Underwood had every intention of the notion eventually materializing; and that he was beginning to think in such terms is a vital indication of one aspect of the kind of artist he would be in the 'twenties and later.

4 In search of style

It would be impossible to overemphasize the importance of life drawing in the scheme of Underwood's development, or the way in which it informs even the most advanced formal shorthand in his sculpture of the 'thirties and 'forties.

The year after the war ended, as after any war, the art schools were bulging with students eager to pick up the threads of their sanity, and refresher courses were available as part of retraining and rehabilitation for all officers. Underwood found himself eligible and, in September 1919, began a year's course at the Slade in what was still the best and most influential life class in England, under Professor Henry Tonks. It had taken him until July, when his first child, Garth, was born, to recover fully from the combination of gastro-enteritis and the murderous influenza that had weakened him severely the year before, and it now must have seemed to him that a year in which to concentrate almost exclusively on life drawing in Tonks's class was the best way of getting started again and the surest foundation from which to work out his own direction.

By present-day standards, in which painters expect to have begun their careers, or at least to have the basis of their development fit to exhibit by the time they have completed a post-graduate year in their early twenties, this was late to embark on a year of disciplined life drawing. He was twenty-nine and admittedly had advanced ideas of his own about drawing before ever he went to Tonks. Nevertheless there was a great deal to be gained, not only from Brown and Tonks's specific instruction but from the traditionally liberal Slade environment of which life drawing had been a mainstay since Poynter adopted the methods and curriculum of Gleyre's atelier in the 'seventies.

The only potential danger was, as it always had been before the war, that Slade students were so much encouraged to speak with a French accent that it could effectively outweigh anything they might have to say of their own. As Sickert wryly remarked, their work did not always convey the sensation of being a page torn from the book of life. The way Underwood dealt with this, as the early life drawings – and later the paintings – bear out, was to bring this Slade language to a pitch of perfection in his own work the better to be able to understand its limitations. Although almost none of them admit it, it is noticeable that the brilliant generation of students in 1911–12 reacted in exactly the same way. Even though Wyndham Lewis included Tonks as a suitable subject

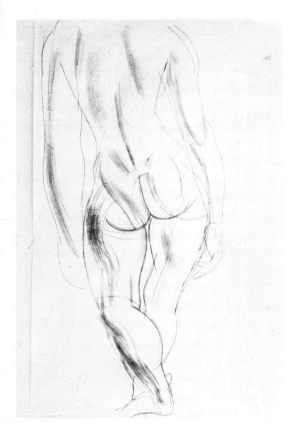

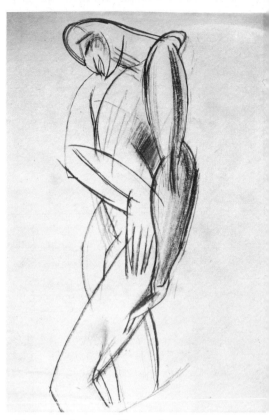

8 Early life drawing. Conté

9 Figure study 1920. Charcoal

for blasting, along with the British policeman, in the first edition of *Blast*, he nevertheless was a highly accomplished draughtsman in a style that was precisely dependent on him. And Underwood's own activities were similar to David Bomberg's in that he was busy experimenting (in Bomberg's case with Cubism), while still a student, in directions that by no means received the

8, 9 official sanction of Brown and Tonks, but at the same time he was readily soaking up the best of what they had to offer.

Towards the end of his year, he was more than ever convinced of the ultimate barrenness of Tonks's technique as an end in itself, and the need for a proper self-expression. It must have seemed to him that Tonks's own paintings, so full of isolated areas of good drawing, seemed to have no unifying direction or purpose; and in preliminary life drawings, too, he became painfully aware of the need to do more than content himself with good Slade grammar and intellectual self-control.

Gratefully assimilating sufficient advanced anatomy fully to understand how to draw the effects of hidden layers of muscle, the tensions and slackness of tendons and attachments under expansion or compression, or such basic changes in section as that effected by the radius crossing the ulna when the wrist is turned, he began to look for a kind of shorthand that would suggest mass by linear means without simply drawing the horizon, or outline, of the form.

38

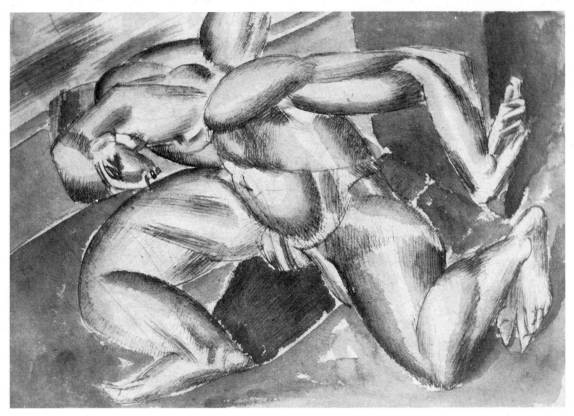

10 Figure study 1920–21. Pencil and wash

Aware of the ellipses in section of any part of the body he began to try to draw axial angles, to suggest volume and direction with absolute accuracy, by describing not so much an outline as an in-line, where the unravelling line appeared over the horizon of a shape and moved towards or away from the eye – for instance like the vortex formed by a length of wire wrapped around a cone.

By this means he began to think how he could signal the twist in a figure or the thrust of a limb in very compressed and economical language without having to state only the boundary of its volume in the way that he was taught by Tonks. Was it possible to draw the moving model by keeping the motions of his hand parallel to the axis of the movement, and hardly glancing at the paper? He began to draw the models quickly in their breaks or when they were walking about the studio, but there was little opportunity at the Slade for half-minute poses or walking models that he was beginning to find most useful to him. He would not have known it at the time, but Gaudier, a pile of scrap paper pinned to his drawing board so that successive layers could be ripped off without delay, had evolved a closely similar technique at his evening classes in November 1912.

At the Slade it was most usual to work on one model from ten until four, often on the same drawing. The figure, which was posed frequently by senior

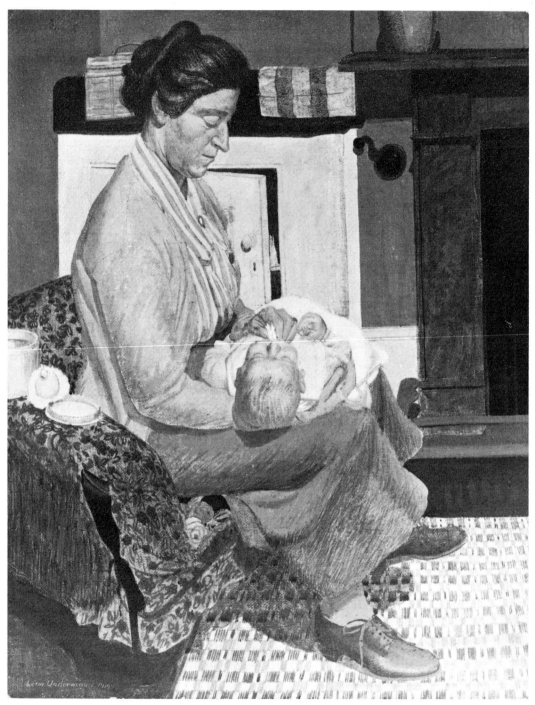

11 *The Fireside* 1919. Oil

students, would as often as not be set in flat light in front of an empty curtain. In fairness, Tonks discouraged too much time spent on upholstering a single drawing but what he required, or what was available from the hour set aside at the end of the day for shorter poses, was still in essence a different sort of drawing to the dynamic investigations that were beginning to concern Underwood.

It is possible, as well as this, to detect other ideas that crossed his mind in 1919–20. He became friendly while at the Slade with both Gilbert and Stanley Spencer, and it is an indication of his growing respect for an independent line informed by original belief, however distinct from his own, that he was briefly influenced by Stanley Spencer. He was strongly attracted by his determination to express himself, quite independently of anyone else's technique or philosophy; he liked his apparent simplicity as a man, and shared his appetite for the slow movements in chamber music. Signs of Spencer are not difficult to detect in some of Underwood's paintings dating from the end of his year at the Slade, and there are even borrowed compositional elements. On closer inspection, these turn out not to belong exclusively to Underwood, and there is clearly some significance in the fact that for some time in the early '20s a large figure composition by Spencer hung in the entrance hall at Gower Street and must have been passed by most of the painting students every day.

Nonetheless, it is interesting that when Underwood much later saw the Burghclere Chapel murals, he realized that, in a very different language to his own, Spencer had solved the persistent earlier problem of how to paint lucidly about the war without painting the war itself. Although his own temperament was not suited to Spencer's village Pre-Raphaelite technique, their ideas and intention evidently had much in common.

Equally, there is a connection between Underwood's experiments and those of another highly individual student, Ralph Chubb, with whom he was to exhibit later. Chubb belongs to what had originally been a '90s romantic reaction to decadent fin-de-siècle art and attitudes that took the form of detailed studies of gypsy life and lore. Its most important expression was the result of Augustus John's meeting with John Sampson, the Romany expert and enthusiast, in 1901, and his subsequent travels. In the 1890s the simplicity of the open-air life was thought of as an overdue corrective to stuffy bedrooms, cigar smoke and Aubrey Beardsley, but in 1919–20 it must have seemed infinitely more attractive as a reaction to the war. Chubb seems to have been able to combine some of the sexual attitudes of the '90s with a passion for gypsy life and ways, and spent much of his time drawing and painting at camping grounds, writing verse, and cultivating the 'deep' or inflected speech of gypsy dialects. It may not be too much to suggest that Underwood's awareness of these attitudes via Chubb had some effect on his own response to the life and landscape he was to experience in Kent two summers later.

Having spent his whole Slade year in the life class, Underwood nevertheless decided to enter for the Prix de Rome in June 1920, although from the beginning there was some doubt about his eligibility because he was not on the full-time

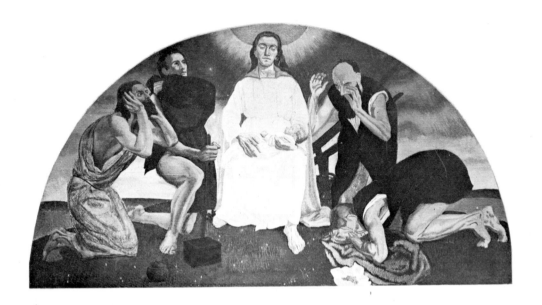

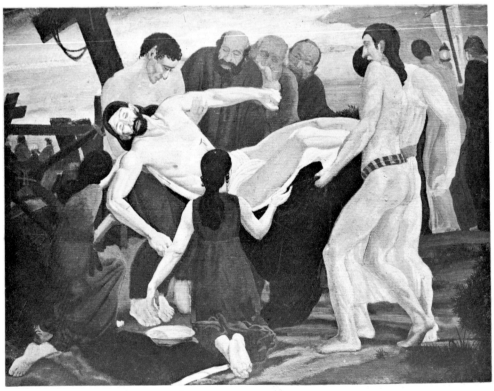

12 *Descent from the Cross* 1920. Oil

painting course. In the preliminary, qualifying, round he submitted a conventional enough picture, a *Descent from the Cross*, the acceptance of which entitled him to go forward to the set subjects, all of which were biblical ones. He chose The Flood. As with his commission for the Imperial War Museum, there is a stiffness about the result that suggests inhibitions about putting on a public display, and more than a suspicion that this is an accomplished picture cleverly tailored to suit the predictable needs of the Prix de Rome committee. It sets out systematically to show that he could compose, that he had a sound grasp of anatomy and was an accomplished draughtsman and painter who had looked at all the right schools for instruction and influence, but it is not a convincing picture. The only clues it seems to contain to his real identity are in the gesture of the central figures reminiscent of *Glad Day*, and the reference to his early studies at the Natural History Museum in the sound way he has dealt with the animals and birds.

What the judges did not know – something one would hardly guess from the confidence of the construction – was that with three weeks to go he left all his preliminary drawings on a bus and had, from then on, to work from memory. Models had been made available to individual competitors in studios set aside for the purpose and, having roughed out a scheme, he had made a series of life drawings according to Tonks's method to equip himself with information about the poses in the design. Perhaps the loss was an incentive. In the event, he was awarded a Premium, specially instituted as being an appropriate way of commending a painter in his category who was on a refresher rather than a full-time course, while the first prize went to Winifred Knight.

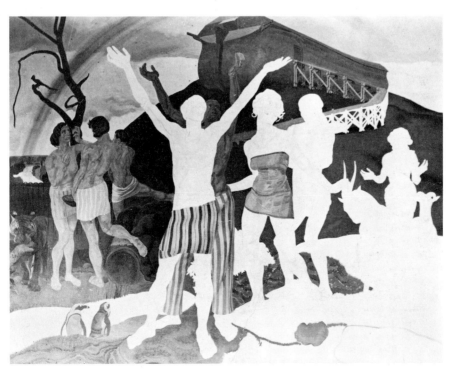

13 *The Flood* (incomplete) 1920. Oil

His picture was reproduced with enthusiastic notices both in *The Illustrated London News*, where it was displayed across two pages, and in the *New York Times* in November 1920, but shortly afterwards he painted it over. The result of the competition, considering that it was open to all students in the United Kingdom under thirty (and that he had not even been painting during the previous nine months), was a satisfactory one. The award itself he thought less satisfactory. It consisted of £100 with the stipulation that the money be spent on a trip to Rome, and Underwood had no intention whatever of going to Rome. He was already on his way to mistrusting what to him was an irrelevant Mediterranean tradition, and he could see no value to himself as a painter to go on a latter-day Grand Tour looking at exactly the kind of painting and carving with which he felt least in sympathy. He was, as he explained to the prize committee, a Nordic, and if they wanted him to spend the money on a journey to benefit his career they should alter the rules to allow him to go to Iceland. Astonished, they refused.

Naturally the whole purpose of the competition administered by the British School in Rome was to give students an opportunity of studying in Italy, whereas Underwood had used it chiefly as a means of being able to work on large canvases from his own model. The correspondence with Evelyn Shaw, the Rome Prize secretary at Lowther Gardens, shows that by the end of 1921 the committee had backed down to the extent of agreeing that he could spend the money on a trip to work in ateliers in Paris. But there must have been a verbal agreement of rather a different kind too. Underwood did go, briefly, to Paris. But in 1923 he spent the bulk of his Rome Prize money on a journey to Iceland – and, what was even better, the competition secretary lent him his own set of salmon rods to take with him.

There remained, however, the problem of how to earn a living. In May 1919, before beginning his year at the Slade, he had found an architect's studio at 12 Girdlers Road, Hammersmith, and succeeded in buying the lease. The studio itself had been divided to form a small room at one end and another very lofty one at the other, twenty-six feet high at its apex, and approached from first-floor level down a double flight of steps. In one corner at the foot of the steps was a voracious black stove, which is distinguishable in the background of many of the early drawings and etchings, though even it was not able to heat so large a space in winter and it was removed in the 1940s. To the left of the stairs there was a door that led through the basement area and out onto the street, making it not only possible to get in and out of the studio without passing through the rooms and passage on the first floor, but to move large sculptures, easels and other equipment in and out if need be.

When Underwood finished at the Slade he began to think seriously about starting a school of his own. The way in which the main studio was divided into two lent itself very well to running classes there while getting on with his own work, and as well as the smaller studio there was a kind of conservatory

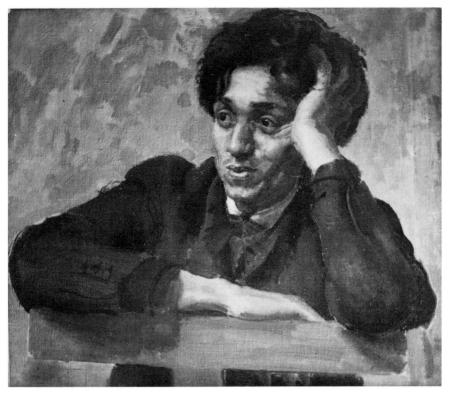

14 *Portrait of Diamantis* 1924. Oil

overlooking the main studio which he could use if both the larger spaces were occupied. Tonks assured him that the Slade was quite unable to absorb all applicants of sufficiently high standard in the post-war boom, and that he was ready and willing to pass on some of these to Underwood, as well as recommending some post-graduates to go on to him afterwards.

Underwood named his school the Brook Green School, after Brook Green at the western end of Girdlers Road, and opened in January 1921. Initially he had only four pupils, although there were never to be more than twelve, and he supplemented his income by teaching, for six months during this early period, at the Byam Shaw School in the evenings. He was deliberately choosy about students and would only accept those he considered showed definite promise, or who were already sufficiently advanced from having done courses elsewhere. As the prospectus made clear, the whole accent of the school was on originality and comparative informality, so that, although there was a rigorous morning and afternoon timetable five days a week, students were treated as artists on arrival instead of just as pupils in the hope that 'the harmful and repressive influences of orthodox art training' could be avoided.

45

'All study which is a means to an end' the prospectus said, 'is eschewed, as it is believed the youthful beginner cannot study for an end which has not been fully apprehended by him.' But ironically this emphasis on self-discovery, summed-up in the leading declaration that the Brook Green School was devoted solely to the development of the individuality of its pupils, was self-defeating to the extent that, like any inspiring teacher, Underwood's methods and attitude invariably came to dominate the outlook of those around him. And, chiefly, it did this via life drawing. Life drawing, as at the Slade, was the mainstay and by far the major part of the instruction at Girdlers Road. 'Good drawing is the foundation of the fine and applied arts', ran the advertisement that he put into London papers and art magazines, and although the notices went on to say that when proficiency in draughtsmanship had been obtained, instruction was also given in other departments, this seldom happened. There were times when he felt that there was no better discipline, in reaction to drawing, than for his students to make woodcuts, but in the main there were no other media used regularly in the school, and Underwood contented himself with running a weekly section for criticism of any paintings, prints or sculpture that his students cared to bring in to him. Even then, the vigour and appeal of his personality, philosophy and imagery was such that it strongly affected their outside work too. Some did not recover their own identity as artists until they left Brook Green; and others perhaps never did. By setting out to encourage their individuality, Underwood showed them so clearly how to draw and think in a certain direction that he instigated almost a total style, a style that was to appear a decade later at full pitch in the generation of students and associates who produced *The Island*.

Nevertheless, there were those whose talents and ability were ideally suited to develop under Underwood's instruction, and who found a related but independent manner of their own. Blair Hughes-Stanton, who, with Rodney Thomas, had been taught by him originally at the Byam Shaw and quickly followed him back to Girdlers Road, is an outstanding example. So, remembering Underwood's early insistence on the instructive discipline of print-making, is Gertrude Hermes. But the reputation of many of his other students ran sufficiently high that R. H. Wilenski felt able to write in the '30s: 'There is no English artist of his generation who can inspire those who believe in him with more enthusiasm or who has had more influence on other English artists of his age.'

Such a grandiose assessment of Underwood's teaching and the place of the Brook Green School in British teaching between the wars has an unfamiliar ring now. In part, that is because the historical mainstream of the art of the period, due largely to Herbert Read's assessment, is not what Wilenski judged it to be at the time; but, as will become clear later, Underwood's teaching was sufficiently regarded that even if he did not exert – for political reasons – a continuing influence at the Royal College, the College in a small but vitally important sense came to him.

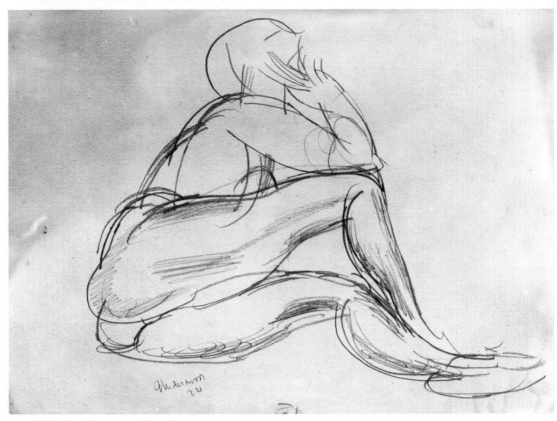

15 Life drawing 1924. Conté

Possibly there was an element almost of eccentricity in all this. It must have seemed eccentric at a time when Alston, for instance, and most drawing professors were still teaching their students to copy the light and shade on the model with neat shading, even sometimes to chart the edge of a shadow, like the edge of a form, with a containing line. Underwood was so concerned that his pupils should look for form, balance, mass and direction in a searching and positive way that he virtually argued them into being able to draw intelligently, and he did so with such enthusiasm and wit – the characteristic gestures like pulling his mouth into odd shapes with his hands to reinforce a point – that those who were anxious to retain their own ideas intact did better to keep out of his way. Edward Bawden, for instance, has said that he took care not to expose himself to Underwood's teaching at the RCA in 1922 for fear he would be deflected from his own much tighter inclinations, and there were others of his generation who felt similarly.

To almost anyone who experienced it, however, Underwood's teaching was at once an inspiration and a release. Like Gaudier, he believed that the role of drawing is to be pleasing to the senses in giving them something palpable, solid. 'If the representation is of a living thing and if it is true, it will be

47

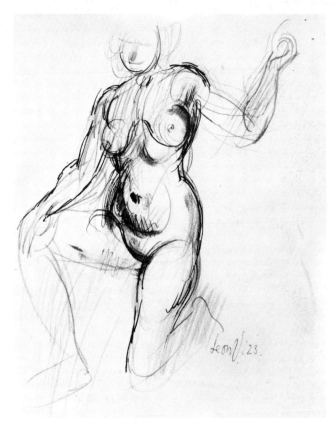

16 Early life drawing. Indian ink

alive. Philosophize after, to satisfy your humanity, but not before. In art one must absolutely respect its limits and its logic – otherwise one arrives at nothing worth doing' (Gaudier-Brzeska to Sophie in a letter, May 1911). And like Gaudier in his letters, he made much use of diagrams to simplify problems of volume, light and the rotation of sections in the figure, on more than one occasion drawing sections through the figure on the model herself by marking her with lipstick round thighs, arms and trunk through varying poses. The expressiveness of abduction, adduction and rotation at given points was emphasized also with the help of diagrams showing time elements, the weight of the line suggesting an advancing or retreating movement behind or in front of the plane of the drawing board. And always there was the atmosphere of discussion and argument on a scale, and at an intimate level, that would not have been possible in a larger or more orthodox school.

Perhaps, however, it was significant that Underwood should have taken the part of God, speaking his lines from a small window at the top of the studio stairs at one of what seems to have been a long succession of hilarious fancy-dress parties – parties that were to appear in symbolic form in his novel of 1928. And it was at one of these in the early '20s, perhaps wearing a mask on the back of the head and shoes turned round so that he appeared to be walking back-

17 *Mary* (study for *Venus in Kensington Gardens*) 1921. Pencil

wards, that one might have found almost any of the models from *Venus in Kensington Gardens.* The picture hung for many years above the studio steps (steps that proved so useful at parties for two girl students to come down in sacks like seals, while those below threw real fish at them), and most of the figures shown were in some way intimately connected with the beginnings of the Brook Green School.

Venus in Kensington Gardens, of 1921, is Underwood's *Déjeuner sur l'Herbe.* 18, 19
Like the Manet, which made use of Giorgione's *Concert Champêtre* in an up-dated 1863 version to show the artist's favourite model, brother and brother-in-law, Underwood transported his favourite life-school model, his wife and friends to an open-air café in Kensington Gardens. The picture was not exhibited until in a show he shared with Ralph Chubb and Olive Snell at the Alpine Club Gallery in May, 1924, and in true Salon des Refusés tradition it was greeted by critics and public alike with derision, sniggers and a good deal of lamentably ill-informed comment. Even P. G. Konody, on *The Observer*, who was generally an admirer of Underwood's work and an intelligent and distinguished critic, wrote: 'To seat a woman in her birthday suit among the correctly-attired frequenters of the tea-house in a London Park is a departure

from civilized conventions for which it is difficult to find a reason'; and *The Daily Graphic* reported that visitors to the exhibition were 'hiding their mouths behind their catalogues. Until I saw their eyes, I did not know whether they were being shocked or tickled.' A reviewer in the *Evening Standard* considered sadly that the picture 'makes the human body as coarse as possible and materializes, as it were, the ugliest Freudian visions of it. It is a distressing phase.'

For all this the painting is the first opportunity to see Underwood at full stretch as a composer: the group is considerably more complicated than it first appears, with the rhythmic movement of the ring of figures round the table in the foreground echoed twice in reverse towards the back of the space, with the central standing figure acting as a hub or pivot. The drawing is marvellously strong and convincing, with the first full-scale appearance of that exhilarating leaping line that was to become so personal a part of Underwood's language when it found a logical expression in sculpture over the next decade. This rhythm, complemented effectively by the rich unity of the colour, demonstrates his thorough grasp of *belle peinture* as understood and taught at the Slade while taking a witty look back at the historical developments that formed it.

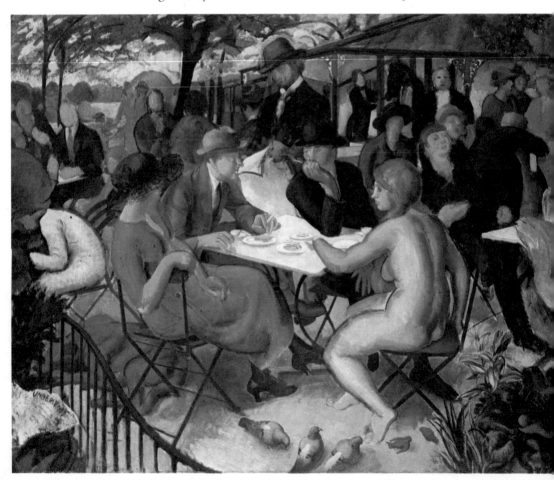

18 *Venus in Kensington Gardens* 1921. Oil

19 *Venus in Kensington Gardens* (det.

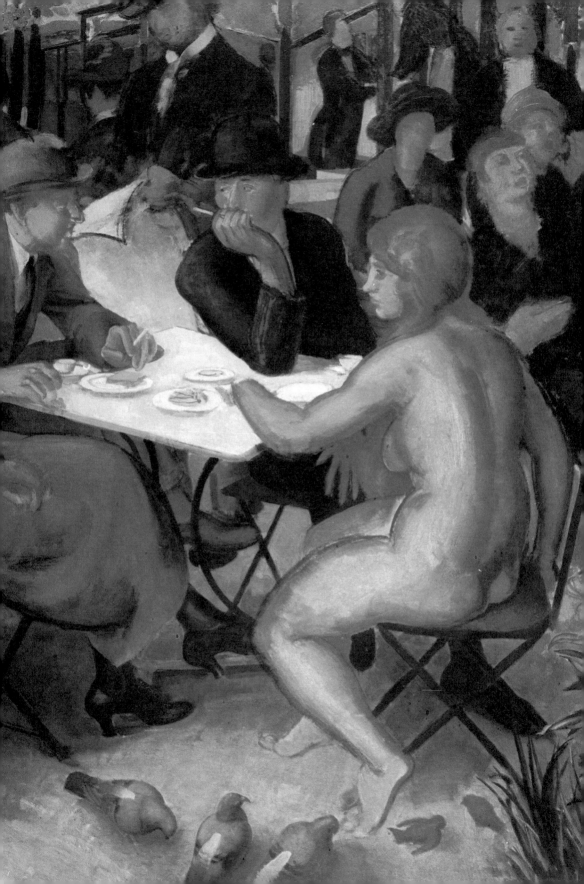

It is a period tour-de-force, with its clear reference to the Tuileries café scenes of the Impressionists, the Moulin de la Galette, and Renoir's *Luncheon of the Boating Party*, but at the same time hinting stylishly at how he would take off on his own. He was over thirty by the time he painted the picture, and the historical references still give it something of the air of an exercise, consummately well carried out; something that could be done with panache at the last historical moment in 1921–22, and a kind of picture that was tried again by English artists in the '60s but without its crucial relevance to the evolution of style and no longer with such complete validity.

The composition was built up in the traditional way from careful pencil and chalk studies – where later attempts at the same degree of immediacy would suggest the use of photographs – and each pose was studied from two or three angles in isolation before being adapted into the harmonious sweep of the whole. Several of these studies survive, like the one for the small girl partly obscured behind the hat to the left of the picture: she was Mary Exeley, the daughter of an etcher and printmaker who lived near Underwood in Brook Green. Even the pigeons were hired from a neighbour for a small fee, and secured by cotton round their legs to a pin in the studio floor so that they could be drawn in detail. The Alsatian under the chair was borrowed from Gertrude Hermes. As to the rest of the dramatis personae, the figure seated directly to the left of the model, with his hand to his chin, is Arthur Outlaw, a fellow competitor with Underwood at the Slade for the Rome Prize and an enthusiastic supporter of the original proposals for a school in Girdlers Road. It was arranged that he should help with the teaching, but although he was involved for a short time at the beginning, he had left by June 1921. He appears also in almost exactly the same pose in a superb etching by Underwood of the same year.

On the left in the background, wearing a tie, is Warren J. Vinton; at the foreground table, left, the artist's wife, Mary; next to her, Clement Cowles, a friend of Underwood's and a commercial artist who, with Outlaw, had originally intended to have some hand in setting up the school; standing in the middle, an Italian model at the school; the nude, Kitty Malone, the life-school model; directly above her, the artist's wife again; the two women at the extreme top on the right, two of Underwood's first pupils, Eileen Agar and Jessie Aliston Smith; and the fringed man leaning back in his chair to the right of Kitty Malone, a self portrait.

The painting measures 40 × 50 in, and that Underwood should have shown his friends and a nude model on such a scale seems particularly to have upset the columnists in the evening papers, though one suspects that the offence was chiefly to have set the scene in middle-class Kensington (the restaurant, on the west side of Alexandra Gate, is no longer there, but it was rather like painting a nude on Derry & Toms' roof garden). The only explanation arrived at for such a thing by the art critic of *The Referee*, under the headline 'A Preposterous Venus', was that either the artist or Kitty Malone must have been drunk.

17

5 In search of subject

Apart from his teaching and the several dozen life drawings per week that he was producing by the summer of 1921, Underwood had returned enthusiastically to printmaking. The etchings he produced in a sudden flurry of activity between then and the end of 1922 are unsurpassed of their kind in the period immediately after the war. Campbell Dodgson saw this very quickly and began to acquire them, often in several successive states, both for himself and for the British Museum, with an emphasis on the white-line technique that no one, except perhaps William Giles, was using at the time.

This development is closely tied up with two encounters: one with John Knewstub, the founder of the Chenil Gallery, in the King's Road, who had the greatest admiration for Underwood's prints and high hopes for their joint commercial success; the other, related to it, the journeys he made into Kent and Sussex to draw, paint and etch, culminating in a holiday at Ashurst, near Tunbridge Wells, in the scorching late summer of 1922.

He had learnt etching under (but hardly from) Sir Frank Short at the RCA in 1910, though, like many of his contemporaries, he owed much of what he knew about the subject to Short's assistant, Constance Pott. She did most of the teaching in his department and was famous for her concern about the students' health, always ready with castor oil for those she considered not quite a hundred per cent. Underwood, like Sickert, soon came to the conclusion that Short's taste was execrable and maintained that he learned nothing from him but techniques and formulae in printmaking that were to be strictly avoided.

He was still head of the department when Underwood returned to South Kensington to make use of their acid baths and presses in 1921, and nevertheless something of his expertise, especially in aquatint, may well have affected him in the first two prints he made there, the *Three Graces* and an extraordinary self-portrait with a landscape background first exhibited at the Chenil Gallery in November 1921.

22

They were the first completed etchings Underwood had made since the war, apart from the isolated print of Ilfracombe of late 1918 which would have stood a better chance of winning Short's approval. These he very much disliked and said so, though his criticism – despite his eminence as a leading figure of the etching revival of 1907–8 – was not greatly respected since he had once declared in a lecture that Goya's *Porque fué sensible*, executed miraculously free-

hand on copper without a bitten line, was 'rough stuff' and that he personally did not much care for it. It was in this atmosphere of great technical refinement but questionable taste that Underwood began to etch again in earnest.

There are a number of small experimental plates including a *St Sebastian* – a portrait head with the first signs of a tentative landscape background – and then almost at once the self-portrait in a landscape, Underwood's first positive step in the direction of an extraordinary series of country pictures and prints done over the next two years. There are three exquisite states. Dodgson bought two of the early ones, with pencilled corrections, for himself, and the Contemporary Art Society purchased a final state for the British Museum. Each is a poignant and arresting combination of apparent naïveté and extreme technical accomplishment in a very cunning balance. Deliberately designed to exploit differences of texture and focal depth, it is a telling image of the alert artist, complete with pipe and felt hat, in the act of sketching surrounded by the minutiae of hard and soft, close and far, the natural and manufactured of his own material.

The month that it first appeared at the Chenil Gallery, *The Studio* included an enthusiastic review. 'It is as vital in conception and expression, as admirable in the drawing as in the planning of the plate' it said, and went on to admire the open linear treatment of the landscape background in relation to the skilful tonal modelling and stippling of the face and hand. It concluded encouragingly: 'We shall watch Mr Underwood's career as a painter-etcher with great interest.'

Knewstub, too, entertained high hopes, particularly in view of the fact that he saw some similarity between Underwood's subsequent approach to country subjects and that of Augustus John. John, together with Orpen, happened to be the Chenil Gallery's main claim to fame because they had been shown there for the first time as almost unknown artists seventeen years previously. Consequently he did not hesitate to imply some connection between the two when advertising Underwood's first exhibition of paintings, drawings and prints which he put on in May and June of 1922, and in the following year he was confident enough to show Underwood's and John's etchings simultaneously. Their prices in 1923 were closely similar, about four guineas for an etching, though John's were invariably in very much larger editions.

His enthusiasm for Underwood's prints led him into flights of speculation. His project for the new Chenil Gallery, of which Augustus John eventually laid the foundation stone on 25 October 1924, included plans for a large studio at the top of the building to which Underwood would transfer his school. This would then be administered by Knewstub, who would pay him five hundred pounds a year to teach there as principal. He first mooted his plan in 1922, but although the new Gallery opened in 1925 Knewstub's plans for a school never materialized. Underwood was naturally grateful for a dealer so eager to solve his financial problems, but perhaps less grateful when Knewstub's insistence on etchings, especially etchings in the manner of Augustus John, began to interfere with his other activities and even to threaten his integrity.

20 *Mother and Child* 1922. Oil

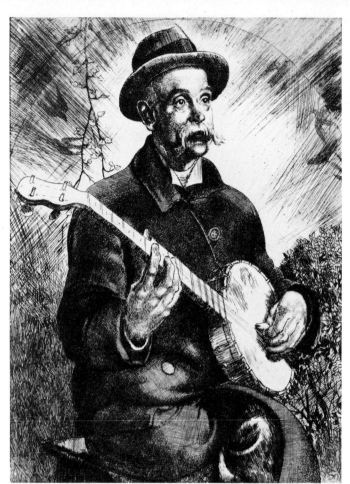

21 *Banjo-Player* 1921. Etching

Certainly the first prints, beginning with the rhythmic *Three Graces* and the *St Sebastian* (that first attracted Campbell Dodgson when he was organizing an exhibition for the Contemporary Art Society in his own house in 1921), are close in spirit to John. There is no way of establishing their exact sequence but it is not hard to guess at it from May 1921, especially with the sudden appearance of Ashurst scenes and characters in July–September 1922, towards the end of the period. In general, there is an extremely subtle use of stippling early on that is gradually superseded by a shorthand of tiny dashes, almost like hair, and the increasing use of some kind of toothed implement or roulette, first noticeable in a small but cleverly handled plate ($3\frac{1}{4} \times 4\frac{1}{4}$ in) of G. C. Cowles from the autumn of 1921.

The portraits, even where they were exhibited for one reason or another under general titles, are perhaps the best of the prints because of their extreme delicacy of touch, in characterization. The earliest is of a street musician, a banjo-player, inveigled into the studio in Girdlers Road in March 1921, a large, rich print with a compelling sense of presence and period atmosphere. Soon afterwards come the portraits of Mukul Dey, the Indian painter-etcher who

21

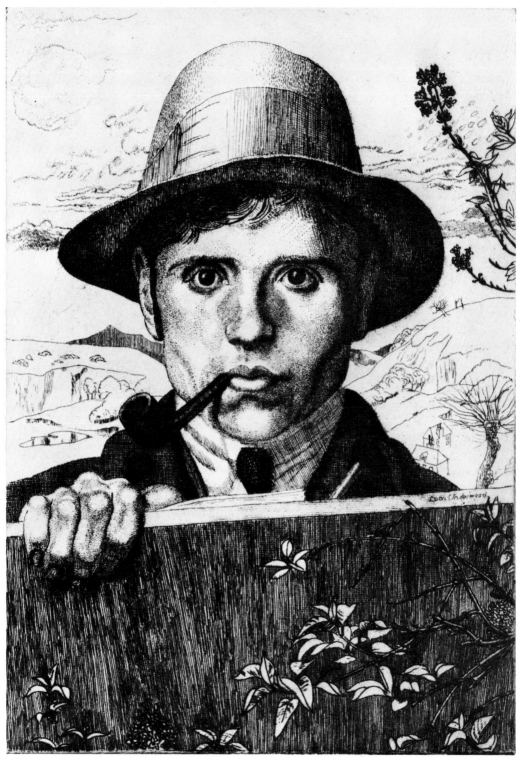

22 *Self-Portrait in a Landscape* 1921. Etching

23 *Kent Landscape* 1922. Oil

24 *Gypsy Ablution* 1922. Watercolour

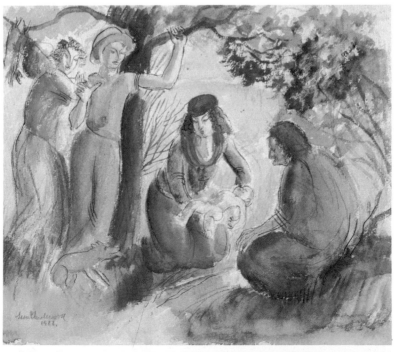

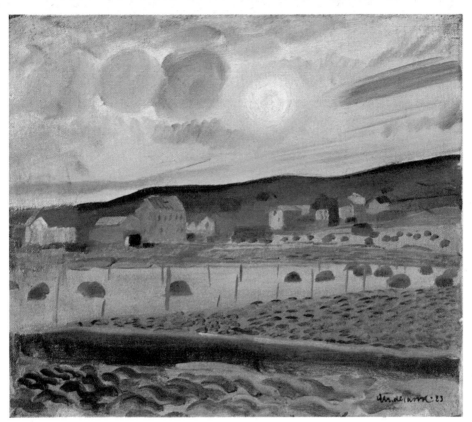

25 *Landscape near Husavik, Iceland* 1923. Oil

26 *Beach Huts, Walberswick* 1932. Watercolour

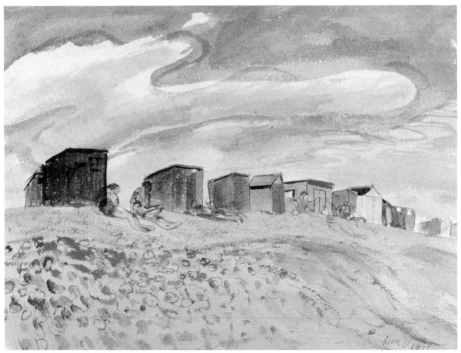

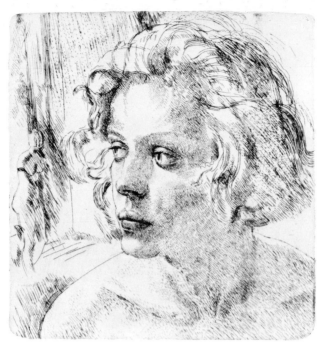

attended the school, and Mary Underwood, exhibited under the title *The West Wind* because of her blowing hair. Dating from the early part of 1922 is the *Tulip Girl*, so called because of the shape of her head rather than after the flowers she is holding, and a lovely drypoint of a seated life model that retains tremendous spontaneity and attack in drawing despite the mechanics of the medium.

This immediacy becomes the more conspicuous in the slight but vivid little etchings, sometimes several to a plate, that he made of many of his students, in particular of Barbara Weekley (who was Frieda Lawrence's daughter) and a delightfully straightforward and objective one of a beautiful girl in profile, bent over a drawing board, who is Eileen Agar at work in the studio in 1922; but at the same time he was capable of extremely complicated and much-bitten plates like the portrait of Mrs Warren Vinton.

Such familiarity with the medium ensured that by the time he went to Ashurst in July he was equipped and confident to work, if need be, with the plate in his lap in the open air. Tastes change, and in 1922 the plate that attracted 27 most attention was a portrait of a life model. It began as a head and torso, $5 \times 7\frac{1}{4}$ in, with a girl looking to her left, but in later pulls it seems to have been cut down to form a 5-inch square, which does not improve it. In the background is a small cast of a female nude that used to stand in the studio. The shadows are astonishingly luminous as a result of the delicate mesh of dashes that let the white of the paper shine through. It is supremely well done but, among the studio portraits, it seems less immediately impressive now than the large 28 version of Clement Cowles, in exactly the pose in which he appears in *Venus in Kensington Gardens*.

The only important distinction is that in the print he has a draughts board before him, the rigid pattern of which makes an effective foil at right angles to the rather vulnerable-looking but rakish hat and the eyes that hang open slightly along their lower lids. It is a strong and poignant etching, as good as anything Underwood produced in this medium in a more or less conventional mould before he went on to experiment more dangerously with big lino-cuts and wood engravings in 1923. Its place among his etchings is closely analogous to the *Venus* in his oil paintings in that it reaches a pitch of excellence in territory that was already known, and made it clear that, in this medium too, from now on he was ready and able to go his own way.

28 *Clement Cowles* 1922. Etching

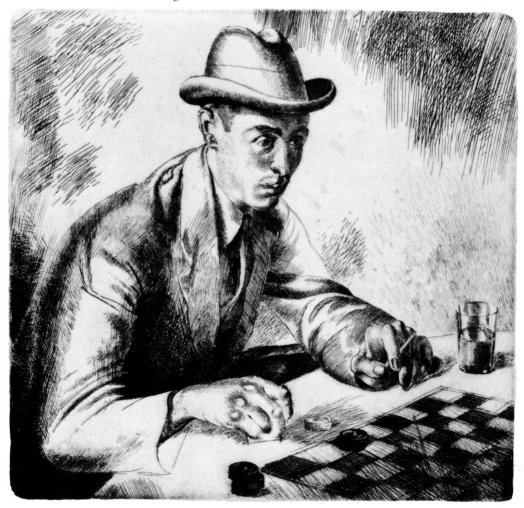

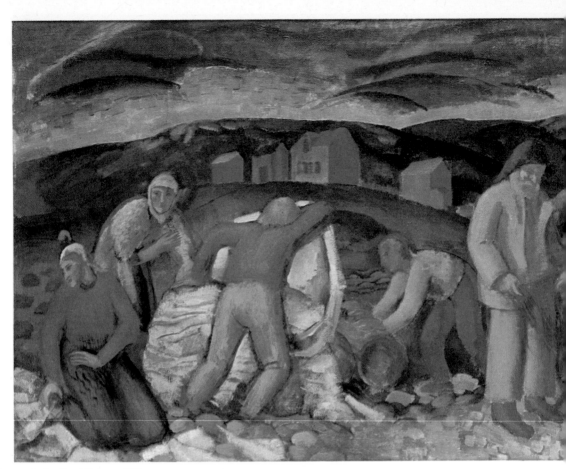

29 *Iceland's All* 1923. Oil

30 *Fisherman's Rosy Love* 1927. Oil >

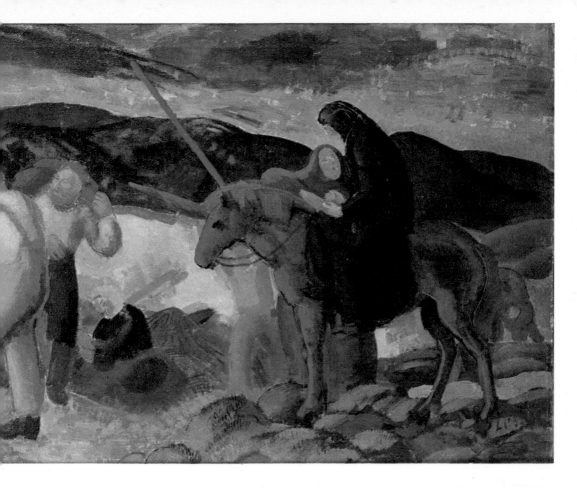

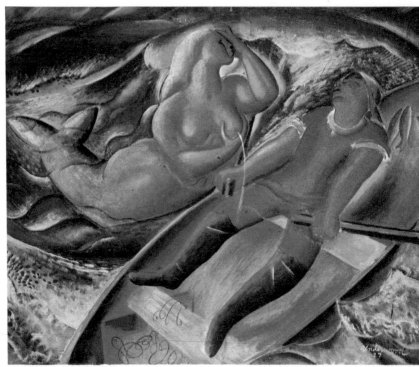

Ashurst is about five miles west of Tunbridge Wells, right on the Kent–Sussex border. When Underwood and the Knewstubs spent three months there in the late summer of 1922 it was a sleepy hamlet temporarily enlivened by the colourful annual influx of hop pickers from the East End. The Knewstub family rented a cottage outside the village while Leon and Mary Underwood and three-year-old Garth lived in a converted oasthouse. Their second child was due in November.

This was a contented period. There was every reason to hope that, with an enthusiastic and sympathetic gallery director, Underwood's work would continue to sell as it had begun to do in July. His drawing school had got off the ground and was rapidly gaining an excellent reputation. And he was in the country, surrounded by subject matter that stimulated and inspired him. He may well have caught something of Ralph Chubb's heady romantic attitude towards the simple life in reaction to the war, and, although no great watershed like some of the subsequent journeys, this is the first occasion on which Underwood shows any real excitement about the environment of his perennial subject, the human figure. His nearest approach to it previously had been in

32 *The Mill, Ashurst* 1922. Drypoint >

33 *Cow* 1922. Etching >

31 *Goat* 1922. Etching

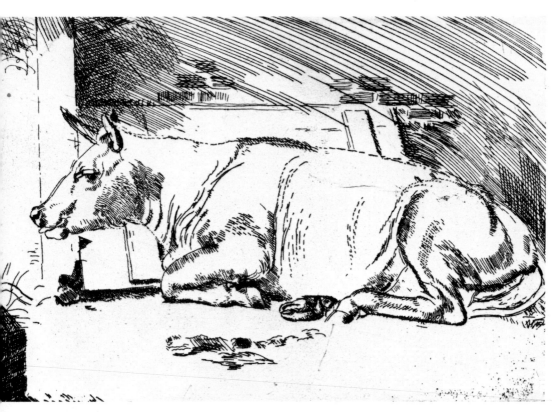

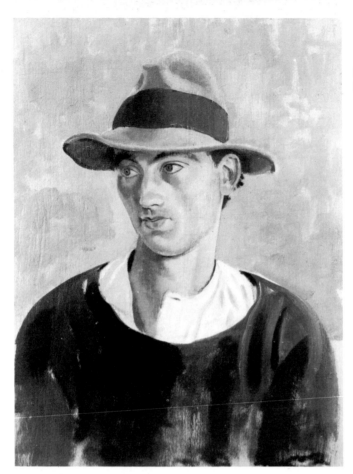

the succession of studies made at Poole, Dorset, in the summer of 1921, when he
became enthusiastic about sailing, bought a small boat of his own and painted
34 some marvellously sensitive portraits of local fishermen. Ashurst was an exten-
sion of the same attitude but, more important, it also represents his first
approach to something more than a purely theoretical interest in primitivism.

 He was excited enough about what he saw to start cutting corners, and he
began to work at astonishing speed in order not to let a subject or idea escape
before he had got it down. His expertise at etching now paid off in that he had
not the least hesitation in drawing straight onto the plate, with no question of
33 second states or corrections. He went often into a byre to draw cows, or sat in
31 the grass to draw a goat marvellously well, with a cunningly improvised
decorative use of its hair and the plants in which it was lying. There is a very
free dry-point on zinc of a young farmer, *Charles*, and a fresh little print of
32 the watermill at Ashurst, full of the spirit of summer. Best of all, and com-
parable with the large *Cowles*, is his study of a local character called Granny
35 Ashdown whom he drew while she sat for him patiently on a milking stool in
the open.

66

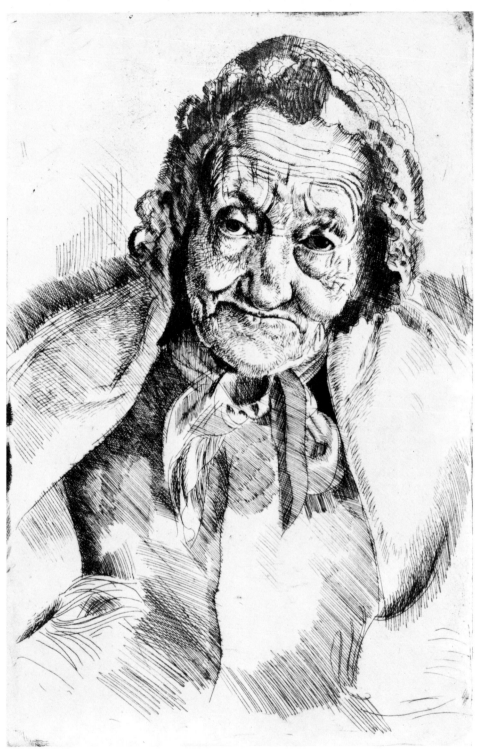

35 *Granny Ashdown* 1922. Etching

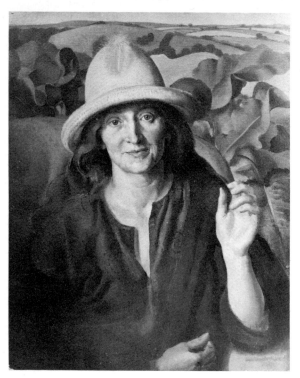

36 *Mary at Ashurst* 1922. Oil

37 *Farmworker, Ashurst* 1922. Oil >

38 *Caspar Knewstub* 1922. Oil >

By this time he was thinking again in terms of a large exhibition picture, and many of the prints, drawings and paintings done at Ashurst relate to it. *Granny Ashdown* does, so do several of the studies of local farm workers and those of the Knewstub children. Most unusually for him, so also do some delectable little
23 landscapes in oils, beautifully constructed views in which the greens of high summer retain their timbre in a sharply diminishing perspective of copses and hop gardens spread out across the weald and punctuated by the baked red of wealden clay. He was not to look at landscape as sharply as this in its own right again until in Mexico, and for the time being he was only a hedge and a ditch away from John Nash (with whom he was to exhibit his completed Kent painting in Pittsburgh in 1924).

A glimpse of such a landscape, almost a latter-day equivalent of the symbolic garden behind a Van Eyck Virgin and Child, is beyond Helen Knewstub in the
20 supremely sensitive and carefully composed *Mother and Child*; and in every picture there is the sense that he was luxuriating in it – the elements so far behind him when they first came into focus in the self-portrait etching of the year before were now all around him in the foreground. He made watercolours of farm labourers and hop pickers as integral parts of the landscape, even to the extent, in one of the best of them, of showing a group washing in the stream
24 between Ashurst and Groombridge where he laid his eel lines.

The simplicity of life in the oast delighted him, and when he was not at work he was out across the fields with a gun to find rabbits for supper or

68

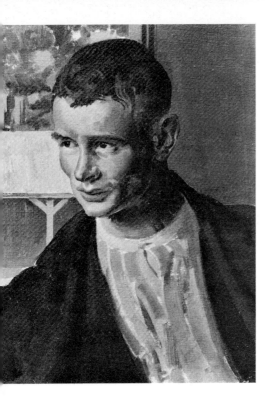
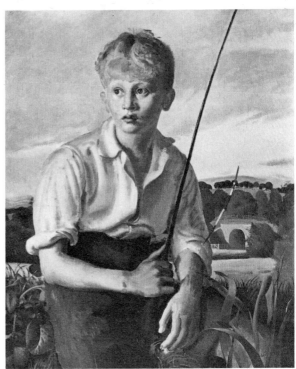

fishing in the phosphorescence of the neighbouring weir. He painted a celebratory fishing picture of Knewstub's son, Caspar, and included a self portrait, complete with rods, amongst the figures in *Peasantry* as a kind of memento. One of the most attractive models from the Ashurst period is the small girl, Wendy Knewstub.

For some reason, perhaps in reaction to the relatively lightweight quality of the watercolours and drawings, however excellent, Underwood felt the need for a full-scale exhibition picture along the lines of the *Venus*. A machine of this kind, a remnant of the same nineteenth-century tradition that dogged Constable in his academy pictures, was still a necessary part of the pattern of exhibiting one's way into some kind of public awareness. Consequently he put everything he had thought about at Ashurst into a frieze-like composition nine feet long and four feet high of absolutely unashamed realism.

Peasantry is a difficult picture. Because Underwood's technique as an oil painter was by now at full pitch it is miraculously well handled, well observed and well drawn, but – like John's large Romany pictures – there is very much the sense of picturesque figures on a landscape stage for no apparent reason. The meticulous way in which they are set down is almost religious, as though displaying with absolute impartiality the evidence of some super-natural happening. One looks along the frieze for the focal point of a small miracle; but there is none. The point would seem to be that Underwood was painting, with as much integrity as he could muster, the facts about what he saw, with no overt

38

39

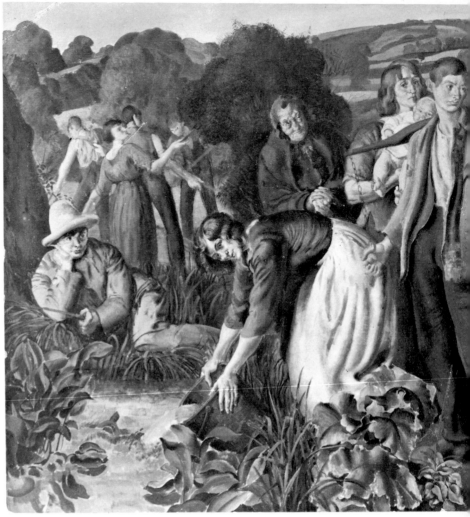

39 *Peasantry* 1922. Oil

references to contemporary colour theory or meaningful form, as an act of celebration. A composition of this size and with so much fitted into its rhythmic jigsaw enabled him to run his mind and his brush over all that he knew about the minutiae of the place and people, to fix it precisely, just as Miró was doing the same year in his key picture (which later belonged to Ernest Hemingway), *The Farm*. Nothing is wasted.

This is dangerous ground for the intelligent artist. The desire to paint about a subject rather than about a current idiom or style does not reach a greater extreme in Underwood's work than this, and such a simple impulse is easily laid open to misinterpretation. The picture did not fare at all well with the press when it went to the United States for the Pittsburgh International in 1924, and collected in the main uncomplimentary notices in New York, St Louis

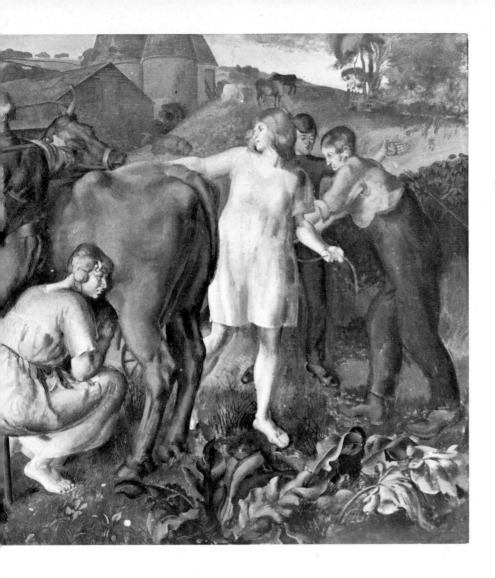

and Philadelphia. The critic in the *California Graphic* thought it 'crowded, ungainly, and with no apparent kindly spirit for its subject', all observations that are exactly the reverse of the truth. Fortunately, the picture of Helen Knewstub feeding her baby received a more enthusiastic reception and was awarded an honourable mention at the Carnegie Institute in June, perhaps giving Underwood a first inkling that he should try his fortunes in America. The picture was continuing to attract attention, and was the one by which he was identified, when he arrived at Palm Beach at the end of 1925. *Peasantry* was eventually bought for two hundred pounds by Sir James Dunn, in June 1927, without its connection with the Georgian poets' celebration of the Weald, and in particular its visual equivalents to much of Edmund Blunden's poetry, having ever been recognized.

In the meantime, however, Underwood was still exhibiting pictures with titles like *Hopping Time, The Pond,* and *An Ancient Ash* at the Chenil Galleries, but having once been set going by the new source of country subject-matter that he found at Ashurst, he was more than ever eager to try painting in a less cosily primitive rural community in Iceland.

The relevance of the journey to Iceland in Underwood's work stems from a slightly different source from the one he had anticipated. He went there expecting to study indigenous art, which he thought would be simple and direct carvings, like Denbigh and Dorset-culture Eskimo art, stemming from a culture adapted to a treeless region dependent on hunting and fishing. Instead, what painting and carving he saw was a feeble imitation of Post-Impressionism with no proper basis in the Icelandic way of life, and he found that the best course for him to take was to investigate, not so much their art, as the people themselves. The effect was that he began to paint less literally and to look increasingly for symbolic equivalents to express the humanity of his subject. The plum skies of the edge of the Arctic Circle got into his palette, and he began to paint an idyll.

He left for Iceland, taking Blair Hughes-Stanton and Rodney Thomas with him, in July 1923. They landed at Reykjavik and made their way north to Husavik, hiring pack horses for the final stage of the journey and adding an edge of excitement by using only a primitive compass for navigation, perhaps as a gesture in the general direction of the simple life they had come to find. They were lent the school at Husavik and used it as a studio, it being the time of year when all pupils were required out in the fields to make hay during the short summer.

Two quite distinct kinds of paintings and drawings were the result. In the first place Underwood took care to record the landscape and faces of the people in exactly the way that he had done at Ashurst. The colour was getting richer, more soaked, but the exquisite little study of farmland with haycocks near Husavik is a direct equivalent of the small weald landscapes, and the portraits he painted of some of the school children are related to the studies of hop-pickers and Caspar and Wendy Knewstub. He got them down directly, unsentimentally and without unduly romantic overtones. Having equipped himself with this factual ammunition, however, he felt able to go a stage further. The line that was still tied tightly round the forms in *Venus in Kensington Gardens* began to flicker and break free into the occasional arabesque. He was no longer specific.

Again, but admittedly on a lesser scale, he set about composing a definitive statement, this time a panoramic view of Icelandic life. Again there is a frieze, and again the gestures and relationships of the figures are as important for what they actually depict as for how they are arranged. From his own experience, he knew how to dry hay and gut fish and he wished to set down this simple economy, and the techniques on which it was dependent, in his picture.

72

40 *Icelandic Girl* 1923.
Ink and wash

The narrative has a basis in journalism, in the same way that the purpose of the official war picture had been to show how a camouflage tree was erected, but now, instead of his brother posing in a variety of positions for all the figures, he symbolized the farmers and fishermen he watched in Husavik.

It was an unfashionable stance. Critics would have preferred him to express himself with a purely pictorial language dependent on colour and form, but instead he referred them emphatically to the subject of his picture as the source of his interest and concern. The fact that, as with *Peasantry*, it was cunningly composed and orchestrated must not be allowed to compromise what it was about. This time the distinction is that the figures are no longer individual portraits, like Granny Ashdown and the rest, but generalized Icelanders whose function is to demonstrate their way of life in their instinctive reflexes to the elements in the changing seasons. To this extent the canvas is broader and there are more poetic options open.

Ironically enough, Underwood had no inhibitions about borrowing southern imagery in following this idea up. The benign influence of the elements could be expressed, for instance, by a mermaid squirting milk from her breasts into the dangerously rocking boat of a fisherman, and the more he saw of the local people the more aware he became of a totally intuitive response to the business of earning a livelihood within so simple and hand-to-mouth a culture.

30

73

Mermaids must have seemed almost rational in a social and economic situation where the emotional response was not only more vivid but more useful than the intellectual one. The months of darkness, he found, turned the islanders in on themselves and into their own imaginations. Their visual tradition had frozen up and atrophied in favour of a spoken one: they were great story-tellers.

He took trouble to learn Icelandic. A man who lived in a turf-covered hut not far from the school helped him (he had published a novel the previous year in Reykjavik), and he also became friendly with the grandfather of a family called Boklin who kept the local store. The old man had learnt half-a-dozen languages from books during his many winters. To both of them he gave drawings and watched their astonished reaction. All this set Underwood thinking about communication and expression, the way in which a culture develops channels of communication in those areas of least resistance and specifically in the directions most useful to it. It was not a consideration that he saw being taken much into account in Europe in the mid-1920s despite the widespread en-thusiasm for African art, and it was an aspect that he was to think over very carefully later in relation to static, or tribal, cultures as opposed to so-called developing ones.

For the present, however, he concerned himself with trying to express his inherent satisfaction in the approach to primitivism he found in Iceland. The fact that he chose to do so on the one hand by gathering data about the way of life, and on the other by making a poetic comment on it, is indicative of his state of mind; but it also suggests, much more significantly, that a part of his person-ality as an artist was beginning to peel off, away from the rational and analytical in the direction of a statement of belief. He had spent years as a student in acquiring a precocious and refined technique, a manner if not a style, in the full realization that it was worthless without just such a belief, and now he had found the first plain indications of a direction of his own.

With his Icelandic reaching the dizzy heights of a long narrative nursery rhyme about a little hen who planted golden wheat, exactly in the spirit of his stay, Underwood returned to London in time to reopen Brook Green School for the autumn term. Typically, however, he did not waste the opportunity of gaining some further material in the process. Hughes-Stanton and Thomas went home on their return tickets but Underwood determined to work his way back by trawler. He managed this by getting a Faroe islander to row him out to one while it was sheltering from a storm in Akureyri and bribed the captain to take him aboard with a case of Spanish wine. Despite a rough passage and having to fulfil his undertaking to spend much of each day gutting and sorting fish, he found time to make many drawings, and added what he saw to his store of information about northerly seas that had begun with the dangerous journey back from Norway in 1914. He was almost ready to write about it.

6 A new Primitivism

William Rothenstein, passionately devoted to art but subscribing to no particular dogma or philosophy, had what Augustus John called the flair of a bloodhound. Partly that was no doubt because Rothenstein early preferred John as a draughtsman when Brown, Steer and Tonks were keener on Orpen; but the truth of the observation was borne out by his influential role and quick reflexes in a long succession of developments in British art from Whistler onwards. Though by no means of the Bloomsburys and usually at odds with Fry, he was capable of tremendous insight in totally unexpected directions – an example would be the speed and certainty with which he recognized Wyndham Lewis who, except that he could draw well in the approved Slade manner, belonged to no tradition that Rothenstein would otherwise previously have understood. Not least of his achievements was his entirely revolutionary spell as principal of the Royal College, beginning in 1920.

In August 1920, he came to see Underwood in the studio at Girdlers Road, admired his work, and somehow persuaded him to go back to the R C A to take drawing classes in the late afternoons and evenings, starting in the autumn term. The changes Underwood himself initiated there were to have far-reaching effects and at once caught the imagination of the more advanced students: poses were shorter and the subject did not consist necessarily of only one model, Alston's meticulous shading was discouraged and the emphasis was on conveying volume, mass and direction with the greatest economy possible. He tried to instil into his students such, to them, astonishing notions as the need deliberately to ignore contours in favour of form. A natural teacher, he had them looking and drawing in an entirely fresh way, not just with their eyes but with their brains. What was more, as at Girdlers Road, he found that in helping them with their problems he threw new light sometimes on his own; their elementary mistakes had some bearing on his.

It is probably accurate to say that by this time he had developed considerable personal style and panache. An extremely forceful and original character, he had more than an inkling of his own direction, was absolutely no respecter of persons, and had already developed a healthy and, if need be, outspoken contempt for officialdom in general and a mistrust of gallery directors and critics in particular. His mind constantly went in many directions at once. Perhaps he was garrulous, truculent even. Certainly he wanted a more poetic, more

romantic solution to the problems of expressing a spiritual truth in post-war art than he could see around him in the remnants of anglicized Post-Impressionism, or in the Cubism-in-motion of the surviving Futurists in eternal pursuit of *velocità*. The general direction, he felt, was seriously wrong: it needed to be rethought much more thoroughly, more radically and from much further back than the 1860s, and he passionately believed that one springboard from which that could be accomplished was life drawing. No one, however, told him what to do.

It is characteristic of Underwood that throughout a long life his independent nature has invited him to cross swords with all the most distinguished men who might have furthered his career. It may not always have been necessary, and it was certainly not always his fault, but – if he cared to consider it – he has paid a high price in isolation for his integrity. In Rothenstein's case, as far as it is possible to tell, there was a clash of two extremely volatile and unorthodox methods of teaching. The matter came to a head when the Principal interrupted Underwood's class without asking him and instructed his students to make studies of a bundle of foliage he brought enthusiastically into the studio. Underwood, incensed, went to his office intending to write out his resignation. Unable, in the heat of the moment, to find a suitable piece of paper he got some lavatory paper and wrote it on that, leaving it on Rothenstein's desk. The college files show that his resignation was officially accepted in June 1923.

A man of Rothenstein's calibre was well able to understand, if not to respect, such an action. Although the two did not meet again until long afterwards, he was a frequent visitor to Underwood's exhibitions in the 'thirties and was an admirer of his work. A memo from Rothenstein, dated June 1921 and now in the Royal College staff files held by the Public Record Office, describes Underwood as 'an unusually accomplished draughtsman with an accompanying ability to impart orderly method'.

Underwood's impact on teaching at the Royal College had been so strong that shortly after his resignation a number of students from the painting and sculpture schools came to him at Girdlers Road and asked him to take them in special evening classes. They said that there was no comparable life class to his own at South Kensington and that they were eager not to be interrupted in their studies by his disagreement with William Rothenstein. At first he refused, feeling that he was barely getting sufficient time already for his own work, but the group was insistent and returned with new proposals for the arrangement in October 1923. Among them were Vivian Pitchforth, Henry Moore and Raymond Coxon, with whom Moore shared digs at the time in Walham Green.

It was finally agreed that they should attend at a cost of two-and-sixpence a week plus their best drawings. They also undertook to keep the studio tidy and look after the stove, neither of which they did to much effect in subsequent months and, in Underwood's opinion, there were no best drawings anyway. Those he was given, including Moore's, he tactfully destroyed, though he

accepted them in the first place to encourage the class and so as not to upset their feelings.

Moore had arrived at the Royal College in 1921 from the Leeds School of Art and was at work in the Sculpture Department under the stern classical gaze of Derwent Wood. His stone carving instructor, Barry Hart, expected his students to use pointing machines, so all Moore's free carving was done out of college. He was twenty-three, eight years younger than Underwood. For the period ending July 1922, Derwent Wood's report on Moore read: 'His life work shows improvement. Design not to my liking. Is much interested in carvings', but he was intent on improving his life drawing, which ultimately was to constitute almost twenty years of study – two years at Leeds, four at the RCA and with Underwood, seven teaching at the RCA and seven teaching at Chelsea.

Moore now states unreservedly that Underwood's teaching was for him an important formative influence, and that, apart from Rothenstein with whom he used to draw and who introduced him to many of the leading literary and artistic figures of the time, Underwood was the only teacher from whom he learnt anything of importance during his period at the Royal College. Like the rest of his contemporaries, he was not only stimulated by his vivid way of dealing with problems encountered in drawing but by his ideas and philosophy in general. That is not to say that he agreed with them, but he did soon come to recognize in Underwood a man whose approach was one of ideas, poetic and sometimes literary conceptions, rather than primarily of pictorial or sculptural form, despite those considerations being apparently uppermost in his life drawing.

What Moore did not realize at first was that Underwood had himself for some years been making experimental carvings. He heard chipping one evening during class in the spring of 1925 and came up to the small room overlooking the studio to see what Underwood was doing. He was at work on his first large carving, in rather golden and grainy Mansfield sandstone, a big rhythmic female torso, and Moore at once pointed out that he was carving a particularly blunting medium with a cold chisel (a chisel not so much for carving as for opening packing cases). Underwood, however, said he preferred it and continued with it even though Moore, next time he came, brought a handful of more easily manageable tools for him to try.

This little incident, trivial in itself, is almost symbolic of what was to happen later. Moore, the accomplished student and potentially great sculptor, concerned to find that his teacher was more preoccupied with what his sculpture was about than with how it was carved. Both, as will become clear, had closely similar starting points. Underwood, though he was only on the point of realizing the fact himself in 1925, was essentially an artist in three dimensions and not two. Both for a time developed along closely similar lines. But by the late 'twenties the initial distinction between concept and form predictably took them separate ways; Moore's essentially formal and analytical approach became

49

the vital mainstream of the modern movement, while Underwood's conceptual kind was temporarily isolated and ignored. The fact may have saddened Underwood but it did not surprise him – because, like Blake, he came to believe passionately that his own alternative was the right one.

Nothing if not versatile, in a period when not to specialize already made the critics ill at ease, Underwood was beginning to think increasingly about sculpture. In his search for honest form he could not help but be aware that painting was deliberately illusionary in its implication of a non-existent third dimension. He was beginning to need, too, the permanence and presence of the real object, not in imitation of something else but in its own right; and he had noticed that seminal observation in Ezra Pound's little book on Gaudier-Brzeska that, by 1916, 'we have again arrived at a stage when men can consider a statue as a statue.'

The influences were plain: Gaudier was certainly one and, though he was not an admirer of Fry and Bell, the gospel of significant form as propounded in Fry's essay on negro sculpture in *Vision and Design* of 1920 was another. He had been steadily buying African sculpture since 1919 and by 1922 had amassed enough to draw some conclusions from it. Its initial impact had been an emotional one, just as Picasso and Derain had reacted emotionally on seeing it first, haphazardly displayed, at the Trocadero in 1906. But for most artists by the 'twenties, and certainly for Fry, it began to embody much more specific and intellectual aesthetic principles. For Underwood it was necessary to relate what he saw of primitive carvings to distinct impulses in western culture.

Frank Dobson, before the war, had gone frequently to the British Museum to try to assimilate the purely formal lessons of Negro, Peruvian and Poly-nesian art, and when Moore reached London for the first time in 1921 he learnt far more from what he saw of African and Mexican sculpture at the British Museum than he did from Derwent Wood at the RCA.

Nevertheless, as Gaudier discovered and pointed out in his letters to Sophie Brzeska, merely to adopt the formal language of African sculpture was by itself inadequate because what he was seeking to express was far more complicated and intellectual, stemming from a civilized culture. The need, however, was still to 'present my emotions by arrangement of my surfaces, the planes and lines by which they are defined'. And it is with this area in particular that Underwood was beginning to concern himself because it was related to the way in which, in his painting, he had already been trying to look beyond style to content and expression. Aware of this difficulty, he began to carve – slowly and thoughtfully at first, by way of experiment, using any spare stone (even chalk pebbles from the beach at Birchington) that he could pick up.

He began sculpting while at home on leave in the autumn of 1917, in a borrowed garage near his parents-in-law's house in Wolverton. As always in search of the optimistic image and in reaction to the war, he carved a dove. It was in Caen stone, biscuit-coloured, about a foot long. At once he was aware

41

78

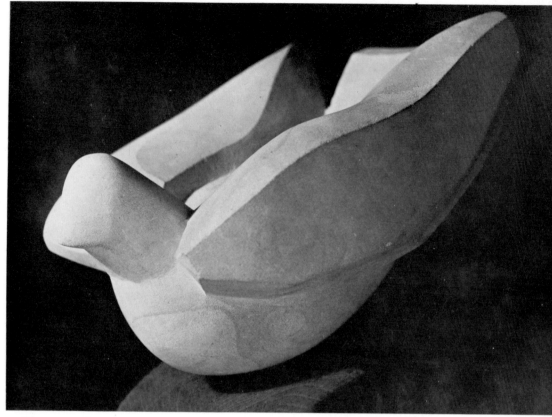

41 *Dove* 1917. Caen stone

that tactile sense meant more to him than visual illusion and, what was more, the physical aspect of the work satisfied him: in painting there was always the likelihood that the picture would be finished before he was, and in sculpture this could seldom happen. The only available photographs show a firm piece of carving with a convincing egg-like refinement in the compactness of the forms but a pleasantly flowing silhouette. It was a successful experiment, and as soon as he was fit again after the war he began to do more.

Initially he was attracted to the egg shape because of its ultimate simplicity of volume and planes, and the way in which it could be pierced without losing the character of its silhouette. While he was thinking about this, he explored it on a small scale by carving pebbles. The results, to judge from photographs and the one surviving example, were good out of all proportion to their size and intentions. They show that he already had an astonishingly sure grasp of the emotional possibilities inherent in drastically simplified biological forms. All except one are on the theme of embryos, dictated by the monocoque surface of the pebbles. Unfortunately, in almost every case, the salt found its way out of the

42

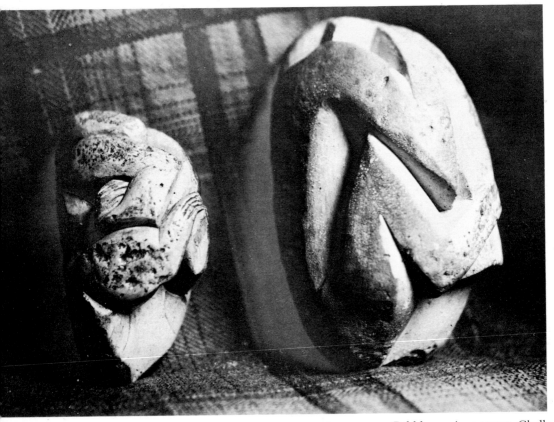

42 Pebble carvings *c*.1920. Chalk

chalk, fluoresced and eventually pitted and broke up the surface before Under-
wood thought to make casts. The only survivor in bronze is a superb little
crouching figure of which the protruding vertebrae come together into the
curving shape of a snake. It is called *Serpent in the Flesh*. At once it is apparent that
he was finding ways of embodying the essence of a poetic concept in rigorous
formal language. The piece shows a respect for near-abstract 'primitive' quali-
ties but with a distinct and tightly compressed idea.

All these date from 1920–21, as does another pebble carved into a Brancusi-
like head, the small *Nereid*, and a second, very early, head in hoptonwood, a
chip of stone picked up in a builder's yard and giving him room to make a
sculpture only six to eight inches high. Clearly at this stage he was carving
anything he could lay his hands on in order to experiment with a variety of
strengths and weights. One large-grained, brittle piece of Seravezza marble
he tried was the broken top of a washtable. He cut it back and front in shallow
relief in a nicely stylized arrangement of a hunter and his dog. Soon afterwards
it broke again into smaller fragments and now only exists in photographs.

80

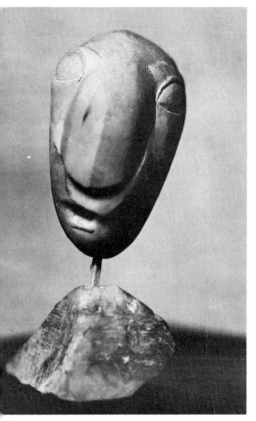

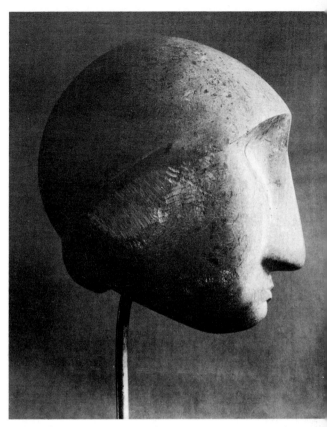

43 *Pebble Head* 1921. Chalk

44 *Head* 1921. Hoptonwood

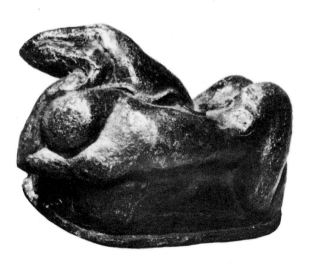

45 *Serpent in the Flesh* 1921. Bronze

48 There is a wittier example from the same period, or perhaps from the beginning of 1923, that was rediscovered recently in a private collection in Sussex. Underwood exhibited it originally under the title *Brains Below the Belt*, because it was carved from the inverted head of a broken piece of eighteenth-century statuary that he managed to obtain from the yard of the Victoria and Albert. (Much fragmented sculpture had been stored there in disarray since 1919.) It was white Carrara marble, and had been the bearded head of a man. By cutting into the features but retaining part of the formally chiselled beard as his new subject's hair, he made a tender mother and child, a marvellously powerful curling mass protecting the child at its centre like a bud. It is exceptionally well worked out for an early sculpture, with none of the literal qualities he had explored in two dimensions in the Ashurst picture of the same subject.

49 The first sculpture of any size, however, was the Mansfield sandstone torso, four feet high, that he had discussed with Moore. Despite the cold chisel it is

46 *Hunter and Dog* 1921–22. Scravezza marble 47 *Female Figure*, white relief 1922

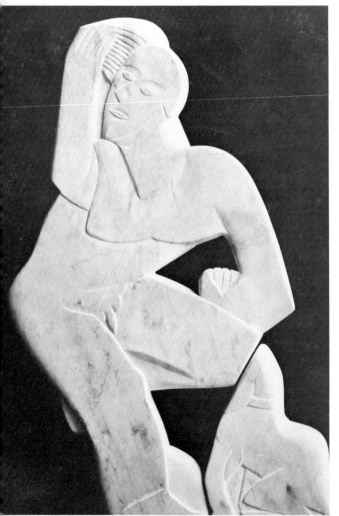

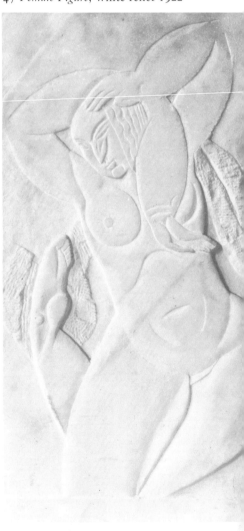

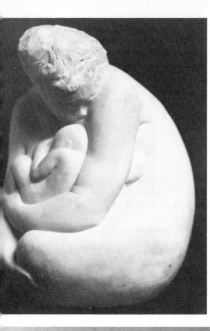

48 *Brains Below the Belt* 1922–23.
Carrara marble

49 *Torso* 1925. Mansfield sandstone

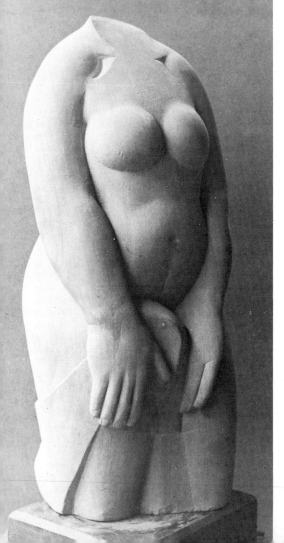

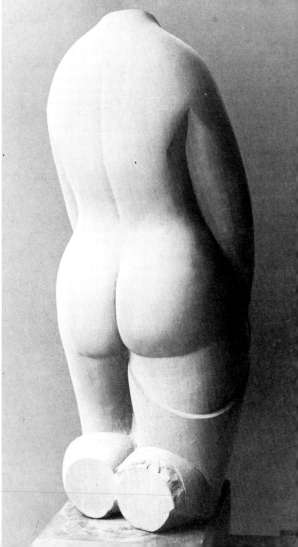

beautifully and meticulously carved, with a powerful sense of the rhythms that set up across the surface of the shapes and hold them close together in a large firm mass. It has great weight and presence, a certain finality about it, and as such it represents the heavy anchor that recurs at intervals throughout Underwood's work, but more especially towards the beginning, as a corrective to the general movement upwards. This torso, a generalized one that is not based on a response to any particular model, exists substantially as an object in its own right, the static earthbound end of what was to become his spiritual kite string. It was only after he had got a thorough grounding by carving this piece with an unsympathetic implement that he took Moore's advice. In fact he went one better and bought some tools off a blacksmith, first heating and fashioning them to suit his own requirements.

51
50
With improved tools and in mounting excitement he began to intensify his efforts. The wonderfully attenuated and stylish slate torso and the *Mountain God* in pink and white alabaster followed in quick succession. Both have a powerful upward thrust, and, in the case of the *Mountain God* with its cowled head, a deliberately phallic appearance. This overt reference to fertility is one that recurs throughout Underwood's work in a poetic form; much later, in 125 the *Phoenix* conceived in 1939–45, for instance, the erect penis has flamelike wings and the directional impetus of an ascending bird. Here the figure is compounding in its hands a symbolic bouquet suggesting the blossoming of life, of seed, but there is also at once a more complicated philosophical aspect that has to do with the mountain itself. The nature of the stone, its apparent inert quality, gave him the idea of trying to suggest the division of static and dynamic matter, all nature being in fact dynamic, in a constant state of change, but at vastly different rates as epitomized by the slow erosion of the mountain of the alabaster itself) and the sudden blooming and wilting of a flower. This concern with temporal relationships, especially where the imagery of the apparent permanence of rock is concerned, also becomes a poignant poetic weapon later on. The phallic totemic effect has much in common with Gaudier's *Portrait of Ezra Pound*.

As Underwood had come to expect, all this early sculpture met mostly with derision when it went on show at the Alpine Club Gallery, in Mill Street, in May 1924. 'It is one of those shows which happen now and again, but for which it is difficult to find any excuse', wrote the critic on the *Birmingham Post*; though Konody, in the *Observer*, noted a keen sense of rhythmic design, and the astute critic of the *Architects' Journal* praised the Mansfield torso and said that he considered that Underwood's carvings demonstrated a real feeling for three-dimensional expression. He considered him more of a sculptor than a painter.

As a critical response it was not much, but for Underwood himself these early carvings were a vital new beginning. And within a week or two of the exhibition closing he made, quite fortuitously, a dramatic discovery in northern Spain that no longer left him in any doubt about which direction to take in sculpture.

84

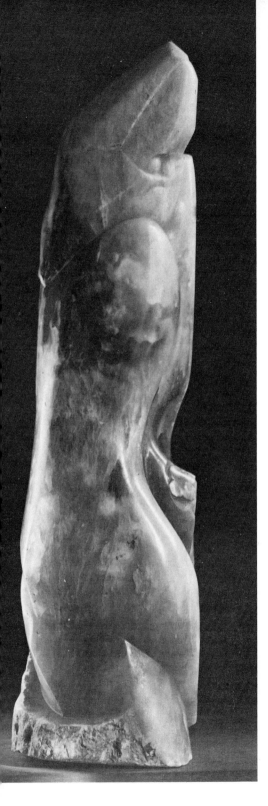

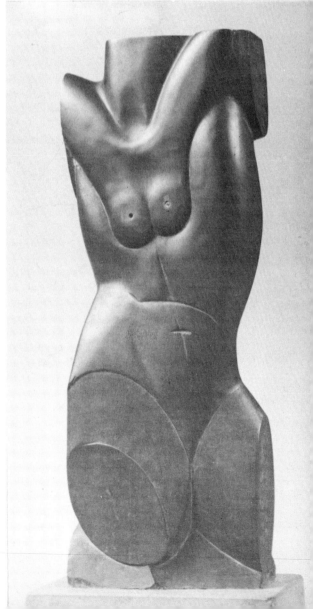

50 *Mountain God* 1923. Alabaster

51 *Torso* 1923. Tournai slate

By July 1925 Underwood was taking his students, who at this time included Gertrude Hermes, to Castel Stari in Dalmatia, where he made a series of beautiful watercolours, some of which were exhibited at the St George's Gallery in the autumn.

Periodically throughout his career he has painted landscape in watercolour, usually when travelling or on holiday and more especially during the Second World War when he was unable to make sculpture. The results in almost every case have been supremely successful. They have a vibrancy, breadth and immediacy born of absolute mastery of technique and a confident attack that is surely the result of the small scale and lightness of touch of the medium in contrast to the solid manual labour of carving or the stiff disciplines of etching and engraving. It is as though a muscular, calloused hand picks delicate flowers. Underwood never seems to have attached much importance to the medium. He used it sometimes to store information but more often, like a simple Kodak camera, to remind himself of a day spent on the beach, or a lazy afternoon on the river. The results were stacked away in drawers and boxes, and forgotten. They may be delightful but they had no real connection with the mainstream of his thought.

26, 132

The prints, on the other hand, did. In a sense they too were made in reaction to life drawing and to the more direct physical preoccupation of the early carvings, but it is characteristic of Underwood throughout that he was eager to explore any technique to the limit. It is generally true to say that, in the fields of both etching and watercolour in the twentieth century, the greatest work has been done by all-round artists like Picasso, Matisse and Rouault and not by specialists in either medium. Underwood has certainly shown great freshness and technical ingenuity in both, as he has also done as a wood engraver. In 1925 he and several of his students, notably Hughes-Stanton and Gertrude Hermes, represented – or came to represent – an alternative and an opposition to the Society of Wood Engravers founded five years before. The new English Wood Engraving Society no longer treated the activity as a craft in the purist sense. Underwood saw it principally as an additional means of expression, and recognizing, among other things, the traditional limitations of black and white he turned to an emotional use of colour that had much in common with his lino prints.

In the period between returning from Iceland and leaving for the United States in late 1925 he was at work on a series of allegorical lino prints, cut with a graver in white line, to be issued as a folio by the St George's Gallery in George Street under the title *Human Proclivities*.

His experiments in white-line printing had led him to some interesting conclusions. He had quickly discovered that to work in white line, as Bewick had done, required a totally different approach to that of normal etching. It was by no means sufficient simply to print a conventional plate in reverse, as a negative. In the first place the subject needed to be lit so that it was the light-catching planes which had to be described, instead of the shadows, for a valid

86

reason. The arrangement had to be thought from dark to light instead of vice versa. The plate would then be etched in the usual way but printed, with a copper-plate press, as though it were a relief block with its etched lines clean and only the surface inked-up.

There are a number of examples of Underwood's use of this process among his prints in the British Museum, notably a self portrait with drawing board, on copper, a portrait called *Dora* and *The Fox and the Grapes* (a reference to Bewick's white-line *Aesop*). The self-portrait relates to another of 1922, printed positively, in which Underwood's features are only just discernible behind the trappings of a Brook Green fancy-dress party. The studio stove is in the background, and on the back of the drawing board that he is holding is the first appearance of his rebus, or punning signature, a lion under a clump of trees – later modified to a lion beneath a log. By 1924 the experimental etchings had given way to lino cuts on a larger scale, leading ultimately to the high point of his printmaking in the colour prints of the early 'thirties.

He was in the middle of this development when he made the San Marcello watercolours in the summer of 1925, and after leaving Dalmatia he took his students on a highly critical tour of Italian museums, churches and art galleries, trying to encourage them to relate what they saw to their own problems. By August they were in Florence. Moore, too, had been in Florence that summer, on a tour that included Paris, Rome, Assisi, Padua and Venice. He was impressed with the Indian sculpture he saw in the Guimet Museum, but significantly he was mainly concerned with studying Giotto, Masaccio and Michelangelo. The more Underwood saw in Florence, the greater his need to return to some primitive source, to rethink. There almost seemed an inverse ratio between the two. Then, quite by chance, he found an old illustrated newspaper in his hotel, with a short article about the cave paintings at Altamira.

It is necessary to appreciate that despite the transformation of the interest in Negro and Oceanic art into a discipline of its own in the 1920s, the caves of Franco-Cantabrian rock art had received little or no attention as a source for contemporary artists.

Underwood at once sent his students home and set out for Spain by himself. He got as far as Bayonne, where he had gone to see the El Grecos in the Museum, and there ran out of money. Uncertain what to do, he befriended some Americans who fortunately volunteered to buy some watercolours. Though unable to afford a wash or a meal beforehand, Underwood went to their hotel smelling like a tramp with his portfolio and succeeded in selling enough drawings to enable him to take the train to St Andaire, and at Touva la Vega hired a cart to take him the last few miles to Altamira.

The cave extends three hundred yards into a limestone massif but the paintings are in a shallow gallery about thirty yards from the entrance, with those in the best state of preservation on the roof. The floors have long since been dug out and lowered, but in 1925 it was necessary to crawl much of the way and to examine the paintings by lying on one's back, often in water. The

German archaeologist, H. Obermeier, was at work there at the time and invited Underwood to inspect them with the help of his acetylene lamps and ground sheets. He said, perhaps rather condescendingly, that he would be interested to hear an artist's interpretation of their meaning as opposed to an anthropologist's. Although the cave entrance had been discovered in 1869 and excavations started by Marcelino de Santuola ten years later, the authenticity of the paintings had long been denied – and even officially repudiated at the Congress of Anthropology and Prehistoric Archaeology held at Lisbon in 1880. The cave art found by Henri Breuil in 1901, near Les Eyzies, was so clearly related that it dispelled all doubts, however. Cartailhac recanted, and it was generally agreed that the Altamira paintings were from the upper Paleolithic period, about 40,000 B C, though they are now thought to be less than half that age.

By 1925 they were in a very poor state, and in some places hard to make out at all. Nevertheless, as his eyes became accustomed to the lamplight and he traced their shapes on the limestone roof, they had a cataclysmic effect on him. At once he was struck by the quality of the drawing, which showed, he felt, that Magdalenian man was a consummate artist. To draw like this suggested that he must have been at a pitch of intellectual and artistic development entirely at odds with accepted ideas of material progress and our assumption of a direct relationship between technological and mental civilization. What was more, these paintings could be taken to represent the high point of a cycle, the upward movement of which could be charted by the three phases of cave art, beginning about 25,000 B C with simple finger-drawings in damp clay and progressing through two-colour solution modelling, that made use of rocky projections and the natural features of the rock-face, to the extremely refined and sophisticated polychrome paintings of Altamira and Font de Gaume. If this was correct, there arose the formidable paradox that though so-called primitive cultures may be inferior in terms of their economic and technical development this was not true of their art. At once Underwood began to think about recurring cycles of style.

When he emerged from the cave in high excitement to discuss what he had seen in broken German, English and French with Obermeier, he found himself confronted with the same objective reasoning and interpretation that is still in most text books on the subject today. The purpose of the paintings, runs the argument, is primarily a magical one: an attempt to capture and contain the spirits of the animals themselves and, through them, to obtain power over the source of supply on which the hunting culture was entirely dependent. This, thought Underwood, was typical of a scientific response, attributing magic as a poor explanation of anything it was unable to account for at an objective level. Underwood's own response was at once more romantic and instinctive – and subjective. To him the paintings represented what he thought of as a distilled knowledge of the technology of hunting, and they above all reinforced his conviction of the crucial importance of significant subject at a time when most

artists, goaded on by Fry and Bell, were preoccupied exclusively with significant form.

From here he could go one stage further. The quality of the paintings suggested a search for idealism, a statement of belief, that could only logically be interpreted in relation to the hunter himself. But there are no drawings of men at Altamira. The subject is exclusively the game that the hunter must kill in order to survive, and which is, by its nature, stronger and faster than he. All his resourcefulness, patience and courage were required for him to succeed because of his comparative lack of equipment – in exact inverse ratio to his present-day equivalent whose absence of such qualities is compensated by high-velocity rifles and telescopic sights. Up to this point the traditional assumption about the function of the drawings was right, but their level of achievement, Underwood believed, must be the result of a much more radical approach to the subjects themselves. The only explanation he could see that fitted this theory was that the hunter identified with his quarry, that the man became the animal, appropriated his qualities. The bison is the hero: the artist projects himself in the image of the bison. If this distinct relationship could be taken to account for the extreme refinement of the drawings, the same link between technology and belief as a reason for expression suggested to him vivid analogies in other cycles, in particular in Greek and Renaissance art and their declines into a purely objective reflex to visual stimuli. There had to be what he began to call 'an icon of belief'.

In order to develop this theory he began to look more closely at the succession of technological innovations that accompanied each cycle. His interest in the relevance of the art of prehistory to what was happening in the twentieth century became a passion, and he determined to follow it up as far as possible, not at a theoretical level, but at a purely practical one. It was, as he saw it, the theory of anthropologists, art historians and museum officials that constantly obscured the facts. Finding it difficult on his return to England to study stone-age technology because only primary (tool-making) tools survived, and the secondary had decomposed, he advanced to a study of the bronze age and began to experiment in a whole range of relevant techniques, learning bronze-casting and ultimately making replicas of bronze-age tools which he used as they were used by their original makers.

He knew, now, that subject matter and expression were linked to belief and technology. Having grasped this principle in relation to recurring styles he now needed to see, historically, what happened when a static, tribal, culture met head-on with the technical expertise of a developing one. There were two obvious examples, in Africa and in Central America, and Underwood decided first to go to Mexico.

VANITY FAIR: Contents for MARCH, 1927

FRANK CROWNINSHIELD—*Editor* DONALD FREEMAN—*Managing Editor* HEYWORTH CAMPBELL—*Art Dire*

Published monthly by The Condé Nast Publications, Inc., Boston Post Road, Greenwich,
Conn.—Executive and Publishing Offices at Greenwich, Conn. Editorial Offices, 19 W.
44th St., New York. Cable address, Vonock. Condé Nast, President; Francis L. Wurzburg, Vice-President; W. E. Beckerle, Treasurer; M. E. Moore, Secretary; Philippe Ortiz,
European Director, 2 rue Edouard VII, Paris. Subscription $3.50 a year in the United
States and Colonies, Mexico and Canada, $4.50 in Foreign Countries. Single copies 35c.
Address all correspondence relating to subscriptions to Vanity Fair, Greenwich, Connecticut.
Entered as second class matter at the Post Office at Greenwich, Conn., under the act of
March 3, 1879. Printed in the U. S. A. by The Condé Nast Press. Copyright 1927 by
The Condé Nast Publications, Inc., Reg. U. S. Patent Office.

Vol. 28, No. 1 **35 cents a copy** **$3.50 a year**

Subscribers are notified that no change of address can be effected in less than one month

Design by Leon Underwood

7 Jazz-Modern

It was necessary first to find a pretext. An exhibition he held of the San Marcello watercolours at the St George's Gallery in late October 1925, though reasonably successful, did not raise – at nine guineas a painting – sufficient funds to finance his journey.

In the event, three things happened that enabled him to go. The most important was that Eileen Agar, who had always felt certain that Underwood would meet with success in the United States, gave him two hundred pounds. Second, he decided that instead of going straight to Mexico he would try to get work doing tempera murals in new houses in Palm Beach. He felt certain that there were commissions to be had there and that it would thus be possible to satisfy an increasing urge, brought on partly by making sculpture, that if he was going to continue work in two dimensions it should be on a large scale. Third, he concluded that the best security he could take would be the smallest and most easily transportable pieces from his African sculpture collection, which he could sell in New York if he ran out of money. Consequently he left the Brook Green School in the care of Blair Hughes-Stanton, and embarked on the *Bremen* in December.

It is worth pointing out at this stage that Underwood's work was beginning to become known to the general public in London and that his reputation was spreading. That this impetus was lost to some extent in the 'thirties has sometimes been attributed to the time he spent in America at a moment in his career when a more public-relations-minded artist might have continued in London and consolidated the progress he had already made with critics and dealers. If this occurred to him at the time, that such a move might have a disruptive effect on the passage of his career, it is significant that he considered continuing his search for the secrets of primitive culture as infinitely more important.

As it turned out, the period he spent in Palm Beach was completely abortive. He was dependent on John Dunn-Yarker, a dealer he knew there, and although the *Palm Beach Daily News* ('Twenty-nine years devoted to Society, Golf, Hotel and Club Life of Palm Beach') announced his arrival at 300 Worth Avenue with an enthusiastic two-column write-up, neither succeeded in finding him any commissions. Helpfully, the paper mentioned the Carnegie Institute *Mother and Child*, and went on: 'It is in mural painting that Mr Underwood is putting his chief endeavour at this time, and it is for the purpose of

20

executing such work in Florida dwellings that he is in Palm Beach.' None of his potential patrons could be induced to keep appointments, however, and after he had been subjected to expensive delaying tactics for some weeks by Addison Mizner, he wrote to say that if Mizner forgot him next time he would be putting a ladder up to his window. This got him his interview, but without result. His financial situation was worsened by his meeting there with friends like Hugh Dilman, at that time more broke than he was, whom he bought free meals, and soon there seemed no alternative but to go to New York, sell his Negro sculpture, and try for the time being to get work as an illustrator. As it happened, with Underwood's experience and talent as a printmaker, nothing could have suited the moment better.

As with the watercolours, his own attitude to the work of this period would seem to be that it is of only marginal importance. The obverse of his earnest researches into negro carvings and primitive painting is a kind of informed frivolity that has more to do with the superficial and iridescent mood of 'twenties design and illustration than perhaps he would care to admit.

He began with an introduction to Brentano's through an Oxford friend of William Rothenstein's son, John, Joseph Brewer. By April 1926 he had received two commissions from them, to illustrate books by Phillips Russell and by June he had also completed eight wood engravings for *The Music from Behind the Moon*, the first publication of the John Day Company. This was a mildly pornographic adaptation by James Branch Cabell of *Madoc et Ettarve, poème d'aventures*, printed originally in Paris in 1898, and Underwood's blocks injected into it a good deal more poetry than the text deserves. The edition was 3000.

The blocks were well received on publication in September, and he sold twenty-five signed and numbered sets of them with an engraved title page on Japan folio at $120 a set.

On the strength of this he found a studio in Greenwich Village on 8th Street West and opened a private drawing school, hiring a model for life classes one day a week, while continuing his work as an illustrator. Although he found it difficult to obtain boxwood in New York, and was forced to make do with pear which resulted in prints of less good quality, this return to the disciplines of engraving gave him so much satisfaction that he began to think in terms of writing and illustrating a book of his own. The secret of the Cabell illustrations had been their flickering attenuated line, dramatic changes of scale and tricks of perspective. His approach was light and inventive, perhaps deliberately whimsical, technically adept but very much giving the impression that he did not take himself too seriously, all of which were characteristics ideally suited to the mood of New York books and magazines in 1926.

The drawings for *Vanity Fair* title pages, which he produced that summer, precisely reflect a cultural atmosphere of which the symbol was the cocktail and the highest literary form the society gossip column. The tone of the magazine was almost breathlessly flippant and effervescent, its layout and illustration just cutting free from the last limp tendrils of Art Nouveau, despising

the rigours of Cubism and fitness for purpose, and drifting up into the heady new atmosphere of Art Deco like bubbles in champagne. A readership still in the thros of hectic frivolity and good-time, wanted only to be amused. Underwood's drawings cultivate the fantastic air of puppet theatre with his jumble of harlequins and dancers well-equipped with period accessories like *sedanca da villa*, golf clubs and voluminous plus fours, spilt cocktails and up- 52
dated putti, all put together with abrupt changes of scale and vista that come out as a highly personal form of Neo-Rococo.

His own book, published towards the end of 1926 by Payson & Clarke, depends for its effect on a similarly stylish and lighthearted approach, though it is as much a delight for its wit and freshness as for its unified design. It also tells the reader, between the lines, a good deal about what Underwood was thinking on weightier topics. He chose to write a book of short verses about animals and birds which set out to explain their various psychological differences in symbolic terms.

However well he may have done this, the idea itself and the form he adopted were not original. Apollinaire's *Le Bestiaire ou Cortège d'Orphée*, with 39 wood-cuts by Dufy, had first appeared in 1911, and although it sold badly until a more successful version was published in 1919 it was the forerunner of a great many French, English and American books on the same theme treated in a similar way. The result, however, is essentially period, and very cunningly composed, with the lettering and disposition of the verse nicely balanced by the weight of the print.

The massive bulk of the elephant, for instance, reaching with his trunk 53
delicately to pick up a fallen paintbrush, faces this:

> *The Elephant understands.*
> *Walking ponderously, his hands*
> *Have worn their fingers out, and so*
> *In a row his nails now grow*
> *Around his wrists and ankles.*
> *His wounded sensibility*
> *O'ercame the inability*
> *To pick up things between his toes*
> *By growing fingers on his nose.*

Both in drawings and text there are witty references to current obsessions – the car for example. In discussing the snake's dryness, the verse points out that:

> *The wily serpent never spoils*
> *The appearance of his motive coils*
> *By using lubricating oils.*

– and is accompanied by an ingenious and amusing engraving of the snake and a passing car.

93

53 *Elephant* from 'Animalia' 1926. Woodcut

Called *Animalia*, and subtitled *Fibs about Beasts*, the book is serious only in the respect that it characteristically prefers the poetic or fanciful explanation to the scientific one. Garth Underwood, to whom it was dedicated, was seven at the time and was later to become Principal Lecturer in Biology at the City of London Polytechnic. On the dedication page he is shown as a naked baby thoughtfully contemplating a frog, while above him is written: 'To Garth/For whom cleaving facts asunder fall/And fancy sheds a healing light on all'. There is an irresistible reference here to Underwood's views on subjective and objective interpretations of natural phenomena, as though to imply that the whimsical view retains often a more vivid truth – a line of thought coinciding exactly with the views of e. e. cummings.

Cummings, himself a great enthusiast and sympathizer of the human zoo as described in his *Enormous Room* of 1921, used the poetic accuracy of Underwood's joke as a pretext for an extremely witty and apposite article, illustrated with the *Animalia* engravings, in an article published in *Vanity Fair* in March 1927. With astonishing accuracy he explained the identity of each species in terms of Freudian mirrors, in other words of the identification of the spectator in a succession of different mental states represented by the various animals, an entirely flippant version of Underwood's own identification of the hunter with the bison in the caves at Altamira.

All this helped the book on its way. It was awarded the New York Publishers' prize for book design in the autumn and received a good deal of favourable attention, especially in the publishing press, for its graphic inventiveness and in particular for the design of its jacket. The prints themselves came back to England for the English Wood Engraving Society's annual show at the St George's Gallery in December, where they shared a wall with prints by Eric Ravilious. In New York the Weyhe Gallery, at 794 Lexington Avenue, published them and others on the same theme in editions of 50 signed proofs, and to boost sales in 1927 the *Bird and Fish* was advertised as print of the year.

Now temporarily cast in the role of illustrator as far as the critics and public were concerned in America, Underwood was nevertheless busily trying to apply some of the three-dimensional principles he had discovered through sculpture to his painting. Chronically short of money, he was apparently never at a loss for ideas to keep his head above water while he got on with his work. He took out an American patent on an invention he thought up that would enable rail trucks to run on the road by substituting a second set of wheels with pneumatic tyres – an early version of container transport to save unloading – but could not find anyone to finance it. Phillips Russell fixed up a job for him with a woollen vests manufacturer who wanted a trademark for his product consisting of a polar bear wearing one of the vests, standing on an iceberg. He prepared a set of illustrations for Eugene O'Neill's *Emperor Jones* but the publishers rejected them in favour of some by somebody else.

54 *Dolphins* from 'Animalia' 1926. Woodcut

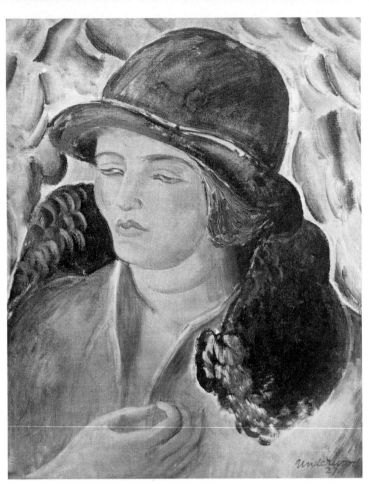

In May 1926 he met Leonard Huntress Dyer, who had designed and produced a new system for steering liners, and went to stay with him on his private island in the Bay of Fundy, where he was joined by his wife; and also in New York he had run across a friend of Warren J. Vinton, his early student, called Lawrence Hoyt. Contacts with all these people, and the eventual sale of the African carvings he had brought with him, enabled him to keep going. Selling his African art turned out to be more difficult than he had anticipated: there was only one important collection of primitive art in New York at the time and this was supplied exclusively by a French agent who never failed to point out that anything other than his own pieces were certainly Japanese copies.

The painting by Underwood that best epitomizes his stay in New York is in painful contrast to the gay jazz-modern frivolity of many of his contemporary engravings, and reflects his serious intentions much more accurately. It shows an old Italian immigrant, the mother of a friend of his, in an attitude of complete resignation and isolation, her face without a trace of hope, her big hands helpless in her lap like two dead birds. Once having seen the face, Underwood painted it over a long period with the help only of a small black-and-white photograph,

58

two inches square, which he felt compressed the dreadful air of desolation, the sense of a cinder taken from the fire and left to smoulder out by itself. The monumental quality of the clothes serves to accentuate the vulnerability of the old woman lost in a New York that seemed otherwise to be celebrating. Such a comment suited him better than the other portraits he painted, then and when he returned to London, of society women. One in particular held out hopes of large-scale patronage but, finding that Underwood perhaps did not see her quite as she saw herself, declined to buy her own portrait or, in the end, anything else.

Examples of these that survive constitute a stylish mixture, again very much of the middle 'twenties. They have the eton crops and retroussé noses of Bright Young Things but with a voluptuous rhythm that is more languid than jazzy, more bouncing and idyllic than slim and fashionable. The paint, too, is fatty and heavily loaded, often with very hot and rather arbitrary colour that refers back to the opposed purple and vermilion of the canvases inspired by Iceland, like *Fisherman's Rosy Love*. The effect of this is to suggest a form of decorative painting that may not have been entirely intentional. The results are seductive,

55

57

30

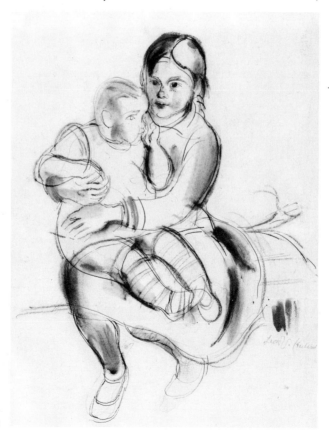

56 *Two Children* 1923.
 Ink and conté

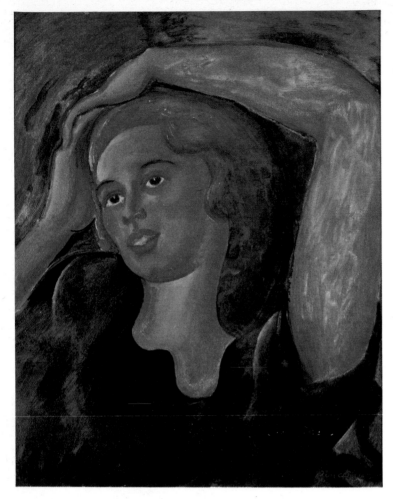

57 *Rose* 1927. Oil

58 *The Ember*
(Italian Immigrant)
1926. Oil >

especially for instance in *Cecile* or the portrait of Jean Tennyson, but despite the beguiling 'twenties features, the purpose of the paintings, and others like them, was to carve out with the brush a convincingly solid monumental form. Both the pungency of the colour and the slightly hedonistic air of the models is within range of Matthew Smith, with the difference that Underwood was dependent on drawing rather than colour to express the weight of a form in space. His line glides gracefully in and out, plotting the mass. A number of examples were successfully exhibited at the Carnegie Institute in 1930, including *Tam o' Shanter*, but Underwood was learning to beware portraiture.

By the spring of 1927 he was certain enough about his ideas on book and magazine illustration to publish a long article on the technicalities of the subject in Brentano's *Book Chat*, but by now he wanted to use his new weapon in a more personal direction. To fill in, in March, he produced a very stylish and witty set of drawings and coloured lino-prints for a children's book, *The Adventures of Andy*, published by George H. Doran Co., in a vein that has much in common with his work for *Vanity Fair*. Some of the simpler line blocks are as good as

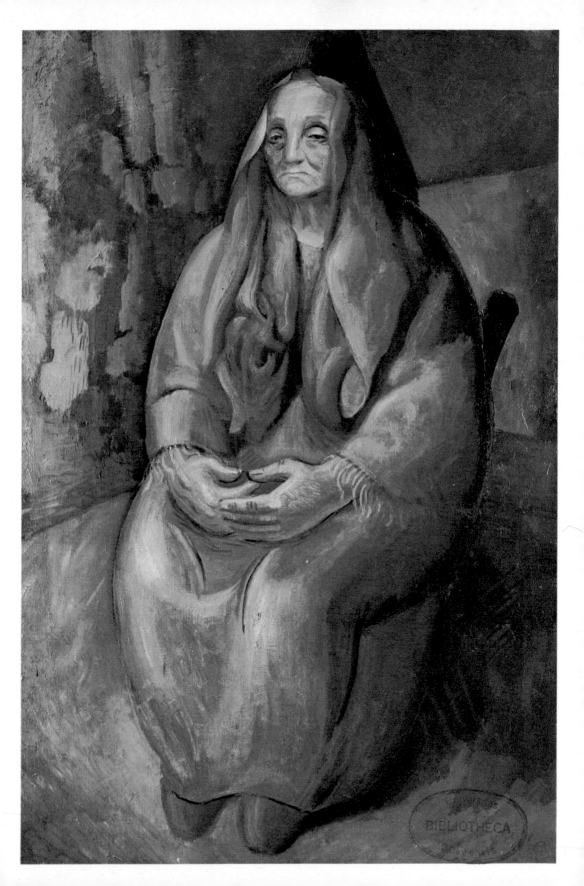

anything of their kind he published in New York. But by April, his head buzz-
ing with ideas, he was on his way back to England to write a novel.

He settled down to write, not at Girdlers Road, but in a tiny cottage at
Nanjulian, Cornwall, lent him by John Dunn-Yarker, Agnew's American
agent who had been unable to help him in Palm Beach. The 60,000 word text
and seventy woodcuts were complete by the end of three months and Under-
wood took them straight back to Brentano in New York. He also had with him
a number of watercolours, etchings and wood engravings, many of Cornwall,
that he had found time to make during the same period and which were
exhibited in March 1928 at the Weyhe Gallery. *The Siamese Cat*, as the novel
was called, was published in early 1928, received first prize in a publisher's
competition for the best designed book of the year and brought both Brentano's
and Underwood some welcome publicity though it was generally misunder-
stood by the critics.

59, 60

There are several ways, despite its apparent lightness of touch, in which the
book is crucial to an understanding of Underwood's career. It is a fable at a
deliberately artificial level, profusely illustrated not only with full-page wood-
cuts, but at all angles and any moment within the text (a row of mice scampers
hectically along the top margin of every page). Its prose is lightened with
snatches of verse, swapping in and out of rhyming couplets and blank verse
laid out for dialogue, as though in the script of a play; at some stages the nar-
rative stops and the main protagonists discuss the plot with the author – a device
that dates from the eighteenth century, stopping to consult his gentle reader,
but nonetheless effective.

The story, which must be read at a symbolic level, is about a Siamese kitten
brought by ship with a cargo of (Siamese) twins to England. It survives a series
of misadventures on the way and, among much else, saves the ship in a storm by
persuading the captain of the superiority of its own instinct over his naviga-
tional instruments. Tossed overboard by a sinister sailor called Nicotine, it is
rescued by the pilot's daughter whom it teaches to communicate by different
inflexions of its 'miaou', and a series of metaphysical and philosophical dis-
cussions take place, including one on the nature of abstraction and another about
natural selection, all of which seem designed to show the superiority of intuition
over logic – as with the cat's instinct over the ship's compass (which, of course,
was subject to failure through an electric storm).

However, the book goes a good deal further. The middle section, which is
perhaps less well realized, involves the cat with a movement that looks a bit
like Fabian Socialism, and also in a court case in which questions of justice and
personal liberty are discussed, with a woman acquitted, thanks to the cat, on a
charge of stealing a loaf of bread and the jury ending by taking a collection for
her in a police constable's helmet. Gradually it becomes clear that the wisdom
of the cat, though he knows little, is being absorbed by intellectual humans
who know a great deal. The comment on communication is that, while humans

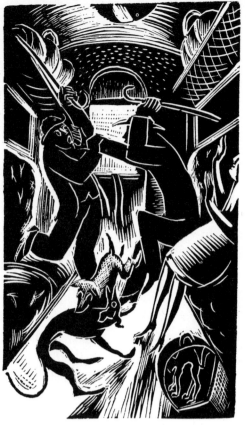

59 Title page of 'The Siamese Cat'
1927. Woodcut

60 Illustration from 'The Siamese Cat'
1927. Woodcut

speak the same language and constantly misunderstand each other, the cat has no difficulty in making itself clear. The dialogue begins to emerge as being between artist and scientist, subjective and objective, and slips in and out of fantasy:

> An intellectual fool and
> A learned ignorant
> Went to see an eel in
> The region of Levant.
> The intellectual one said,
> 'Vision alters shape;
> A snake may become an eel
> In a jellied lake.'

Ultimately, after the interaction of fantasy and reality are established by a fatal air crash during a fair, at which everyone laughs and applauds enthusiastically assuming the accident to have been intentional, the hero is destroyed by its fellow cats who are jealous of its faculty of communication and prefer to keep, as cats will, their sense of independence.

Into all this there are worked a good many fragments of autobiography and thinly veiled references to individuals, particularly to gallery directors and critics, and to poor Miss Place Tradition who ends by entering an academic convent in Piccadilly. The early chapters on board ship clearly relate to the return journey from Iceland in 1923, there is no shortage of mermaids in the book, and the writing often has much in common with the illustrations, in particular with the physical quality of woodcuts, in that it is entirely graphic: 'Smoke from the stack, swayed by the ship, drew a wavy line down the sky.' There is a fancy-dress party that is closely similar to those held in the Brook Green studio. There is an exhibition of work by Modern French Masters of the Depressionist and Repressionist schools (entrance two shillings and sixpence, catalogues half a crown); a voyage across the Atlantic in a liner that floats upside down and is decorated inside the hull with realistic scenes of calm seas and perfect weather; and a telling little scene, out of Underwood's experience of the Great War, in which two snipers meet and make friends in No Man's Land, one armed with a quick-firing bible and the other with a microscope, and each is shot in the back by his own side.

Through all this runs one more extension of the objective-subjective idea. The cat's quick intuition symbolizes belief which is beyond knowledge and is only verified, or vitiated, later by laborious scientific proof, but the hero is nevertheless in a constant state of dissatisfaction, of enquiry. Towards the end, when this dissatisfaction lessens, he is in despair. The suggestion seems to be that contentment derives paradoxically from a form of discontent, and that the state of having nothing further to worry about is fatal. This is precisely in line with Underwood's poetic approach to *Animalia* and much else:

> *Too much knowledge is not good.*
> *It spoils the children's wonderhood.*

Reviewers, except for one in the *Philadelphia Ledger*, mistook the novel for an exercise in Surrealism and failed to see that all its parts contribute to the same argument, the same philosophy. So also did Phillips Russell, who wrote an introduction that leaves no doubt in the reader's mind that he had not the first idea what the book was about.

'A thought and an action and an object are synonymous to most cats' was the aphorism with which Underwood decorated the endpapers. The Siamese cat (one belonging to Sidney Burney of the Burney Gallery was the inspiration of the book) was a rarer and altogether more exotic-seeming animal in 1928 than it is now: and the same might be said of the novel. If it were reissued now, as it deserves to be, it would surely find a more receptive audience. Its philosophy is not only more familiar but immeasurably more popular.

8 Utopia in Mexico

By the time *The Siamese Cat* was published Underwood was on his way across Mexico. Neither its reception, nor the theft of his paintings from his apartment next to an illicit bar back on 8th Street West, was known to him and he would hardly have cared, for he was already on his way to a whole new source of subject matter and a watershed as important as the transforming experience at Altamira three years before.

What had happened was that Underwood had been to see Lowell Brentano on his return to New York in the autumn of 1927 and pointed out what a good idea for a book it would be if he and his friend Phillips Russell were to retrace a journey made in 1839 by John L. Stevens and the artist Catherwood through Guatemala, the Mexican states of Chiapas and Tabasco and the peninsula of Yucatan. Russell would write a travel book about it and Underwood would draw the illustrations. To drive the suggestion home, Underwood emphasized what a strange thing it was, and how regrettable, that American archaeologists constantly came to Europe to turn over the tired stones of the Acropolis when, did they but know it, they had inestimable treasures on their own doorstep.

His interest, of course, had first been aroused, as had Henry Moore's, by ancient Mexican art at the British Museum and in particular by photographs of the Chacmool, the extraordinary Toltec-Maya carving of a rain god of the tenth century found at Chichen Itza. But in Underwood's case this formal enquiry was very much overlaid by his later thoughts about peaks of aesthetic expression in relation to particular kinds of primitive culture. The concept of the noble savage is one that is also discussed in *The Siamese Cat*, and the notion of an idyllic state in technologically primitive conditions was what had excited him about Iceland.

In fairness, whether Underwood knew of it or not, there was nothing particularly original about approaching Mexico in this vein, especially at a sociological level, in the nineteen-twenties. Politically there had been a strong attraction for European intellectuals in Obregon's bloodless revolt and the new social dispensation of Calles in 1924, and more than a few European writers went there in search of the promised land. Aldous Huxley, with the idea that Mexico was Utopia, went ostensibly on the trail of the noble savage and with plans to found an artistic colony there, bound up with his experiments with

mescalin. Middleton Murry went, and so did D. H. Lawrence, who painted bad Mexican landscapes and wrote *The Plumed Serpent* in 1926, about Toltec-Aztec gods like Quetzalcoatl. Later, in the early 'thirties, but still very much part of the literary cult of Mexico, Malcolm Lowry lived there to write his once much-underrated novel, *Under the Volcano.* As Bevis Hillier has pointed out, it was by no means only a literary movement either, and there were far-reaching effects in architecture and design, and also in interior décor, which make Mexico an important ingredient of the between-wars style. It found its way into English drawing-rooms in the shape of stepped wireless cabinets like Aztec temples, and the extreme eagerness with which the avant-garde threw out the old aesthetic potted fern and quickly adopted the cactus, as immortalized by Osbert Lancaster in *Homes Sweet Homes.* As far as new architecture was concerned, by the mid-'twenties Mexico was fast on the way to becoming an indispensible source not just of decoration or accessories but of form itself. In his *An Architectural Pilgrimage in Old Mexico* of 1924 Alfred Bossom cited Aztec and Toltec as typifying the American spirit in architecture far more convincingly than the colonial style: 'Mexico!' he exclaimed. 'Not to visit Mexico is not to know the western hemisphere.' And parallels between much American and European building, skyscrapers in particular, and Mayan, Zapotec and Aztec architecture are clear from a glance at their silhouette.

Nevertheless, although what Underwood was doing was consciously or unconsciously a part of all this, his immediate overwhelming enthusiasm for what he saw in Mexico already had seeds in his work on the infinitely wider time-scale and geographical basis of the new energy his generation had discovered in all kinds of primitive art. Underwood was concerned with it as the high art of a static, tribal culture, and with its confrontation with – and destruction by – Western, Catholic culture at the hands of Cortez. His view of Aztec and Mayan civilization was an undeniably romantic one, and the whole journey was undertaken with a romantic gusto and an eye for the picturesque that, at least in Russell's case, misses the real force of primitivism and is taken up instead with colourful anecdotes about shark fishing, tiger hunts, meals, conversations and arrests. There was a strong temptation to see Indian culture in an idealized light, perfect within its own narrow terms of a maize-based economy existing in a mild climate with deep rich soil and crops growing in fertile conditions to enormous sizes. The approach entirely belied any of the aspects suggested by recent research, certainly as regards the Mayans, the sudden collapse of whose empire some six centuries before the Conquistadors reached the shores of Central America has been explained by conventional autopsy techniques on a large number of skeletons unearthed in northern Guatemala by a Harvard University expedition. Osteobiographic examination showed that the Mayans had, entirely contrary to previous belief, suffered to an alarming degree from all kinds of vitamin deficiencies and malnutrition, including iron-deficiency anaemia and haemorrhages associated with scurvy. The fact that their descendants who live in Central America today are appreciably smaller than

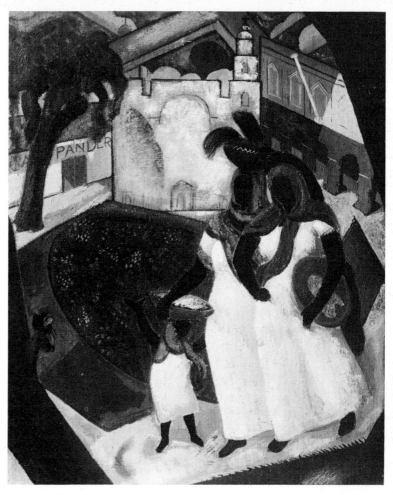

61 *Street Scene, Merida*
1928. Oil

their ancestors is attributed to the cumulative effect of chronic malnutrition over the centuries.

This, though, runs strongly contrary to the European view of Indian civilization in the 1920s. Underwood's own attitude has much in common with Gauguin's glorification of the life and art of the South Seas in the 1890s, and although it borrows and freely interprets many primitive sources it is still essentially doing so at an intellectual level as a conscious escape from a corrupt and sentimental, though obviously much more sophisticated, western visual tradition.

The journey itself is also a telling period element with exactly the spirit, made popular by Rider Haggard, of Englishmen disappearing into the jungle and ending up as the gods of primitive peoples, and such incidents as the real-life disappearance of Colonel Fawcett in Brazil in 1925, together with the newly popular vogue for the Lost City, and the cult of Atlantis.

Underwood went first to Merida in Yucatan where he laid plans for the expedition and did some research while waiting for some weeks for Russell to 61, 85

arrive. He was detained in New York, but Brentano had written them a fat cheque for the journey and there seemed no reason to hurry. Stevens and Catherwood had travelled from south to north for their book *Incidents of Travel in Central America, Chiapas, and Yucatan*, a dry title for a record of 3000 miles of excitements and catastrophes, and Underwood and Russell decided to go in the opposite direction. They planned a route along the south-eastern and southern shores of the Gulf of Mexico, up the rivers of Tabasco and over the Sierra Madre to the Pacific east of the Isthmus of Tehuantepec. While waiting, Underwood read an account by the French archaeologist, Le Plongeant, of some travels and excavations he had done in Mexico in the 1860s and became completely engrossed in the idea of the, as he saw it, ideal tribal culture wiped out for gain by Cortez, with Montezuma the symbol of indian nobility and Marina as the tragic catalyst. This was strongly reinforced by Prescott's *Conquest of Mexico and Peru*, particularly as the conflict was so neatly symbolized by Cortez's use of gunpowder against simple thonged weapons like the *atle-atle*, and the initiative of a dynamic culture epitomized by his utilizing sulphur obtained from Chimbarazo to manufacture explosives during his advance on Mexico City. Psychologically, in every respect, this was what Underwood had been looking for since 1923.

When Russell arrived and they eventually set off in January 1928, it was agreed they should travel as far as possible by the simplest means in order to keep in close contact with their subject and be in a better position to talk at length with people

62 *River Crossing, Campeche* 1928. Oil

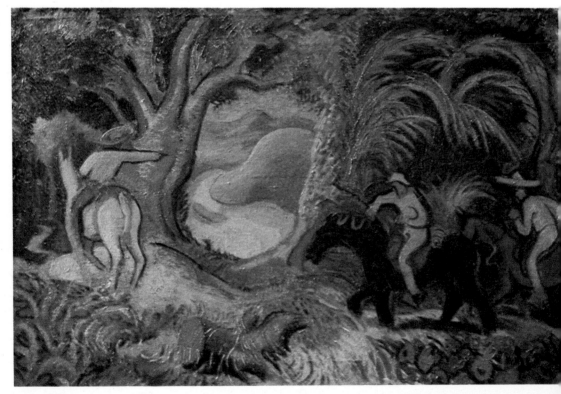

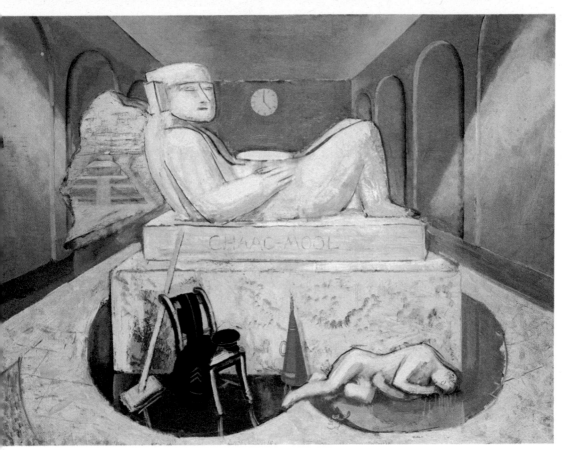

63 *Chacmool's Destiny* 1929. Oil

they met on the way. They chose the *correos*, or ox-drawn postal service, and 71
where necessary used pack-mules, horses and canoes. Although Underwood 62
always carried small sketchbooks in his shirt pocket, it occurred to them that,
since Phillips Russell was an artist manqué, it would be amusing and might be
instructive if Underwood took notes of the journey and Russell made some
drawings and watercolours. They tried this for a time but as well as writing up
the anecdotes along the route Underwood did a great deal of excited drawing,
not so much for the book as for his own use.

 They began by trying to make a cast of the limestone Chacmool (the Red 63
Tiger, that gives its name to the book) in the Yucatecan museum but found this
a long and difficult task without the proper tools – a reflection on the sculptors
who had themselves been forced to carve it with no more than flint axes and
rubbing stones. Making use of modern engineering for the last time they
travelled from Dzitas to Chichen Itza by hired Model T Ford, full of unwanted
guests, and, watching the Castillo, the shining pillars of the court of a thousand
columns, and the terraced Temple of the Warriors, steadily approaching above 64
the grey bush (the rains were still two months off), Underwood was once and

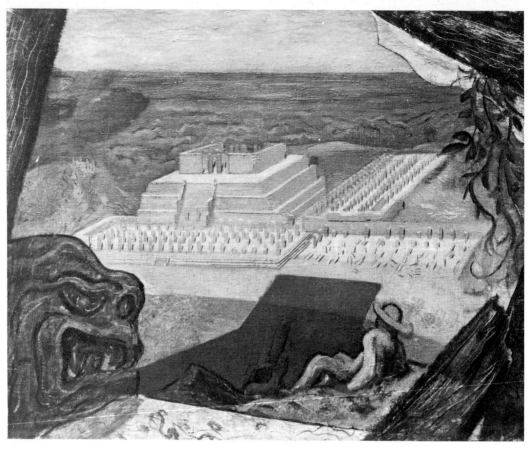

64 *Temple of the Warriors, Chichen Itza* 1929. Oil

65 *Campeche Coast* 1929. Oil

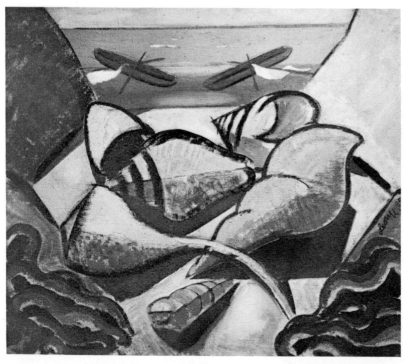

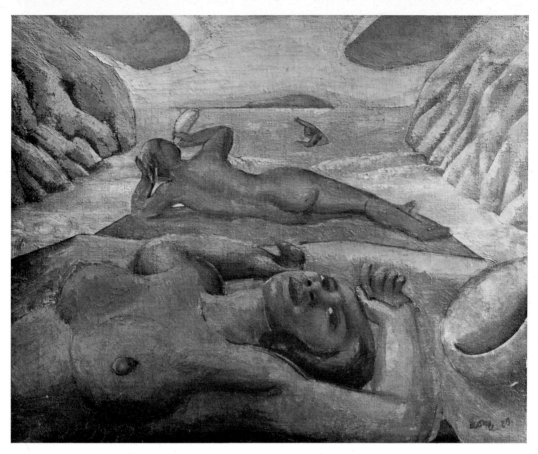

66 *Coast of Yucatan* 1929. Oil

for all convinced of the extreme cultural refinement of builders and sculptors who technologically were still in the stone age, and yet whose sophistication and precision as astrologers were borne out by the Caracol half hidden in the undergrowth. From that moment this paradox became his principal subject: it lasted him ten years. He was still making colour prints on Mexican themes in 1939.

67, 68, 69
72, 77, 78

From Chichen they went to the coastal village of Bocas, with its rose-pink tropical sunsets and perpetual pervasive smell of drying shark, where they hired two indians to take them on a week's trip to the islands on a fishing and hunting expedition. They camped for some days on the island of Pundersak, living on fish, tortillas and papya melon, learning to fish with a handnet (Underwood drawing the circular opening motion of the throw) and harpooning alligators by night with a carbide torch. Russell, very much the intrepid adventurer, is often perhaps more amusing than he intends – for instance in describing their first close encounter with an alligator while bathing: 'To make certain that it was an alligator, we swam back to the boat to use it as a platform.'

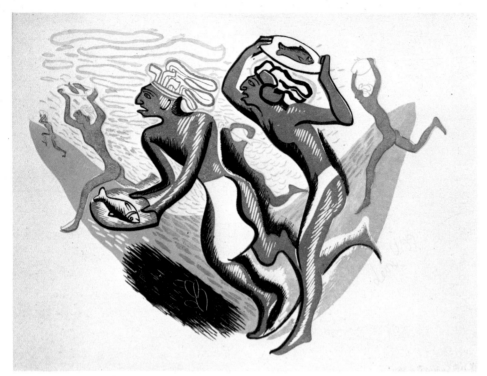

67 *Montezuma's Fish* 1939. Colour print

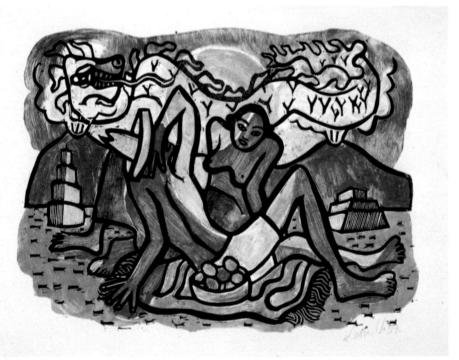

68 *Quetzalcoatl* 1939. Colour print

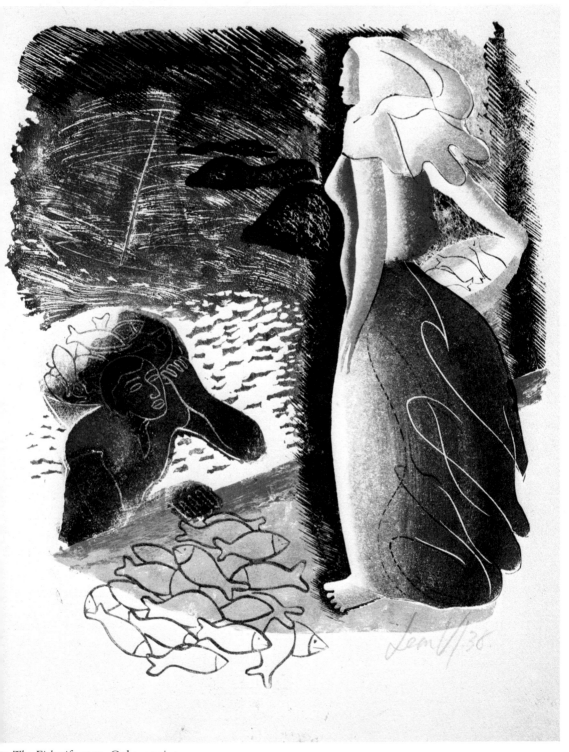

9 *The Fishwife* 1939. Colour print

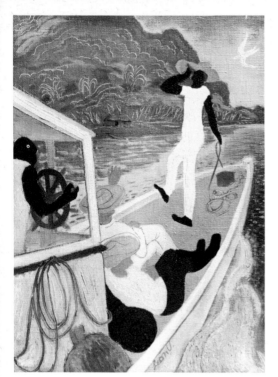

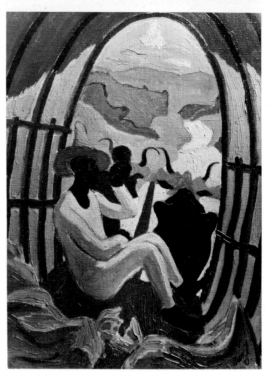

70 *Banana Launch, Tabasco* 1934. Oil 71 *Los Correos* 1934. Oil

The white sand of the islands was composed of tiny shell fish, and there were great numbers of sea birds, especially flamingo. All this, perched in the bow of their *cayuco* appropriately called Venus, Underwood drew or committed to memory. The skill, grace and innocence of the indian guides reinforced his preconceptions, despite having seen drunkenness on *habanero* before setting out, and he and Russell noted that their passivity had not only enabled them to retain their poise but to keep their language intact. Spanish, in Yucatan, is the language of business: Maya, of the people. He learned how to load shells according to whether they were to be used for shooting birds, jaguars or the *coatimundi* (a kind of racoon); he tried to catch iguana by stopping their holes; watched alligators caught barehanded by slipping a noose over their jaws and wrestling them into the boat; and he learned how to cook indian-fashion in a *pib*. He drew girls bathing on the shore and carrying cornucopias of fruit in the market, or with plates of fish on their heads, all later the subjects of memorable paintings, prints and carvings.

Returning to Bocas, he and Russell were arrested for taking photographs and clearly suspected of smuggling, but released in Progreso. Further down the coast at the sixteenth-century Spanish town of Campeche they went deep-sea fishing at night with the local shark-fishing hero and were caught in strong north-easterly squalls and nearly run down by a steamer for good measure.

65

Back at the quay, exhausted, the following morning, they sold their night's proceeds of dogfish and hammerhead sharks. From Campeche they took a boat further south to the island of Carmen, and then boarded another *canoa* to Frontera and on to Villa Hermoza, capital of Tabasco, where Cortez landed in 1519. Some of the way they were in the company of gypsies, and always with indians who confirmed their earlier impression of perfection before the fall by singing constantly, laughing and offering to share anything that they had, especially the bananas and eggs that seemed to be their staple diet.

In Tabasco Underwood began to draw the many *charros*, or cowboys, that he saw in the towns, and the fertile countryside which in some areas yielded four crops of corn yearly. Going as far up river as possible by banana barge, again the subject of many drawings, they hired horses at Tacotalpa and set off to cross the Sierra Madre, swimming their mounts and pack-mules over rivers and marvelling at the *cochuyo*, the Mexican firefly, so bright that children put them in cages and used them for lanterns.

74

70

72 *Bathers* 1939. Colour print

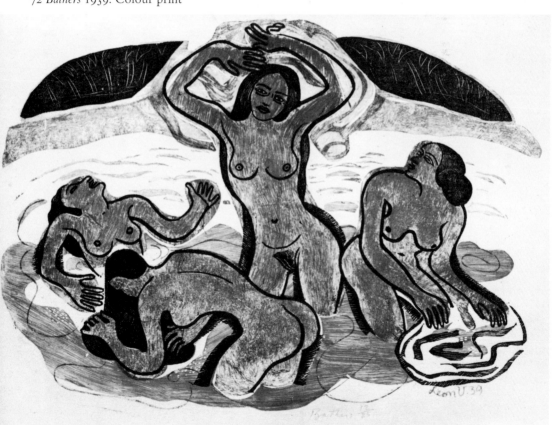

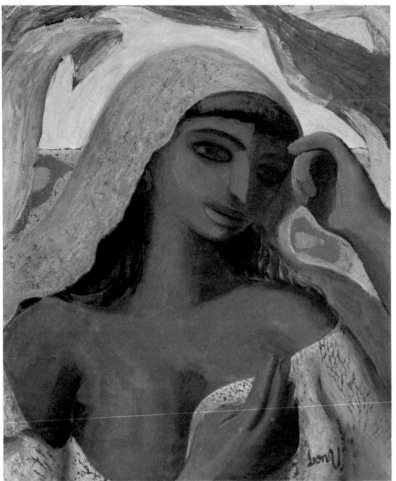

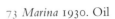
73 *Marina* 1930. Oil

Although the whole point of all this is that the corn-planters and thatchers whom they met on the way, their guides, the flora and fauna and the countryside were ideals of a kind of paradise, at this stage in the journey a note of discomfort is discernable in Russell's text however much the general tone is one of enthusiastic reminiscence. It was hot and they had not taken sufficient water, their baggage horses were weak and kept slipping off the path (it could take three hours to cut them free of undergrowth and hoist them back to the track), and, what was worse, the men caught cattle ticks, *garrapatas*. They rested one night at Amatan, which served as the name of the village, the tribe that occupied it and of their dialect, and another at Bochil where they saw bad drunkeness on *tequila* and *aguardiente*.

Tuxtla Gutierrez, an old town asleep on the south slopes of the Sierra Madre, was a blessed relief as they started the none-the-less painful process of losing height, and, perhaps in reaction to the physical hardships he had to put up with in the mountains, Underwood's best market drawings and prints seem to have had their origin here. The undulating lines of women on their way to market

78

114

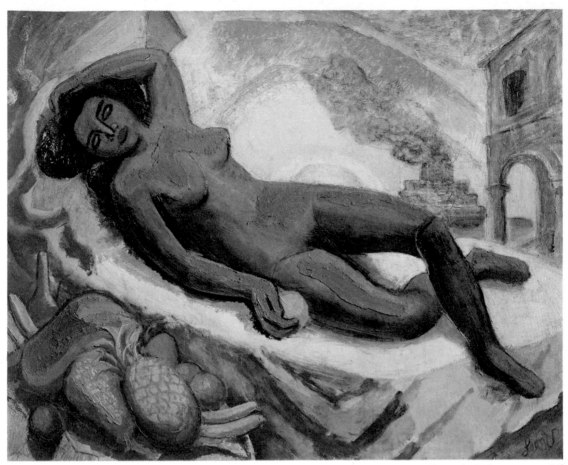

74 *From the Balcony* 1930. Oil

75 *Marina's Remorse* 1930. Oil

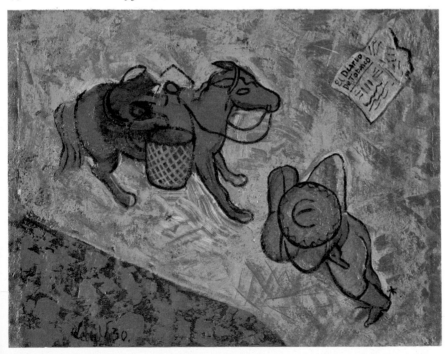

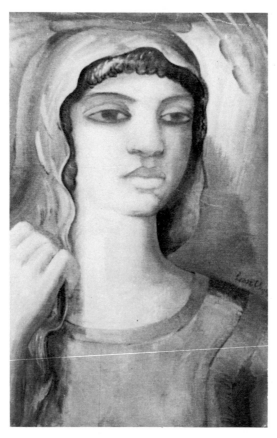

76 *Mestiza* 1929. Oil

carried gigantic gourds on their heads, full of sweetly scented flowers – gourds known as *hiclapestli* painted locally in bright colours – and many of the girls wore gaily embroidered *huipils*, the jackets especially typical of the Zapotecs of southern Mexico. So long and avidly did he draw in the market there that he was eventually had up by the police department on suspicion of some kind of spying, but ended by drawing the commandant, or *jefe*, and was cheerfully released.

Transport out of Tuxtla was almost impossible to come by and the two split up, Russell hiring another hard-worked Model T and Underwood going by bullock cart. As it happened, for the long downward journey to the shores of the Pacific, Underwood's was the safer choice. The Ford, hopelessly overloaded with passengers, baggage and livestock, lost its brakes and had a nasty accident, after which Russell, too, transferred to bullock carts though by this time several days behind. The rains had begun, but the weather did not mar the stupendous views on the last part of the journey up to the Isthmus of Tehuantepec with the soaring peaks of the Sierra Madre on one side and the ocean on the other.

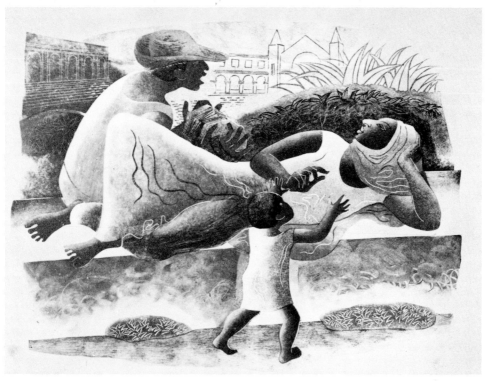

77 *Plaza Gardens* 1939.
Colour print

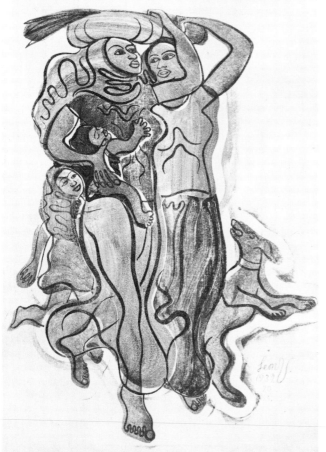

78 *To Market* 1939.
Colour print

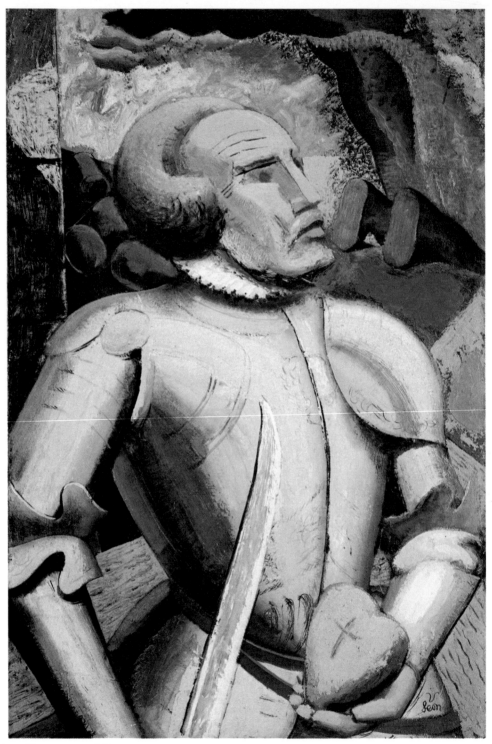

79 *Cortez* 1929. Oil

80 *Montezuma* 1929. Oil >

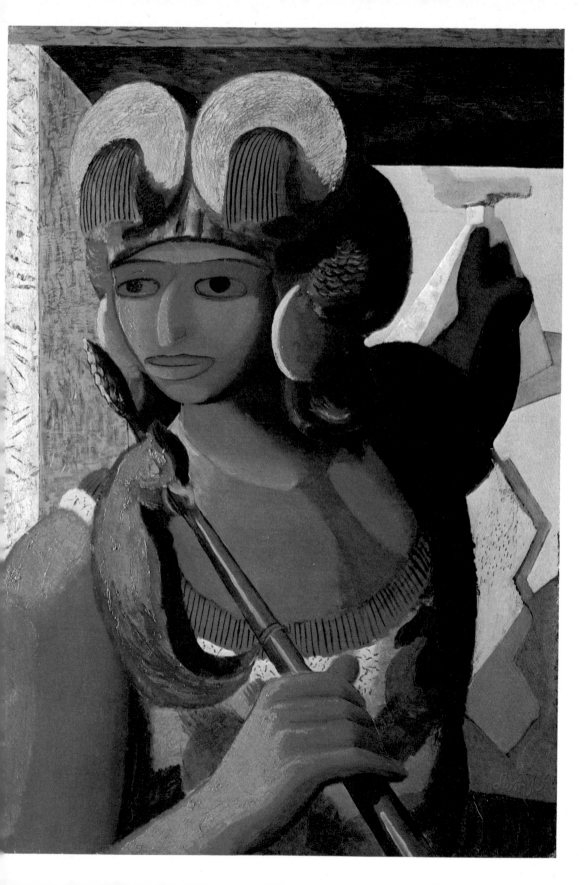

Still not quite spent, the travellers witnessed a four-minute earthquake at Tehuantepec which killed several people at Oaxaca and cracked pavements in Mexico City. By the time they were north of the Rio Grande, however, the magic was behind them. The illustrations Underwood drew later for *The Red Tiger*, published by Brentano in New York in 1929 and in England by Hodder and Stoughton, are the first appearance, usually in simple line drawings but occasionally in lino cut, of at least a dozen characteristic themes. The heroes and villains of the conquest were dramatized independently in important oil paintings afterwards but Marina's pose and general appearance clearly derives from the Tehuana women of the illustrations. As well as this, as examples, there are the bullock cart drawings; the study of loading a mule done from above, from a balcony, which was also, in time, to lead to a delectable little honey-coloured oil painting; the interior of the banana launch; the indian women bathing, which was to become one of the most rhythmic and sensuous of the colour prints in 1939; and the idea, that was also developed into paintings, of the rivers of Tabasco and Chiapas making, with their surrounding banana plantations and the foothills of the Sierra Madre, a kind of willow pattern landscape of gentle arabesques in a world of plenty, a tropical garden. Not all the drawings are necessarily successful in their early form. In the spirit of the book, and of Underwood's other illustrations apart from the *Animalia* and *The Siamese Cat*, the line is often colloquial, anecdotal, better suited to showing (typically) a dog lifting its leg on a civic statue in the park at Vera Cruz than at depicting Mayan architecture. It is when he stops to formalize and think out a proper imaginative statement that the best of the illustrations occur, and the most atmospheric. The colour print called *Red Lines of Flamingoes Overhead* works better than most, though it is not well printed in the American edition, and with an unpleasant orange block.

73, 75
79, 80

74
72

83

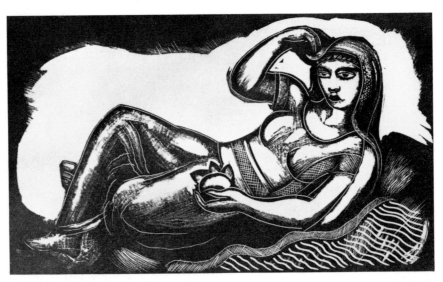

81 *Mestiza Reclining* 1929. Lino cut

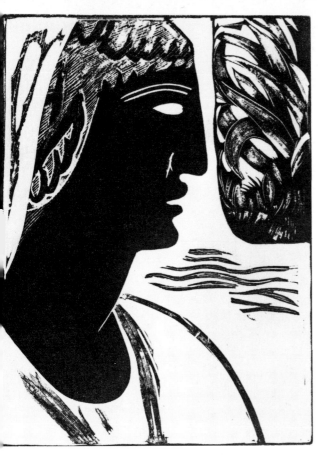

82 *Woman's Head, Chiapas*
1928. Lino cut

83 *Red Lines of Flamingoes
Overhead* 1928. Woodcut

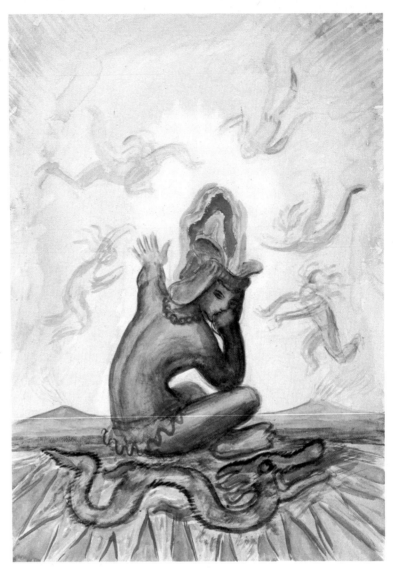

84 *Montezuma's Voices* 1930. Watercolour

Taking a train to Vera Cruz and points north heightened, if it were possible, the contrast between what had caught Underwood's imagination and the civilization to which he was reluctantly returning. The towns, as Russell described them, were like steel, with men separated from their contact with the earth by shoes, pavements and pneumatic tyres. The people were electric and uniform. It was all so much less satisfactory than in dusty Mexico where, especially in retrospect, in the Promised Land, every man's soul was a battleground for the Spaniard and the indian, and where the simple ways of the noble savage warred with the short cuts of the twentieth century.

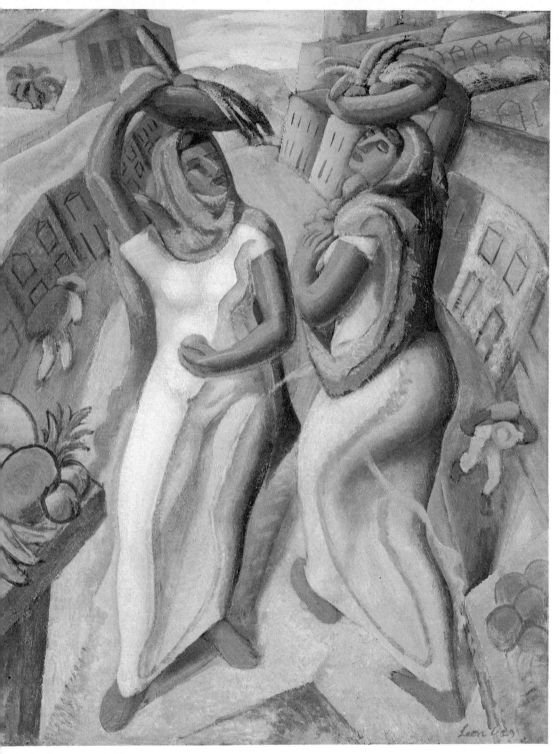

85 *In the Streets of Merida*

By the autumn of 1928 Underwood was back at Girdlers Road, re-opening the Brook Green School to a new intake of students and with a whole fresh subject matter and language of his own. Where his initial response to the formal qualities of primitive art had put him to some extent in line with the mainstream development of the modern movement, as eventually propounded in *Circle* in 1937, he now felt the daunting and at the same time wildly exhilarating sensation of being completely on his own. Not only had he a formal means of expression but a subject directly relevant to the contemporary situation as he saw it: what he would call a subject matter of belief, and, typically, an optimistic one.

He began steadily to exhibit paintings and engravings on Mexican themes, starting with wood engravings of Mexico soon after his return in December, 1928, at the St George's Gallery, which was very enthusiastically reviewed by R. H. Wilenski, following this up with watercolours at the same gallery in March-April 1929. His fellow-exhibitors at the Modern English Watercolour Society included Epstein, Frank Dobson, John and Paul Nash, Charles Ginner, Duncan Grant and Ben Nicholson. Underwood's paintings, three of them, were all based on drawings made in Oaxaca, and at the Wood Engraving Society's show in December there were the *Odalisque, Mexicana, Mexican Fruits* and *Yucatecas*.

It was a period still dominated very much in painting by the late performances of Steer, Sickert and Augustus John and in sculpture by Epstein, who was mesmerizing the public with bronze portrait busts that had little in common with the early pre-war work in contact with Wyndham Lewis and the abstract movement. Though the Seven and Five Society, founded in 1919, of which Underwood had been an early member, was still fiercely active – members in the 'thirties including Nicholson, Hepworth, Hitchens and Piper, as well as Moore who joined in 1930 – new art in England was outstripped in fresh developments during the decade after the war by the de Stijl artists, the Russian constructivists and the evolution of the Bauhaus. Wilenski, who had written so enthusiastically about Underwood, published the first article on Henry Moore's work in *Apollo* in December 1930, but generally it was a period of great confusion and a lack of structural purpose. One of the results was the formation of numerous societies each of which considered itself ready and able to superimpose a valid direction on English art. The most effective was Unit One, the group of eleven painters, sculptors and architects, organized by Paul Nash in 1933 'to stand for the expression of a truly contemporary spirit', but in May 1930 there appeared, simultaneously, two bodies, which were by no means believers in complete abstraction, seeking to achieve the same ends.

The first, called Neo, included Laurance Bradshaw and Sidney Hunt, and showed at the Godfrey Phillips Galleries in Duke Street. Rather self-consciously anti-academic, it chose for its president the gigantic stone Easter Island figure outside the British Museum, to avoid argument, and made the post of chairman rotary. The second was the National Society, which also opened on 9 May at

the Grafton Gallery. Among its members were Dobson, Maurice Lambert and Eric Kennington. Underwood showed in both exhibitions, and there was just time for Wilenski, reviewing them in the Evening Standard, to say that as far as the public were concerned (who still did not know him) Underwood was 'the outstanding discovery at both galleries', before he angrily withdrew his six pictures from the Neo exhibition. 'It was said', he told the press, 'that a certain article which I painted in the foreground of one picture made it unsuitable for reproduction in a newspaper.' These six pictures had sprung another surprise.

Whereas the Grafton Galleries were dominated by Underwood's *Mexican Song* – he was photographed in front of it wearing his travelling outfit by the romantically-minded *Daily Express* – and other Mexican pictures, as well as the much earlier carving then called *Fist*, the paintings shown so briefly with Neo were all in essence Surrealist.

87

86

86 *Fist* at the Grafton Galleries, 1930. Portland stone

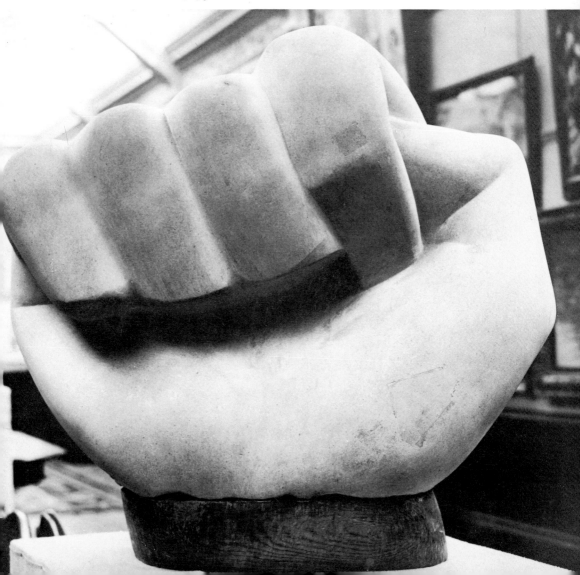

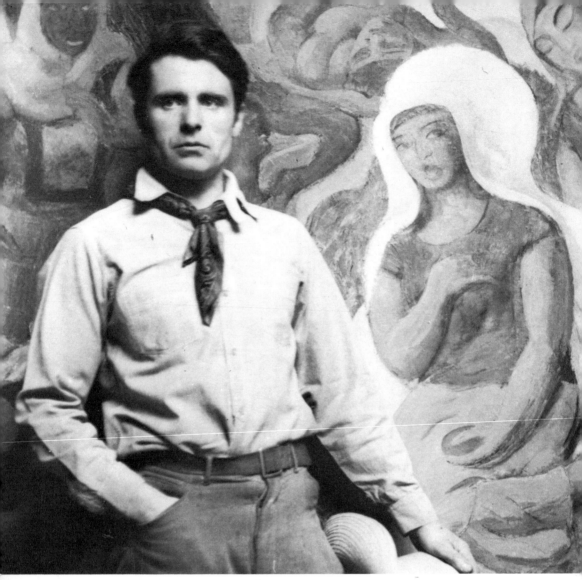

87 Underwood in front of *Mexican Love Song*, 1930

There is a long and complicated history of the involvement of English artists
with Surrealism in the 'twenties and 'thirties, most of them seeking to channel
its energy without in fact being in direct contact with the 'revolution'. If it is
possible to generalize to the extent of saying that from its inception there were
two main tendencies in the movement, one deliberately opposed to all tradi-
tional concepts of fine art and by definition nihilistic (a continuation of Dada),
and the other as still essentially concerned with aesthetic criteria, then Sur-
realism in England belongs very much to the second camp. It is not given to
extremes of Freudian psychology. What it sought to do, for instance in the

126

work of Paul Nash, was to juxtapose fundamentally irrational objects to heighten the sense of Hegel's reality behind and beyond appearances which is really only an extension of a particularly English form of Romanticism. As Marcel Raymond described it, Surrealism represented the most recent romantic attempt to break with things as they are: 'the essence of the Surrealist message consists in this call for the absolute freedom of the mind, in the affirmation that life and poetry are "elsewhere".' Even then, English artists were more likely to use it as a witty vehicle than to apply it consistently as the doctrinaire hard line approach of Masson, Miró and Tanguy.

Surrealism had no real impact in London until very late by European standards: the catalyst was the International Surrealist Exhibition at the New Burlington Galleries in the summer of 1936. This year, Moore was a founder member of the Surrealist group in England, and Paul Nash, Herbert Read and Roland Penrose were also on the exhibition organizing committee. However, the influence of de Chirico had made itself felt much earlier, from the first paintings of lonely figures in deserted city squares that so much impressed

88 *Shores of Knowledge* 1930. Oil

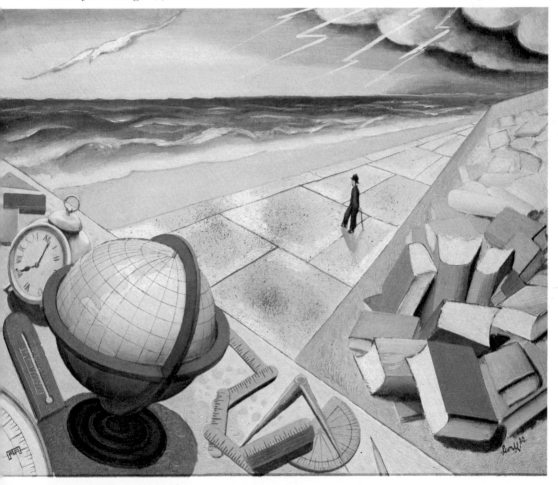

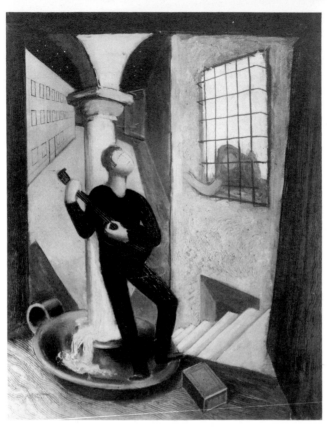

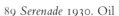

Apollinaire at the Salon d'Automne of 1913, and it is from this that Underwood's temporary – and not very successful – excursion into Surrealism must derive.

Six years after André Breton inaugurated the movement proper in 1924 with his first Surrealist manifesto, but long before it took hold in London, there is a strange painting by Underwood called *Serenade*. It relates to his journey to Spain, to Altamira, in 1925, and shows a youth with a guitar in a deserted street beneath a girl's window. The sky is full of stars and the architecture alone puts one in mind of de Chirico. But look more closely and it emerges that the column against which the boy is leaning, although it has a cushion capital, has melted at the bottom into a gigantic candlestick and there is a two-foot box of matches on the ground in front of him. The girl, like a caged bird, pokes one arm through the iron grille on the window. It shows clearly enough that Underwood was tinkering thoughtfully with de Chirico's 'plastic loneliness' and the dreamlike irrationality of impossible combinations, or chance meetings as Ernst would say, of objects painted quite straightfacedly six years before the Surrealist group was formed in England. And that he was at the same time concerned with aesthetic considerations is suggested by the careful treatment of the surface of the pigment which has been raked, in the foreground passages, to expose an underlying level of colour with a wood-graining comb.

The picture that gives the clue to the sudden appearance of the six Surrealist pictures at Neo was, however, painted the year before: it is hardly Surrealist in intention but it does have about it an uneasy concern with an enclosed world in which nothing grows and into which the only encroachment from poetic nature is symbolized by a visiting bird. *The Fates* of 1929, in which the monu- 90 mental figures of the three women who spin, measure and cut the thread of life are marooned in a space like that of a drained swimming pool, owes its effect to a deliberate trick of perspective with which Underwood was experimenting at the time. In order to heighten a sense of unreality in what were otherwise normal reclining figures, what he did was to make drawings of the two fore-ground models on separate rectangles of paper and then set them up in simulated perspective in relation to the back figure so that they read obliquely, like the side walls of a stage set. This explains the sharp tapering towards the feet, and the odd flatness, which is at once violently contradicted by the bold modelling and heavy shadows. On the one hand the figures might be cut in cardboard and slotted onto their podium in a very small space, and on the other the distance from the bottom edge of the canvas to the feet of the right-hand figure might be quarter of a mile past a block of concrete architecture. Holding up the draw-ings at an angle to the eye he then redrew a finished sketch and worked the paint-ing up from that.

90 *The Fates* 1929. Oil

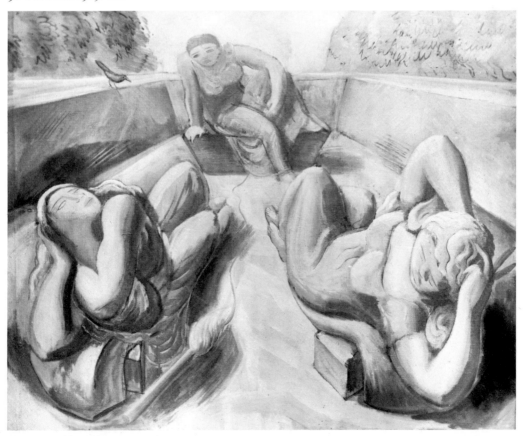

It may not be too much to argue that all Underwood's following Surrealist canvases were concerned to a large extent with similar devices, including the classic casement theme as used by Paul Nash, to comment on his objective/subjective idea of science and poetry. Even the 1929 *Fates* are isolated from the beneficial influences of growth and the changing seasons by their mechanical and mindless activity, and the Neo paintings are full of juxtapositions as telling as the microscope and quick-firing bible in the little scene from *The Siamese Cat*. The painting that caused such consternation at the Godfrey Phillips Galleries is a good example: called *At the Feet of the Gods*, it shows a group of innocuous-enough still-life objects on a marble step. It takes a moment to realize that the white cloudlike forms at the top of the picture are not on the horizon but are the looming cumulus of an enormous figure's toes. Laid at its feet are the symbols and prejudices to which Underwood felt art had been reduced by 1930 – the compass, his old image for a fallible device with which to seek direction; the fig leaf, for concealment; the hot waterbottle, for comfort; and the enema, for purification. It was the enema syringe that was thought unsuitable for reproduction in the dailies and which provoked the artist to take all his pictures home on the second day in irritation. Of the others, the most potent shows a Chaplinesque figure dwarfed on an esplanade with a storm gathering out to sea. That he stands on the shores of science and art is made quite clear by the collection of objects in the foreground (a clock, a thermometer, a protractor) all of which are concerned with producing statistical proof by measurement, while stretching away behind him is an enormous barrier of jumbled books.

91

88

91 *At the Feet of the Gods* 1930. Oil

92 *Excommunicated* 1930. Oil

93 *Tyger* 1930. Oil

Casement to Infinity makes use of the same sweeping perspective, striking quickly outwards as far as the eye can stretch over water to a vanishing track of reflected light, the only difference being that this time the accumulation of still-life objects has paradoxically to do exclusively with the passage of time and contemplation: growth, in the roots, in the egg and in the spider busy spinning on the gnomon of the sundial; the single fallen wing to suggest arrested flight, and, instead of the traditional metaphysical symbol of decay – the fly on the skull – Underwood has put a butterfly: a thing of great beauty given poignancy by the extreme shortness of its survival.

94

The language and imagery is intact but there is an unsatisfactory quality about these six pictures that seems to indicate that so straightforward a statement is too bland, too overtly symbolic, really to get to the heart of what Underwood wanted to discuss. He had made most of these points before in his writing, and in painting he needed more latitude, perhaps even more chance of ambiguity. It was temporarily arresting, for instance in a slightly earlier and weirder picture of a severed head on some telegraph wires, to say that personalities hung on the electric cables through which they exchanged ideas, and that a bird alighting

92

on the dangling skull could literally pick brains, but it was – however vivid – a witty oversimplification. There is an epigrammatic quality that does not allow the painter to sing, or more especially to digress. By late 1931 he had tried and rejected Surrealism, before most English artists of his generation had taken it up. From then on he left it alone.

But in working his way towards this brief experiment with a manner that in the end did not suit him, Underwood had, however, left a trail of tentative ideas that were more useful than the fully worked-out canvases like *Casement to Infinity* could ever be. The technical experiment in *The Fates* is one; the haunting transitional still life called *Tyger* is another, half way between the Mexican still lifes and Surrealism but with Blake's Romantic confrontation of surprise elements that appears much less calculated and more poetic than in Ernst or de Chirico; and, thirdly, there is a simple little painting called *Harp of the Emotions*. Again, there is nothing new about the notion of the human body played in love like a musical instrument, but Underwood is able to give it a peculiarly personal twist. The Surrealist would be quicker to transform rib cage into bird cage beneath the cloak: the poet in Underwood needed moonlight and the music of the imagination to be awakened to new life, a life that was beyond measurement, outside calculation or the bounds of reason.

It is somewhere in this area that he came nearest to making his own brand of Romanticism a vehicle for a loosely Surrealist idea, and to affirming that freedom of mind which stubbornly insisted in disbelieving things as they are.

93

94 *Casement to Infinity* 1930. Oil

9 The Island

If Neo and the National Society thought that in their small ways they were solving the problems of direction that beset British artists in 1930, they had also to take into account the well-tried formula of the manifesto. Ever since Marinetti launched Futurism on the front page of *Le Figaro* in 1909 it had become necessary to stage-manage any new departure in painting or sculpture as though it were a modern presidential election campaign in the United States. At least partly the intention was to reach as large an audience as possible and, with over-heated prose, to provoke the bourgeoisie into fits of provincial indignation so as to surge along on the resulting publicity.

The danger of this was that, in adopting from the outset a literary form, the theoretical side of a new movement could get precariously far ahead of any practical application. By the time the Futurists' so-called technical manifesto was published in April 1910, Marinetti and his followers had formulated a great deal of exhilarating theory about art with absolutely no means of expressing it except in literature and polemic. Equally the 1924 Surrealist manifesto referred to above had a predominantly literary and psychiatric bias, that had to do with political, economic and social change, and which only later was to find forms of visual equivalent. Unit One depended similarly, not only on the writings of Herbert Read, but on the quarterly *Axis*, as did the Circle Group on their publication in 1937.

Although it would not be fair or accurate to saddle Underwood with responsibility for the extreme unevenness of a quarterly conceived at Girdlers Road in the spring of 1931, *The Island* does nevertheless set out to explain to the world what is basically his own philosophy – certainly his own philosophy as understood by his students and by other artists and writers who knew him well at the time. Volume 1, number 1, appeared on 15 June 1931. It ran for four issues, two of which (in September 1931) were combined. It was sold by post and on a subscription basis, though it was also on sale at a few London book shops, including Zwemmer's. It carried no advertising, and had been made possible in the first place by Eileen Agar, the same student who had helped Underwood to go to the United States. Its whole tone and direction is refreshingly free of any awareness of economic factors, which is entirely to the point because, as Josef Bard pointed out in his first editorial, the contributors were

'united from the outset in a strong desire to stand together and to offer a joint resistance to commercialized art'.

How this was to be done, however, is not made clear except in wildly romantic revolutionary terms that insist continually on the virtues of 'the imaginative human being who has the power and courage to be himself'. As a patient reviewer in the October issue of *Apollo* pointed out, the trouble is that all human beings are themselves, 'none more so than they who have neither power nor courage to be otherwise. One must cultivate the art of escaping from the narrow prison of one's ego.' Certainly it contains much that is extremely self indulgent and immature, but generally the wood engravings used for illustration are far more satisfactory than the poetry, essays and art criticism that they are intended to interpret. It comes as a disappointment to realize that a comparatively spare and graceful engraving by, say, Gertrude Hermes has for its literary equivalent a piece of flaccid over-ripe prose – if it is an equivalent. It is comparable with looking at late paintings by Rossetti and then reading his poetry. If this is what the paintings are about then the viewer has to adjust his terms of reference. In the same way, much of the graphic work in all three numbers of *The Island* would stand better by itself. Nevertheless, it is in the text that those involved set out to explain their convictions, so it is worth analysis.

The other contributors, apart from Bard, included Henry Moore, John Gould Fletcher, Laurence Bradshaw, Ralph Chubb, Grace E. Rogers, Eileen Agar and Velona Pilcher. What happened was that in the course of regular fortnightly meetings in Underwood's studio, starting in March 1931, they began to realize that they shared a belief, probably very much encouraged by him, that poetic imagination was more important than style or method. Moving round this theme, they conceived the idea of setting themselves up as a group, *The Islanders*, not so much with the intention of disseminating their ideas – that part of *The Island*'s function, since it was never run as a commercial proposition, was purely incidental – as to provide opportunities for members to discuss the problem among themselves, writing and reading their own manifestos. Underwood, as the moving force behind this, saw it both as a useful exercise from a graphic point of view and as a way of testing and ordering his own thoughts on the subject.

The result was a good deal of talk about the priestly function of the artist, linked with a strong conviction that the romantic spirit in English painting is in some way self-sufficient, springing from basic experiences that remain the same emotionally however much the physical universe is 'shot to bits by the scientists'. There was a general feeling that technical problems weighed heavy on the spontaneous impulse to express ideas, and that there was a pressing danger that styles of expression could too easily stifle the message they were intended to convey – the obverse of McLuhan's notion of 25 years later. The issue of December 1931 includes a statement written specially for *The Island* by Mahatma Gandhi in which he wishes the project well and says that religion is 'the proper and eternal ally of art'.

Underwood himself, deliberately oblique, described how the dance could be the simplest ideal synthesis of feeling and form, the most elemental expression; and when one comes to examine his sculpture of 1931–32 it is clear why. Only Henry Moore concerned himself directly with the more practical aspect of social conditions in which contemporary art might flourish, summarized in true *Island* fashion by Bard as 'a congenial atmosphere... to facilitate the crystallization of proper classical forms for each artist's individual emotional glow'.

The basic philosophy of almost all of this was recognizably the thinking behind Brook Green School but without sufficient, or even adequate, means of expression. The imagery is Underwood's, with the engravers moving, as a reviewer noted, 'in a negroid circle with an embryonic complex', meaning that both Blair Hughes-Stanton and Gertrude Hermes engraved embryos in cataclysmic situations with more than a hint of African primitivism, but this is quite well balanced in the first case by a pleasingly erotic engraving (for a feeble poem about a shepherd boy) by Ralph Chubb, and in the second by two exploratory wood engravings by Moore on the theme of reclining figures dismissed by the same reviewer as lamentable nonsense.

Both Moore's and Underwood's engravings and essays in *The Island* are closely related to projects that each had under way at the time: the issue dated December 1931 includes half-tone photographs among the illustrations, one of which shows Underwood's important oil *Montezuma*, the other a carving 　*80* by Moore in Ancaster stone of a half-figure of a girl with clasped hands that is clearly related to his 18-inch *Figure with Clasped Hands* of 1929. Moore's engravings in the magazine include fragmented shapes suggesting pieces of bone and pebbles that by 1932 were clear starting points for reclining figures. C. R. W. Nevinson was also a contributor. He and Stanley Spencer had recently been among a small group of artists who, with Underwood, had published a book called *Artist's Sermons*, edited by Robert Gibbings, arising out of the annual exhibitions of contemporary religious paintings at the Walker Gallery. One engraving and a sermon on a text of his own choosing had been submitted by each. Underwood's had been based on 'And they were naked and unashamed', but the edition had been so limited that the project made almost no impact. However, to *The Island* Nevinson submitted an essay about new developments in English art since the Grafton Gallery exhibition of 1911, a subject he was well qualified to discuss having touched on almost all styles himself and, through his friendship with Severini, having been at least partly responsible, with Wyndham Lewis, for getting Marinetti to come to London to broadcast Futurism.

Amid all this, Underwood devoted himself either to art criticism or to writing about Mexico and a project arising out of his 1928 journey. There is, admittedly, one poem in *The Island* by him, called *The Good Ship Freewill*, which symbolizes the least convincing aspect of the magazine and the one to which the *Apollo* reviewer took exception – the romanticized drifting, the impractical idyll deliberately summed-up by Underwood in the engraving he made for the cover, of a

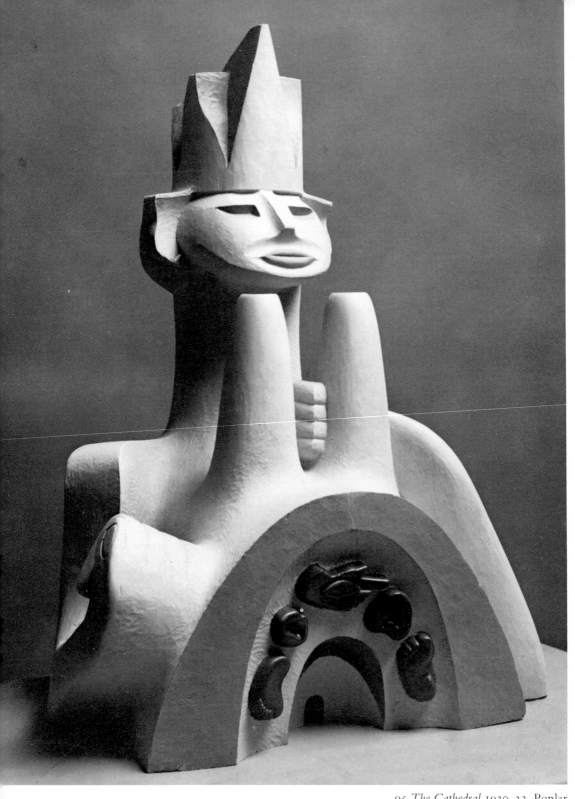

95 *The Cathedral* 1930–32. Poplar

naked figure comfortably reclining on a desert island in contact with the outside world by telephone. The Mexican idea is there, but particularly at second hand, without Underwood's wit in the writing and engravings of those around him, his notion of an ideal state can look soft-centred and sentimental, embodying exactly those characteristics that Unit One was so against. At the opposite end of the same problem, he was able to discuss his own belief that by returning to the use of adopted primitive forms modern sculptors were not necessarily freeing their means of expression. His grasp of the practical application of this made for a vivid insight into the technique of El Greco's distortion in an article for *The Island* that reflects more on his own work, and in an indirect way on Rodin's, than it does on El Greco. El Greco could so easily in this context have been the hero of a piece of period criticism, in the same way that in an earlier number of *The Island* John Gould Fletcher attacked Picasso predictably for his virtuoso performances and for superficiality.

In much the same vein are four short pieces by Underwood published under the general title of *Lines Written in Mexico*, one of which describes an imagined conversation with a Mexican carving at Chichen Itza – its face missing so that it does not betray the full extent of its sorrow – which had some strong things to say about the restoration of many of the buildings and monuments, that, by the time of Underwood's visit, were being uncovered and in many cases reconstructed by the Carnegie Institute. Nevertheless there is no hard core to any of these pieces, perhaps deliberately, and although now they were being published in the depression there is no attempt to do more than romanticize the social conditions or to write vividly of the scenery in vaguely historical terms: 'Treading the white path composed of the fine dust of decaying limestone . . . was like walking in the blood of the old Mayan culture that had trickled down and flowed away from the pyramid and over which beautiful butterflies never ceased to pass and repass.' One hardly recognizes the Mexico described, for instance, by the older members of the Sanchez family in Oscar Lewis's study in any of this, but it has long been clear that Underwood purposely saw the country from a totally different angle, not as sociologist but as mystic. Only a mystic could have conceived what is by far the most interesting and large-scale idea in the first issue of *The Island*. It occupied pride of place after the editorial as though to indicate that if the poetic imagination was to be allowed full rein it must soar upwards in a witty and extravagant display of new ideas if only to justify its existence.

Underwood planned a cathedral. Like his original concept of a gigantic peace monument to be cut in the cliffs of Dover, it had elemental overtones that now put one in mind of Oldenberg. Equally, it combined the notion he had explained earlier to Bard, by saying that only in the dance is there any true unity of feeling and form, with the instinctive behaviour of the hero in *The Siamese Cat* summed up by the sentence on the end papers: 'A thought and an action or an object are synonymous to most cats.' He expressed this by saying, in the notes that accompany an engraving of the cathedral in *The Island*, that 'The form is the

thought and may not be separated from its context in the mind of the artist.'

In the shape of an approximately Mayan goddess with a gilded crown for a spire and dramatically ascending breasts for minarets, it would, if built, stand about two hundred feet high, preferably, as specified by Underwood, overlooking a grassy plain. Some of the other stipulations are deliciously '1931', particularly one describing how, by ascending staircases inside the arms, 'Muezzin Art-Priests would broadcast the wireless call to prayer'. Although cut off much higher up than the figure by Niki de Saint-Phalle, there is still the sense of entering a female figure and moving forward through the thorax to explore the limbs and head in an upward curve of space, which in this case would be divided by three floors served by a lift in a shaft running up and down the vertical column of the neck. Each floor would be decorated with an appropriate colour and filled with the sound of an organ of suitable register, the registers of all three colours and sounds blending in the central well. Underwood attached no particular importance to this part of what would have been a very up-to-date idea, though he would presumably have known of related experiments in colour and sound, especially perhaps those of Russolo and his 'intonarumori' from as early as 1912–14. Over the doorway would be reliefs symbolizing what he described as adventures of the spirit, in the form of a mouth, an ear, two feet and an eye in the palm of a hand. These very simply convey the idea of reception and expression: one foot approaching and the ear with which to listen, and conversely another foot going away to perform actions (with the hand) directed by the eye, with the mouth an organ of both worship and the verbal transfer of ideas. It is perhaps not an intentional effect, but the bas relief of these symbols set in the regular curve of the doorway is closely similar to teeth set in a jawbone, as though the visitor is liable to be snapped up and swallowed whole by this extraordinary goddess which, instead of being worshipped, one worships from inside.

He carved the figure in white wood, about four feet high, and exhibited it as a prototype or architectural model for the intended concrete structure at his exhibition at the Leicester Galleries in the spring of 1934. It was greeted mostly with howls of derision in the press despite an appreciative and enthusiastic catalogue introduction by Wilenski. The cathedral itself was slightly modified in form for the carving, most noticeably by the absence of the tall nipples that originally stood up like finials, passing the face and partly obscuring it. By the time it went on show these had been sawn off to leave tiny circular plateaux on the top of each breast.

As an exotic idea it takes to its logical conclusion Underwood's near idolatry of what he had felt about Mexico, and it has, too, a powerful presence – almost a magic – with its arrogant head, like Chacmool, set on a tall column echoed by the erect breasts. As a piece of sculpture, however, it is perhaps less good than some of the other work he had completed since 1930; and gradually, as he began to find himself in carving and modelling, painting occupied less of his time.

95

10 Take-off: from mass to motion

In order to understand what happened to Underwood's sculpture from about 1930 it is necessary to look at it in relation to what Moholy-Nagy described in *The New Vision* (1928) as the movement 'from mass to motion'. There was a tendency in all the arts to use ever lighter materials, more dynamic forms. Only Henri Laurens and Epstein were developing in what seemed to be reverse, in manipulating – or sometimes failing to manipulate – large masses of inert marble or cast bronze. Nineteen-thirty was the year that Epstein's cumbersome *Genesis* made her first appearance.

It was also the year of Underwood's drawing, *Freedom*. The dove, the subject 96 of his first carving in 1917, bursts from two very solidly but simply drawn hands and goes soaring upward. Because Underwood was by this time on his own, his contribution to the development of motion rather than mass does not take the broader form of using light materials like tin and cardboard, but rather it seeks to take off in spirit in a way that he began to accomplish by the mid-'thirties in spectacular style. The secret, and apparent paradox, of this is that in his life drawing and his endless study of the anatomy of weight and balance, his concern had been with form and structure on a solid base, but it seems to be precisely this groundwork that gave him the initial thrust to become airborne. From now on many of his sculptures surge upwards, threatening to abandon their bases altogether.

This can be illustrated in origin by a large elm-wood carving of 1931. Although Underwood was on his own, there have been occasional moments when he has felt himself free to comment on another artist's work by using it as a springboard for his own interpretation. The swollen *Genesis* was offensive to him for quite other reasons than the ones that so antagonized the press and public. He was familiar with, and sympathetic towards, Epstein's way of suggesting emotional content in enclosed, interlocked forms with the minimum of articulation and movement: what he objected to was the way in which what should have been a supremely spiritual idea was presented in Epstein's carving as a banal physical one. It seemed to him not only coarse and lascivious but extremely badly carved, covered in the white blots of stone-contusions. It offended his sensibility to the extent that he began in 1930 to carve his own version, not in any attempt to make capital out of the publicity and notoriety achieved by Epstein but simply to state the idea as a sculptural one in his own terms.

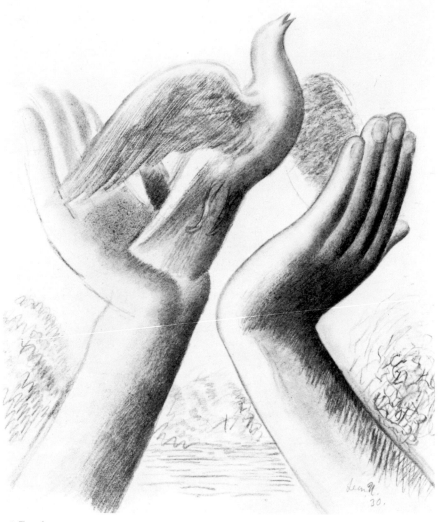

96 *Freedom* 1930. Pencil

The resulting figure is an optimistic one whose symbolism of birth is more
97 that of the birth of ideas, from the mouth of her backward-tilted head, than of
children from her vagina. She represents a moment of stasis in a backward-
and-forward movement of dance, a moment of tension, or change of direction,
before movement resumes. Her breasts turn upwards, her arms and legs cross
over to balance one another on either side of the body. From her mouth, in the
original version, arose the tiny figure, first of one man, then of several in an
ascending column, like vertebrae or a chain of ideas, one generation dependent
on the one beneath it and at the same time supporting the one above. He called

 97 *Regenesis* 1930. Elm >

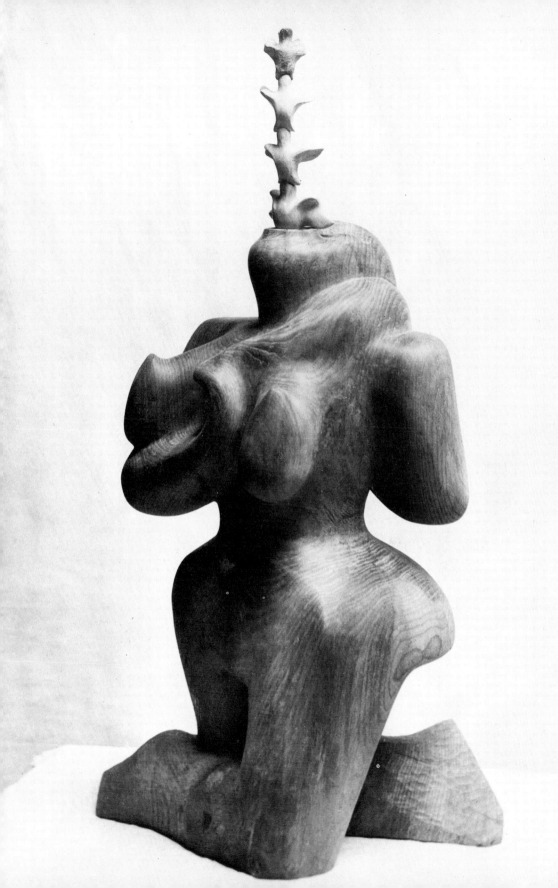

the carving *Regenesis*. By the time it first went on show at the second exhibition of the National Society at the Grafton Galleries in June 1931 its column of men had already become a column of birds, more suggestive of the soaring upward movement, but they were still carved in elm. It was not until 1934 that, linked to another sculptural idea, these were cast in bronze and found their final, and most convincing form.

Naturally, the critics did not take long to make comparisons between the two versions, the one physical, the other more of ideas, but almost without exception they were impressed by the quality of Underwood's carving, ironically, less for its symbolism than for the formal way in which it made use of its material. P. G. Konody went so far as to describe the artist as the willing slave of his material, a characteristic not necessarily much admired at the time but an absolutely fundamental ingredient of what Moore and Hepworth – and to a lesser extent Ben Nicholson – were doing in the 'thirties. Kineton Parker in *Apollo* rightly stressed the way in which the shapes have an inner life of their own that is the result of skilful use of the grain, direction and strengths and weaknesses of the wood itself; the artist had made the elm, dead but once born from seed, live again. But almost nobody seems really to have paid much attention to what Underwood was trying to say about spiritual regeneration.

To follow this idea through is instructive in other directions, too. The nearest he had got to realizing the Dover peace monument plan had been to carve, out of half a ton of Portland stone, the gigantic fist called *Not in Anger*, which was completed before he left for New York. Although it would have been supported on top of a tall stone tower for an arm, it was essentially a massive earthbound essay in carving. Where the stone opened to reveal egg-shaped cups of crystals, Underwood cut them out and sank in corrections to the surface (visible on the index finger and at the muscular base of the thumb). There was certainly no attempt to open the form or free it in any way. But the converse of this is epitomized by the very much smaller hand carved in American walnut by 1934 and called, first, *Greenfingers* and, later, *Lily of the Valley*. It is open, the fingers and thumb seem to ripple slightly in their upward movement as the wrist and forearm are drawn out of a cushioned stone base, and the whole carving is very highly polished. In the first version the polished fingers were dipped in green paint, and the hand hung up to dry. Later, thinking of Blake's *Book of Thel* and wishing to combine the idea of a transient flower with both human transience and the life-thrust, the ability to make and to cultivate, Underwood cut a lifeline across the palm of the hand in the curving shape of a stem of lily of the valley, coloured white.

The extreme poignancy of the juxtaposition of these two images is typical of the new direction in his sculpture. Frequently in the early 'thirties he examined ways of combining, or bringing together, two quite separate elements in one piece, sometimes even setting out to emphasize this by using highly contrasted surfaces, one inlaid or very highly chased, the other deliberately roughened or dull. Another piece relating to *The Book of Thel* is a good example:

86

101

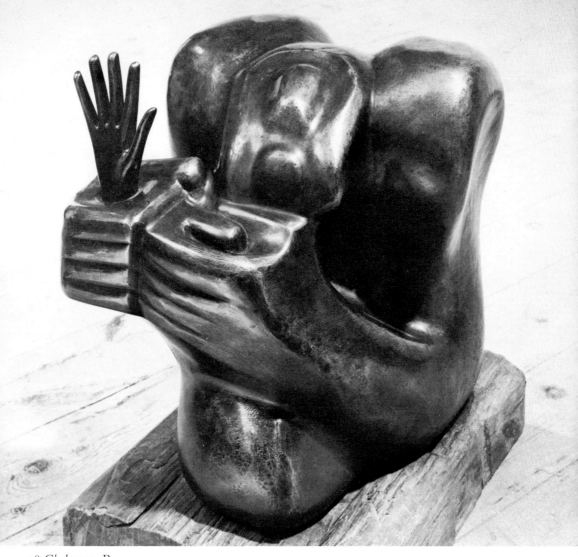

98 *Clod* 1933. Bronze

the *Clod* of 1933 was carved originally in Horton stone which split down the 98
centre when it was almost completed. A deliberately hunched and tightly-
packed shape, again strongly reminiscent of Gaudier, it was as though the rock
were broken open by the power of some new growth. Not wishing to waste so
vivid an accident, Underwood turned it to his own advantage by casting the
figure in bronze and inserting into its solid grip a bright and highly-chased
hand, not unlike the *Lily of the Valley*, which bursts upwards in a sharp little
gesture of plant-like growth from the heavy enclosed volume of the clod.
Taken together the ideas are not only extremely arresting at a symbolic level
but they play off against one another formally to make a tense and dynamic
piece of sculpture.

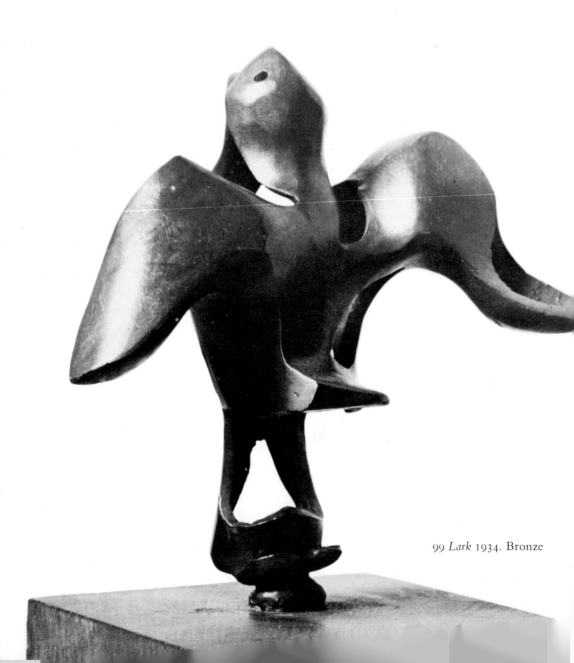

100 *Skylark* 1931–32.
Bronze mounted on wood

101 *Lily of the Valley*
1934. American walnut

99 *Lark* 1934. Bronze

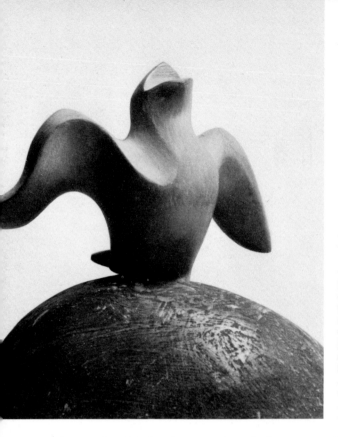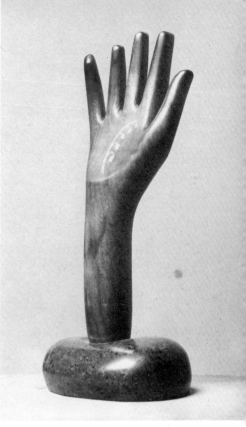

Before tracing this development into the long succession of flickering figures that began with *Flux* in the mid-'twenties, it is worth seeing how it comes closest to taking wing quite literally in the sculptures of birds that culminate with Underwood's first piercing and peeling of a form in his *Lark* of 1934. He 99 began to think how, rather as in the column of small figures from the mouth of *Regenesis*, he could express the exhilaration of a soaring or spiralling spirit, something lighter than air that goes upwards of its own volition. At its purest form, he thought it epitomized by Blake's lark ascending into the sky and soon invisible, though clearly in evidence by its fluttering song at a height where the eye focuses back and forth in search of it in vain. To reach this condition, however, he began with Shelley's more earthbound stage, 'bird, thou never wert', and his first sculpture on the theme shows the small twittering shape leaving (but still very much attached to) a mound suggesting both earth and egg. From 100 here, though, in a sequence of delicate transmutations the base diminishes first into a leaf, then a stem, then into a column and a hollowed column that are almost nothing, until the support is left behind like an abandoned perch and the tiny figure of the bird is airborne.

Having lost the base as nearly as possible, the progress towards Blake's pure essence of the bird begins to effect that too. In 1934 the form is elevated, ventilated, by Underwood's cutting right through it, opening not only the beak but the gyrating wings, the throat and breast. Only the tail kicks back-

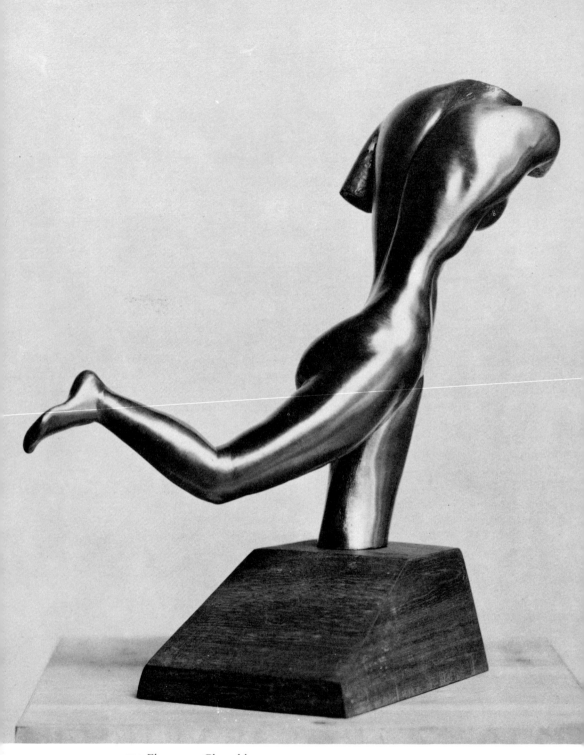

102 *Flux* 1924. Chased bronze

wards in a tiny solid stub of metal. Underwood had arrived for purely intellectual reasons of expression at a solution (actually to pierce the form from side to side) that Moore had found the year before for entirely formal ones – the need to link the front and back without having to travel across or around the whole surface.

In the light of this development Underwood's sculpture would be released upwards in quite a new way, but knowing how this was to happen is a useful pointer to some of the characteristic single figures that had gone before and which themselves constitute the most exhilarating and original formal development of all. They really begin in 1924 with *Flux,* the first fragment in motion, though it was originally made in plaster complete with a small turning head and flowing hair. Before Underwood had been to Spain and recognized the importance of doing his own casting, the piece was cast, like many of the others, by Parlenti, but its transfer to bronze did not seem to him to give it as much motion or animation on the surface as he would have liked. Over a period of weeks he began to chase it extremely carefully, accentuating the double twist of the body in the eddying reflections and hardening the tube-like structure of the truncated thigh with the vertical shine of highlights. Dobson visited him in his studio and poked fun at him for the amount of effort involved, saying that such work was only fit for natives – as well he might have done, seeing that the blinding concentric chasing on his brass head of Osbert Sitwell, completed two years earlier, had been achieved mechanically with a buffing wheel and, in fact, relied on its mechanically hard surface reflections for its celebrated effect, however much, in a jazz-modern way, it recalled Benin bronzes. But from working laboriously over *Flux* in 1925 Underwood began to feel, not only that there was a virtue in remaining in contact with one's surface in the primitive way that Dobson had derided, but of the way in which a sculpture could be made to take on movement and apparent weightlessness by picking up light on a continuous surface.

He had already thought about this a great deal in relation to drawing, and it will be remembered that the chief principle of his own approach to life drawing – and to teaching it – was a sophisticated application of what is really Hogarth's serpentine line. The track charted on the paper is essentially not a horizon in the ordinary way, as, for instance, used by Ingres, but a constantly advancing and retiring point that describes planes and volumes by stating them continuously from all sides like a piece of wire wrapped round a cone. To apply this idea of continuity to a sculptured surface very simply, it is necessary only to imagine a length of tape or ribbon joined end to end to make a ring. If, instead of the two ends joined flat, one is turned over and they are then joined, the outside edge crosses over to form the inner, and the same with the outside surface. The lines of both edges and both surfaces become continuous.

Underwood realized how this deceptively elementary but magical principle could be used to catch and hold light on brass and bronze, and set out to demonstrate it in a figure he called *The New Spirit,* intended as a tribute to

102

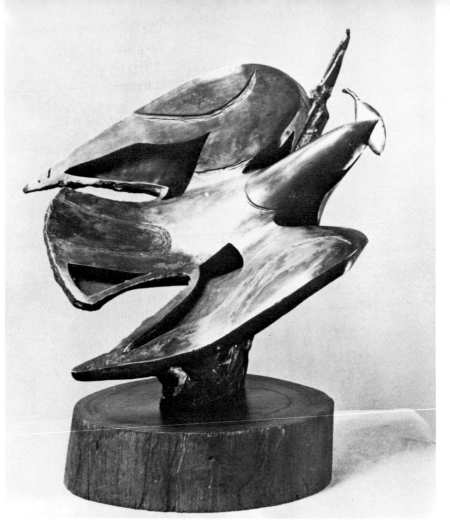

103 *Dove's Return* 1962. Chased bronze

Faraday. Faraday must surely have been a significant choice in that Underwood recognized his inventive genius as a leap of imagination, almost something poetic, in that he had little conventional training or theory on which to rely.

104 *The New Spirit* stands thirty inches high in chased bronze, its hands linked above its head to form a circuit, and every surface turned to catch the light and go billowing to the next. It is voluptuous enough to suggest that all muscle on the figure has been heated, drawn out and cooled into metal drapery tugged by some fierce magnetic field, but more careful inspection reveals that the interacting planes symbolize movement or activity presented in sequence, one surface dissolving almost at once into the next to plot the trajectory of each limb. To this extent it operates in exactly the same way as Boccioni's work, *Unique Forms of Continuity in Space*, of 1913, its intention being to indicate and fix the construction of the action of the body, not, as Boccioni said, as pure form but 'pure plastic rhythm'.

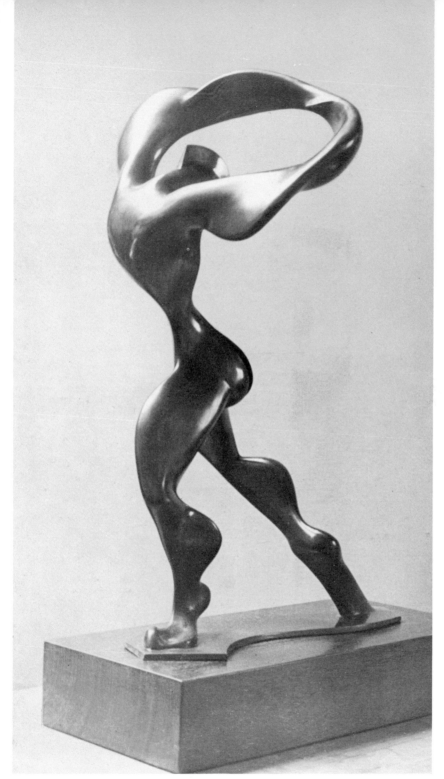

104 *The New Spirit* 1932. Chased bronze

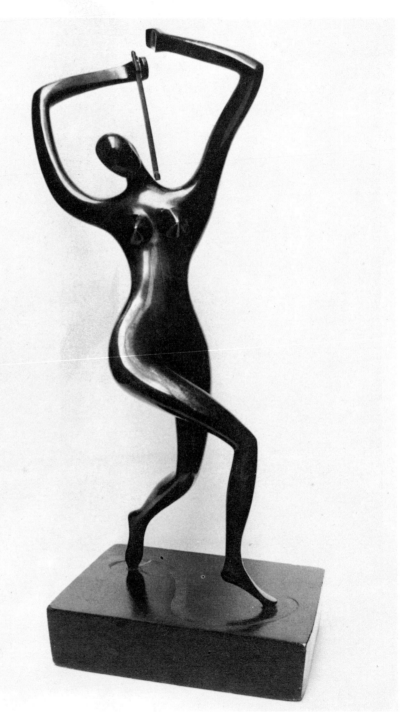

105 *Violin Rhythm* 1934. Chased bronze

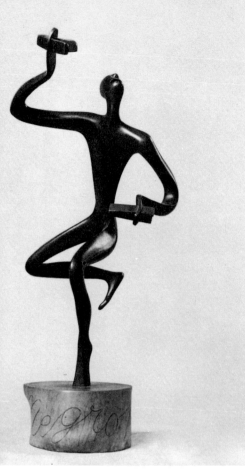

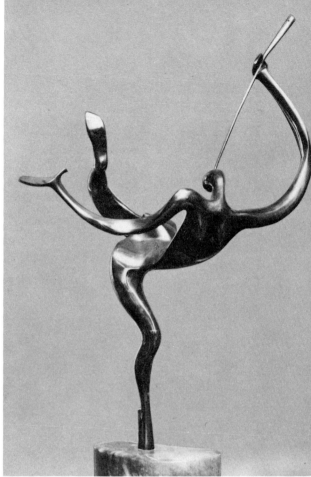

106 *Negro Rhythm* 1934. Chased bronze 107 *Herald of New Day* 1934. Chased brass

This dynamism that is conveyed exclusively through fixing sequences of movement immediately becomes for Underwood an ideal tool with which to express his optimistic imagery. The titles alone suggest this: *Herald of New Day, June of Youth, Violin Rhythm, Negro Rhythm, Liberation. Herald of New Day*, the plaster model for which is now at the Tate, is in chiselled brass, 107 an exquisite dancing figure poised on one leg with its remaining three limbs and head turned upwards in the gesture of a flower with astonishing grace and liveliness. In *Violin Rhythm* the notion of a woman's body as a musical 105 instrument is explored again with a tension that needs no strings, and great refinement in the way the full body becomes a sonorous sounding box; and the 106 *Negro Rhythm* is altogether more of an inspired scribble in the air, the patinated bronze as compulsive as a 12-bar chorus from New Orleans with its insistent syncopated beat, and even, round the base, its title in a rhythmic 1930s script – the whole object, twenty-two inches high, an inspired exercise as vividly period as Edith Sitwell's 'allegro negro cocktail shaker'.

There are moments, however, even after 1930, when Underwood's sculpture is heavy and static as though to remind himself of the physical limitations of life, and to refer back to his paradoxical idea of the relative permanence of inert matter. By far the most compelling and important of these, which are by nature more likely to be carvings than cast models, is the *Mindslave* of 1934. It exemplifies the idea of the prison of the body very concisely. By referring indirectly to Michelangelo's slave, who struggles to free himself physically, Underwood's figure is able to convey the equally terrible slavery of the mind within the trapped body of industrial twentieth-century society that has replaced it. The whole form is wracked by the inability to escape upward that is the essential element of most of his other sculpture. Partly the effect is obtained by the heavy block of Carrara marble, and partly by the way in which the stretched side of the figure almost succeeds in moving upward, only to be turned slowly over at the top elbow and brought remorselessly down through the comparative complexities of the other side of the figure which is under compression, folding in on itself at shoulder and hip.

There is another, incidental, way in which the piece refers to Michelangelo. In 1930 the stone merchant, Fenning, of Putney Bridge, bought up a quantity of marble at Carrara that had been removed long before in order to quarry deeper for whiter marble, the almost pure white used by Michelangelo. Underwood's *Mindslave* is carved in one of the removed blocks and is a very beautiful oyster colour, more subtle and sympathetic than the other. When it was exhibited in Antwerp at the Biennale in 1959 the piece caught the imagination of Zadkine who must have seen, in discussing it with Underwood, that its treatment of the human figure as a psychological rather than an anatomical entity was close to his own monumental intentions.

That this monumental effect could be achieved also on a comparatively small scale in a cast clay model is borne out, for instance, in the *Birth of Eve*, of which Underwood cast an edition of seven himself, some of them in chased brass. Although only about ten inches long it has the presence of a mountain range, full of reversed concave shapes – in the hands and heads – that emphasize the common rhythm of the two figures. They share the same rib-cage, and the serpentine line that runs in and out across the surface of the form both binds it tight and also hints that, though drawn at this stage into the surface of the clay before casting, it will later constitute a clear incision into the skin of metal to reveal the hollow interior.

Before actually piercing the form, however, there is a transitional period in which the line, having become a groove, begins to accommodate an inlay, sometimes – for instance in the *African Madonna* in lignum vitae of 1935 – of silver, or sometimes just of paint. The *Music in Line* of 1937 originally incorporated a strip of lead but it turned too black after a time and was laboriously raked out and replaced by a narrow continuous channel of less insistent shadow. Always in this technique there is the suggestion of the flowing edge of a drapery or some other boundary not otherwise visible in three dimensions,

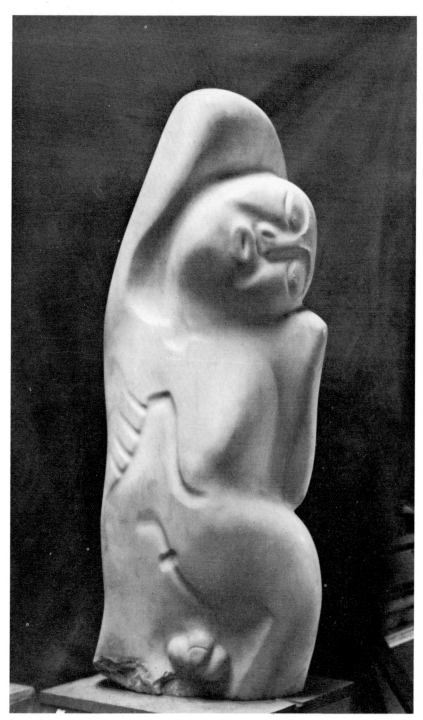

108 *Mindslave* 1934. Carrara marble

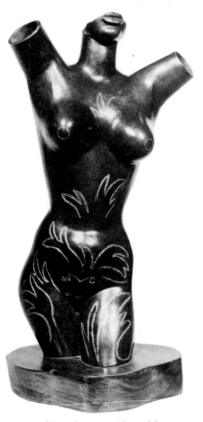

109 *June of Youth* 1934. Chased bronze

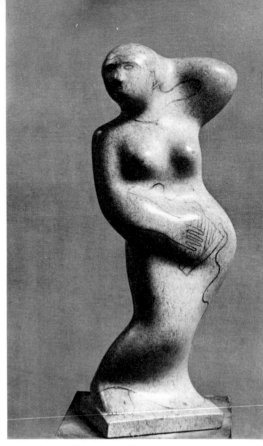

110 *Music in Line* 1937. Roman stone

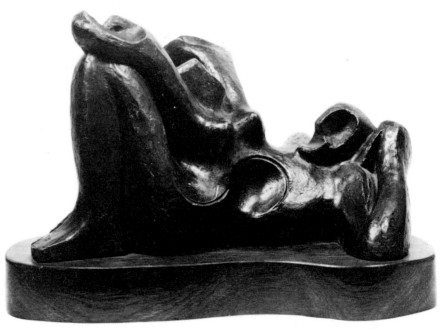

111 *Birth of Eve* 1935. Bronze

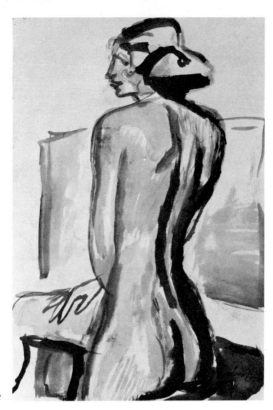

112 *Seated Nude* c.1935. Gouache

like a fringe against the forehead, or the triangle of pubic hair that transmutes nicely in *Music in Line* into a triangular stringed instrument. But its function is not so literal as this in that although it can work as delectable ornament, like the sudden two scrupulously inlaid nipples in an expanse of polished marble, it serves much more to play hide-and-seek with the eye across the form, appearing and disappearing in a way that leaves no doubt that it is one continuous line but one is never sure round which bend it will come looping next. To this extent it can look almost arbitrary but invariably it turns out to be following a carefully reasoned course, in exactly the way that it does in the life drawings.

African Madonna is the most spectacular example. Before starting to carve, 113 the block from which it was cut stood four feet high and weighed almost six hundredweight. The sculpture shows a Bantu mother, a tribe in which children are carried traditionally on the hip, to facilitate which, one side of the pelvis, one iliac crest, has become so over-developed over the generations that it forms a comfortable natural saddle. The piece took almost six months to carve and was commissioned for St Peter's English Church native school at Rosettenville, Johannesburg, ironically enough in an attempt to re-interpret the madonna theme in terms of the African carving that had so much influenced European art, and as an antidote to the insipid plaster madonnas to which South African children had become accustomed.

Before leaving for Johannesburg it went on view, together with *Herald of New Day*, *Birth of Eve* and a number of other new paintings and sculptures at the Beaux Arts Gallery in Bruton Place in November 1935. The London reviews were on the whole complimentary, but its appearance in Johannesburg in March the following year caused an uproar. It was called crude and ugly by the press but defended rather self-consciously by some correspondents who, already suffering fits of cultural indigestion from newly arrived pictures by Derain and Matthew Smith at Johannesburg Art Gallery, considered it 'sincere'. Almost as though to make Underwood's point for him, or that of George Harwood who had first commissioned the carving, a Bantu sculptor was hastily prevailed upon to make a second madonna, as a kind of corrective, that was installed amid much acclaim in St Mary's Cathedral. The sculptor's name was Ernest Mancoba. He had begun carving at the Native Training Institution, Pietersburg, and had lately received a grant from the Union Department of Native Affairs to continue his work in Pretoria. His madonna was an Italian Renaissance version. The *Rand Daily Mail* reported that such cultural warfare was not only a favourite topic at tea and dinner tables but was even disrupting serious games of bridge.

In May, Underwood replied to his critics in an open letter to the *Rand Mail*, saying that he hoped in time the sculpture would be accepted as belonging to a new and different order of beauty by the descendants of those African artists 'whose simplicity of expression helped to rescue Western art from the slough of naturalism and vulgar sentiment' into which it had fallen in the nineteenth century. His remarks resulted in a flurry of colourful exchanges in the correspondence columns, his detractors angrier and more lucid than before, one going so far as to say he could well imagine that 'if a low type of negro were asked to portray the madonna and child, he would most probably do so in the same manner'.

Through all this there runs one other general consideration that is a key part of what Underwood was trying to do – the perennial sculptural problem of the base; the anchor and pedestal resulting in what Rilke called 'a sculpture's circle of solitude'. In the process of getting his lark sculpture airborne, Underwood had first elongated it and then cut into it, in an attempt to dispense, if possible, with the whole idea of a piece of metal supporting what was supposed to be a freely ascending shape. However there was still the risk that, on the one hand, a base in his other sculptures would fulfil its traditional function of putting them on a podium – as something essentially apart from the spectator, displayed at a discreet distance – and on the other, that any change of material in the support would be disruptive of the unity of the sculpture itself. It is a dilemma that has had to be faced by all twentieth-century sculptors, and one that has been solved within their own limits by the most recent generation by simply placing their pieces on the floor, eliminating bases altogether, in an attempt to make them work as objects to be judged on a human scale like any others.

113 *African Madonna* 1934–35. Lignum vitae >

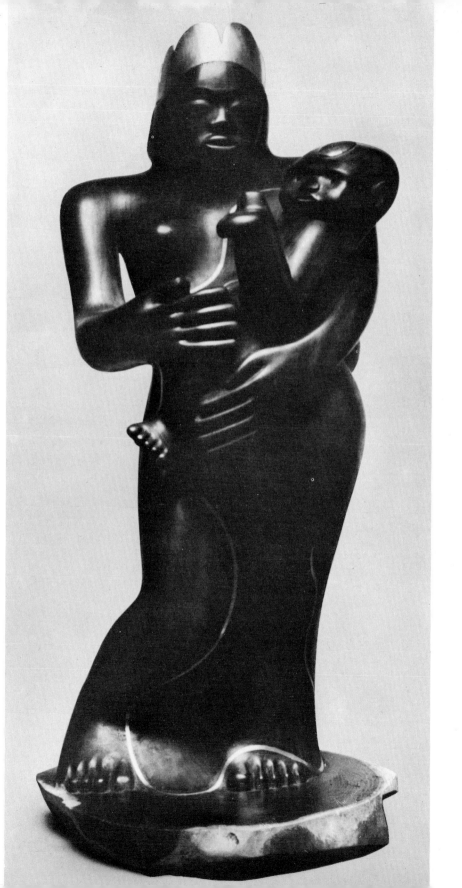

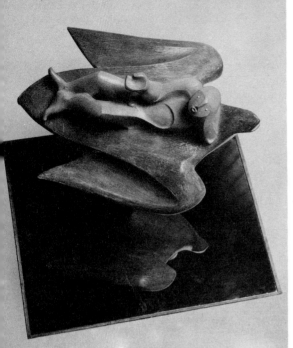

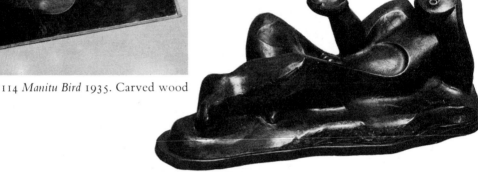

114 *Manitu Bird* 1935. Carved wood

115 *The Chosen* 1968. Bronze

 This would not suit Underwood. By 1935 he was beginning to look for ways of actively including the base either as part of the composition, in the same material, or, much more significantly, as an extension of the sculpture's own imagery. The first time this happens is in an early wood-carving inspired by

114 a legend of the North-American indian, showing a small figure carried, at death, by the Manitu bird, symbolizing the spirit that supports the body into afterlife. In the original version, the bird's head was turned back as it flew to sustain its burden with (spiritual) food. Much later Underwood adapted and cast the figure alone, with its palm turned upward to receive benediction, as

115 *The Chosen.* But the point of the version shown here is that the bird, gessoed a sky blue, was mounted on a mirror so that, seen from above, it caught a reflection and took on the simple symbolic function of water, the Styx. By far

117 the most successful later application of this principle is in *The Sower* of 1948 in which the perfect curve of the body is echoed by a simple base in the shape of

105 a scythe, but other telling and poetic examples are *Violin Rhythm* whose base takes the form of the reverse curve cut in the sounding box of the instrument,

119 or *Piping Down the Valleys* in which the support is a sliver of hillside in the shape of a crescent moon. Similarly the idea of continuity in *Childhood of a Planet*, 1936, a rosewood carving of the three figures of a family interlinked and

116 *The Ancestry of Beauty* 1936. Bronze >

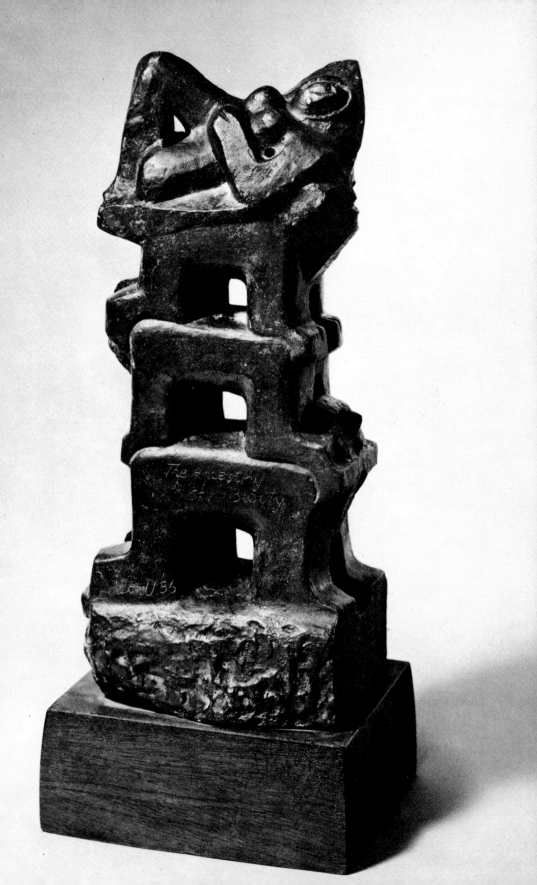

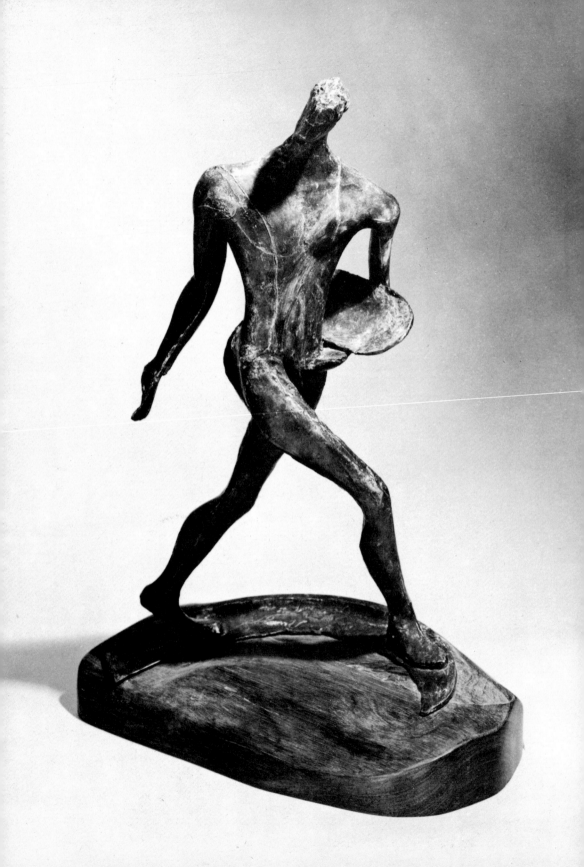

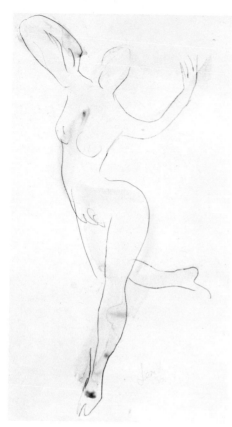

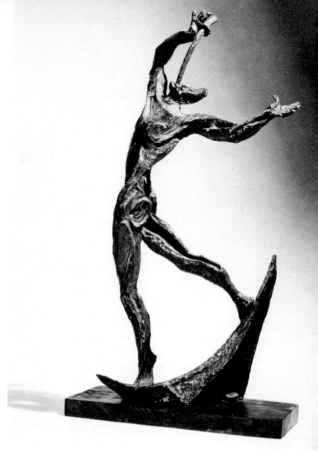

118 Life drawing 1936. Pencil and wash 119 *Piping Down the Valleys* 1961. Bronze

closely dependent on each other for support, is emphasized by the use of a ring, a circular base pierced in the middle.

A further way of solving this problem was to make sculptures in which there was a series of ascending bases, one locking onto the next to form a column or totem-pole. *The Ancestry of Beauty*, 1936, is an example. Here the lowest section is a rectangle of roughened metal out of which grows a rudimentary figure on its hands and knees, with, on its back, another slightly smaller, and another on that to form a pylon. At the top of this evolutionary column a voluptuous figure reclines in much the same pose as women in some of the Mexican colour prints. The reference to an indian type has the effect of suggesting the kneeling shapes as Mayan or Aztec stools or architecture: they certainly have a similar crow-stepped effect, but the whole piece has a convincing unity that encloses and is dependent upon the base, not as an additional form, but as an integral part of the design.

From here it is only a short step to arrive at totems like those carved by Underwood expressly to embody his idea of the artist raising himself by what he called 'his subjective interpretation of objectivity', a laborious movement in which force of imagination wrestles him to an upside-down position above

< 117 *The Sower* 1948. Bronze

his own purely physical limitations, a state of mind which in turn supports a visionary spiritual condition (symbolized in *Totem to the Artist*, 1934, by a metal inlaid nimbus round the head of the uppermost figure) from which he has the faculty of seeing from above – in other words is able to impose order on, and make sense out of, the apparent chaos beneath.

120

In a second piece the restraining, or earthbound, part of this idea is shown in a way more forcibly with a different kind of symbolism much closer to the kind used by the Kwakiutl and Haida tribes on the Pacific coast. But instead of consisting, like most indian totems, of a column of many animals, it makes use of just two: a bird and a snake. The bird struggles upwards to escape while the snake, bracing itself on its coils, wraps itself round it in a terrible constricting and restraining motion. As a result the totem has two quite distinct vertical directions, like a pile-driver, and nothing could convey more vividly Underwood's conception of the duality of the mind, the soaring and the earthbound, the free and the imprisoned, the subjective and objective. An important part of his expression of this idea, however, lies in the choice of the totem-pole as a shape that is essentially self-supporting, an object that depends not on an artificial base but on growing directly out of the ground like a tree.

121

Totem to the Artist, incidentally, is the only sculpture by Underwood to have been purchased for the Tate Gallery through the Chantrey Bequest (the Tate itself bought *June of Youth* in 1938, and *Herald of New Day* was transferred there from the Victoria and Albert Museum in 1952); and the *Serpent and Bird* is interesting for its opal inlay. Typical of Underwood's initiative in adapting all kinds of unlikely materials to serve his own ends, this turns out to be a fragmented electric-lamp shade: smashed up, the curve of the shade was ideally suited to the convex surfaces of the carving.

In several other of the earthbound carvings, in particular the beautiful and very compactly worked-out *Mermatron* of 1936–37 and the *Music in Line* already referred to, the base is treated unashamedly as a block or podium but carved out of the same piece of marble as the figure, without interruption, in an attempt to retain a unity through the material. This, too, can work, although it does mean that any upward impetus is firmly anchored to the floor and, however steady figures stand as a result, the heavy lower part can be visually distracting.

122

There is only one sculpture that reverses Underwood's usual direction and dives unambiguously downwards. Called *Rebel Spirit*, it dates from the early 'thirties and was in fact carved from a piece of poplar removed from the block used for the *Cathedral*. Painted black and then French-polished to a bright shiny surface to emphasize its rippling movement, it symbolizes Underwood's deliberate – almost ecstatic – plunge into his own difficulties. The whole weight of the figure cascades onto the lowest point of the elbow in a sequence of muscular leaps and bounds from the dished soles of the feet and bulging calves, relieved at the moment of impact by the hole tunnelled directly through the form at the point where the wood has reached its densest mass below the head.

123

120 *Totem to the Artist* 1934. English yew >

121 *Serpent and Birds* 1934. Acacia and opal glass inlay >

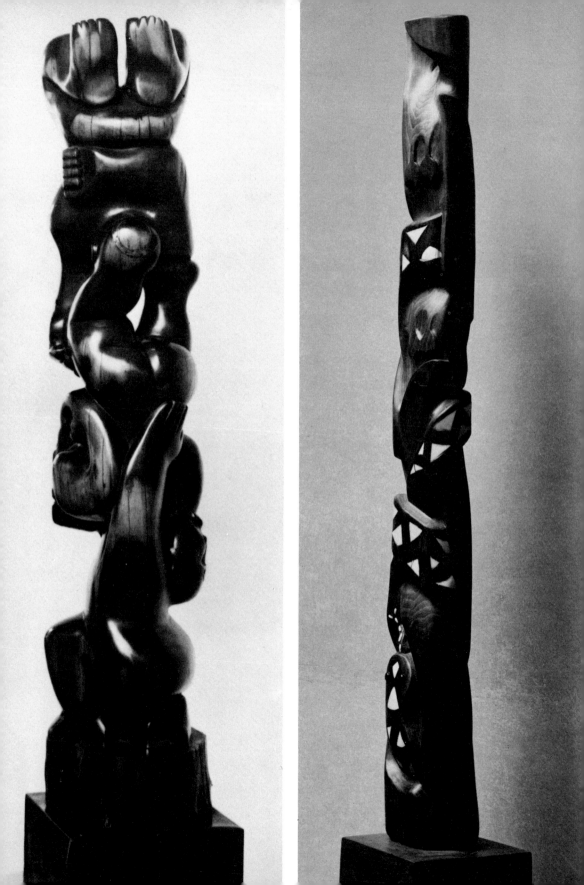

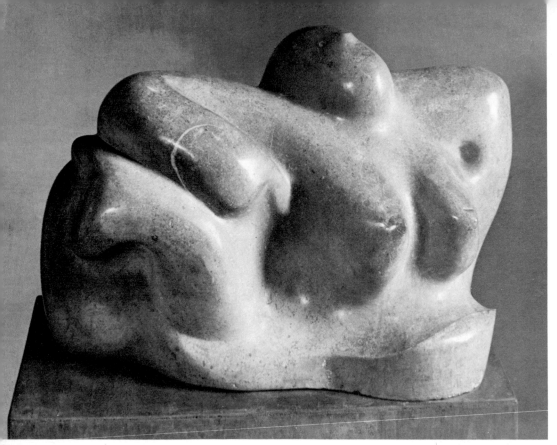

The one weakness of the piece, as he well realized, was exactly the weakness of the material in relation to the base problem. There was no way of making it stand without leaving the distracting wings of wood outside the arms, which go some way towards spoiling the vital central elbow. To get round this, not long ago the piece was cast in bronze, the extra metal cut away, and the figure made to join its support at the lowest point alone. Taking advantage of the opportunity, Underwood added strings of bubbles, wrapped across the shape, ascending past it, like the earlier inlaid line. They put the figure more convincingly underwater, but, despite the base, the poplar carving of the original has a vitality and thrust that seem energetic enough to send it deep into more resistant elements; and perhaps the mental diving equipment that Underwood took with him on these sculptural explorations is best displayed in a slim book he published in 1934 called *Art for Heaven's Sake*.

Always extremely lucid himself, and concerned then, as now, by the pretentious and misguided art philosophy he saw around him on all sides, Underwood got into the habit in the 'thirties of scribbling down comments, thoughts and epigrams about what he was doing. Sometimes they went onto

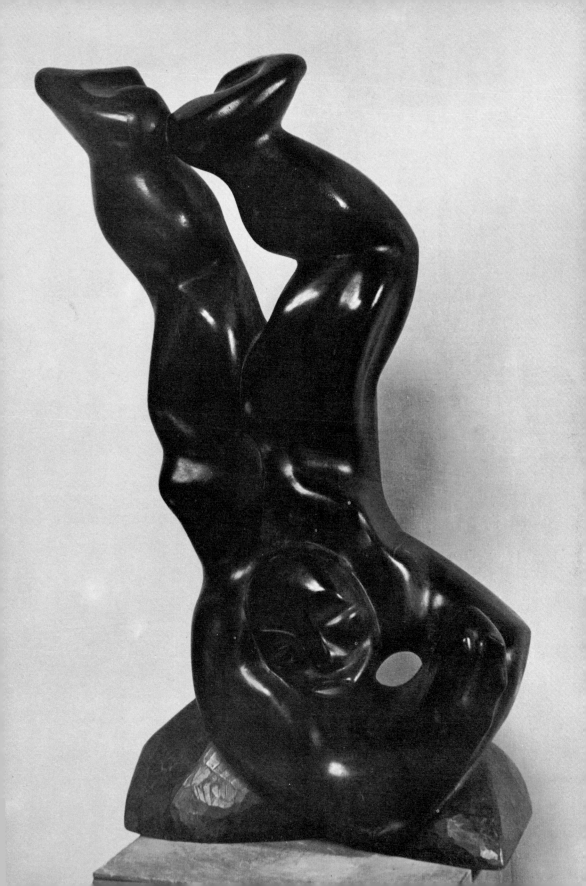

scraps of paper, sometimes into the margins of life drawings, and quite often onto the studio walls at Girdlers Road. Almost all are poetic expressions of his driving idea about the superiority of intuition and imagination, very much in the tradition of Blake; but, less like Blake, they also include occasional insights into the function and survival of the artist in an age of technology, and a great deal about the adoption by him of archaic and primitive styles. And beneath them all there is a chauvinism that clearly springs from familiarity with, and respect for, the literary streak in English painting (Hogarth in particular) and at the same time what amounts to a resentment of the colour theories and the insistence on purely pictorial analytic values of the School of Paris. The notes were published by Faber after being noticed and selected by R. H. Wilenski, who had discussed Underwood's work in exactly this respect 93 both in his *English Painting* of 1933, in which he reproduced *Tyger* and 96 *Freedom* to make his point, and in a short essay he contributed to a series about contemporary British artists, edited by Albert Rutherston, as early as 1924.

Before looking at them in detail, it is useful to examine first a catalogue introduction that Underwood wrote for an exhibition he organized at Sydney Burney's gallery, at 13 St James's Place, in the winter of 1932. Burney was evidently a dealer with great flair and initiative who sold not only very new European sculpture but Eskimo carvings, African and Polynesian art and Chinese terracottas. His was the ideal gallery in which Underwood could demonstrate his own view of the sculptural qualities that link prehistoric examples to those of the twentieth century, not ignoring time and place but showing how chronology had no direct relevance to the line of development. He set out in a loan exhibition, of the kind that could hardly be mounted now in an ordinary commercial gallery, to show how at the zenith of each cycle of style – for instance in Greece of the fifth century BC and in a Gothic carving of 1350 – the formal and expressive considerations are closely similar, while those of sculpture from Rome of 400 AD are not remotely comparable.

Although such connections between modern sculpture and that from Polynesia and Africa were obvious and quite easily demonstrated, Underwood concentrated on indicating far more complicated references. With an impressive list of lenders that included Roger Fry, Augustus John and Eric Kennington on one hand, and Samuel Courtauld and Henry Oppenheim on the other, he assembled works from Mexico, India, China, Egypt, Africa, Persia and New Zealand which were exhibited alongside pieces by Rodin, Degas, Gaudier-Brzeska, Modigliani, Moore, Hepworth and two sculptures 124, 104 of his own, the Ancaster stone *Torso* and *The New Spirit* in bronze.

To impose order on so much apparently diverse material he first divided it into static and dynamic, putting each in separate rooms, and separated his discussion in the catalogue introduction into three main parts: one dealing with the rhythm of materials, the next with what he called the rhythm of the sculptor's motive, and thirdly with personal vision as being very often the only lasting indication of a people's culture, surviving in their sculpture long after

166

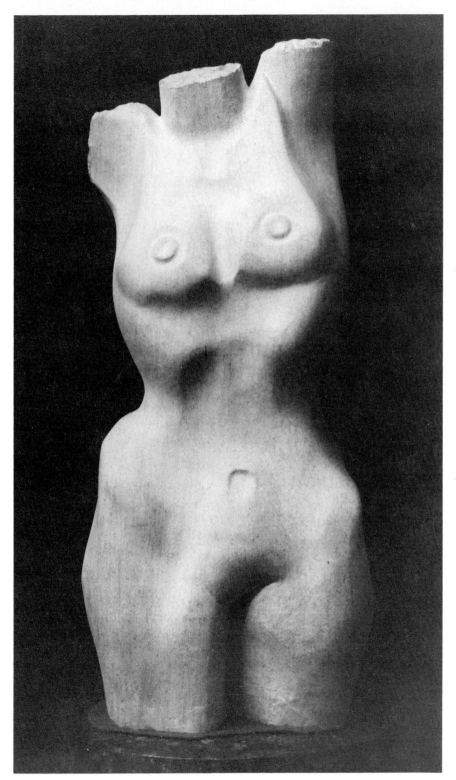

124 *Torso* 1925. Ancaster stone

records of their physical adaptability, martial force, wealth or system of government have disappeared. That he did this at all is an indication of the extent to which he had settled in his own mind the positions of those peaks of achievement that he thought important, and to which he was trying to relate his own work. The perfect sinuous turn of Gaudier's *Dancer*, one foot stepping lightly down from its base, must have made an enlightening comparison with the equally lively attenuated rhythm of a Sudanese wood figure, and *The New Spirit* itself with the metal flow of a dancing *Siva* from twelfth-century India. This is a starting point, a fundamental tenet of Underwood's about the nature of sculpture, but the views he put down in *Art for Heaven's Sake* take it that necessary step further to equate this philosophy to the constant awareness of technological change – in other words to show the theory in practical application in an evolving society based on, or regulated by, essentially material developments.

The catch here is that his insistence on the superiority of the imagination can seem to exclude the acquisition of objective knowledge. This is where *The Island* philosophy goes wrong, not that that was Underwood's fault. Some of his students and those around him were so excited by the poetic approach that they lost themselves at once in a soft Romanticism that had no bearing on the contemporary situation, and even set out to exclude it. By 1934 Underwood himself was fully aware that there must be a relationship between art and technology in that the imagination, or belief, was being continually overhauled by material progress: always the artist must have what he called a new icon of belief, ahead of and beyond scientific proof. 'No significant artist of today', he began in *Art for Heaven's Sake*, 'can work without a definite idea about the reconstruction of the world he and his fellows live in.'

Taking this at a purely practical level first, he stressed his opposition to William Morris's and Samuel Butler's version of social change via a return to mediaevalism and the rejection of the machine:

'By all means let the machines clean our boots and fill our larders, but not our dreams.'

'If necessary, sink a mine shaft in your front garden – but keep a corner in your back garden into which you can retire from its noise to listen to the song of the thrush.'

And, perhaps best of all: 'Type your circulars and keep a pen for your love letters.'

But the essence of what he had to say is more to do with the straining upward of the spirit, as embodied in his sculptures, not necessarily for a Christian ideal despite the heaven of the title, but towards a purer state (symbolized by heaven) that is 'the most perfect sublimation of his old desires'. He reserves the right, throughout his work, to rewrite the bible in his mind, just as Blake did, but the choice of what is frequently Christian or biblical imagery arises chiefly because it contains in a concise form vivid and arresting psychological truths that have the advantage of familiarity.

168

'The artist is the sower,' Underwood wrote, 'who casts about him original thought, woven out of intuition and imagination; and, when the conditions are right, germination takes place. The artist is the sower who at the harvest time is over the horizon – on his way to sow new ground.'

This kind of thing is too good to paraphrase. The following is a very short selection to indicate some of the essential points of his philosophy:

'Art and life have drifted apart. They have drifted branch-like from the main stem, and the main stem which is aesthetic culture has withered.'

'I would compel an interest in art by legislature. Hygiene is no more natural to the average man than beauty, but nevertheless legislature has done a good deal in first making him appreciate and subsequently love cleanliness. The result was achieved by the threat: "You will die if you are not clean." We artists should say: "You will not go to heaven unless you love art".'

'I have been able to make use of some of the aesthetic theories of today. My difficulty with so many of them is that they are too abstract – too dissociated from life to hold poetry which runs out of them as out of a colander.'

'There is impressed in the art of a race a character which is due to its racial temperament, and in English art, which I imitate, it is that of freedom.'

'For the artist, everything counts – even breakages count – and the imaginative artist's selection, for his purpose, from everything that is available to him must tend towards complexity. His path is therefore one of synthesis, not analysis.'

'In spite of the library of literature that accompanies *cache-toi* analytic art, it is surprising – rather it is not surprising – how little it is understood. But it has had the effect of causing the true art to be almost forgotten.'

'Art must return to life through the imagination – not to a partial aspect of it in science and its abstractions.'

'I do not consider intuition better for being independent of reason. The ideal is the synthesis of the faculties, as Blake implies by "The marriage of heaven and hell".'

'While art is sick, recognition is a snare. The true art is left to the artist who refuses to circumvent a lack of recognition at a cost that threatens his integrity.'

The clues here are very definite. By 1935 Underwood had temporarily abandoned painting altogether to concentrate on sculpture, guided by precisely these principles – which must also, incidentally, have been an inspiring part of his teaching at Brook Green. They can be summarized by saying that he felt very strongly that sculpture and painting had lost their significance in human affairs, and that in their place there was a desert of abstraction (of essentially analytical art) that obscured common experience and became incoherent because it concerned itself not with poetry but with the mechanics of vision. He was coming to see himself as an isolated figure whose only hope was to concentrate on optimistic subject matter in a period to which the whole idea of subject was increasingly unfashionable, a period when the cycle of style, as he understood it, was approaching its lowest point.

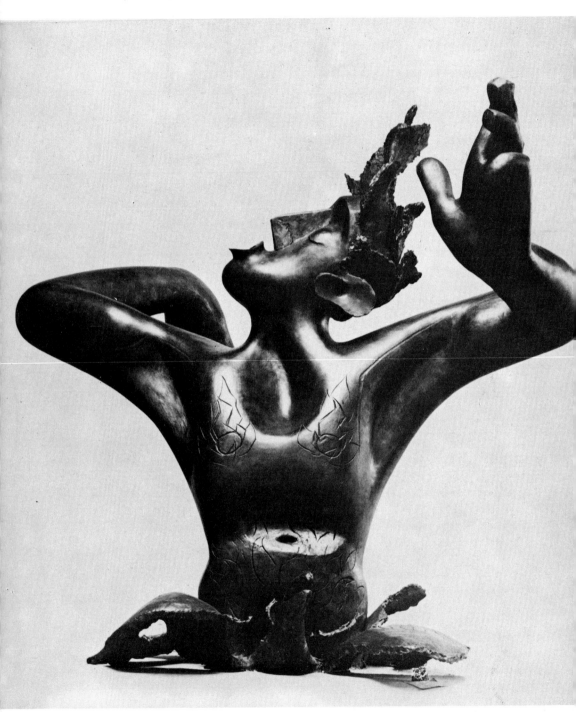

125 *Phoenix for Europe* 1937–69. Bronze

11 Alone

Resigned to his isolation, Underwood's output between now and the outbreak of war must not be confused with the soft Romanticism, linked to the Surrealist movement and accentuated by the violent quarrel between abstraction and Surrealism that came to a head with the International Surrealist Exhibition at the Burlington Galleries in 1936 and the publication of *Circle* the following year. He had long ago tried and rejected Surrealism; and his own sculpture had taken off in marked contrast to Moore's which became increasingly solid, abstract and monolithic when he began carving out of doors in Kingston in 1935. (Moore made a tour of cave paintings in the Pyrenees and at Altamira in 1936.)

Nevertheless, Underwood's prints and sculpture from the years leading up to the war do provide a more colourful and optimistic view of human nature than was usual in a period suddenly obsessed with politics rather than with aesthetics. Wyndham Lewis, who became a Fascist, frankly saw the 'thirties as a relief from the frivolous masquerade that ended with the Depression in 1929. The world, he considered, had been getting 'extremely silly'. Underwood's continuing stream of wood engravings show no real political awareness, though they no longer have the flippant lightness of touch of the New York years. Instead they concentrate, as does the sculpture, on his larger concern with ideas that still relate closely to his discoveries in Mexico of almost ten years previously.

The superb colour print, *The Fishwife*, for example, belongs to 1938–39, and Mexican themes were still inspiring tremendous resourcefulness in every kind of technical and symbolic device. Printing with woodblocks or lino in the Girdlers Road studio, he tried a dazzling variety of approaches, all within the voluptuously curving line that appears and disappears round equally seductive areas of colour like the inlaid line of his carvings. There are the uses of opposed texture, overprintings to induce whole new ranges and gradations of subtle colour, and an exhilarating directness in the drawing that all go to make up a unity of method and intention that he has not surpassed in later prints, and which nevertheless appears to have been accomplished effortlessly and with extreme economy of means. 69

When they went on show at Zwemmer's in his exhibition there in June 1939 these colour prints sold for three and four guineas each. They included, from

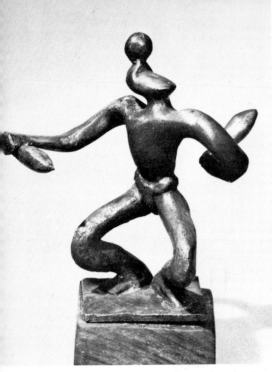

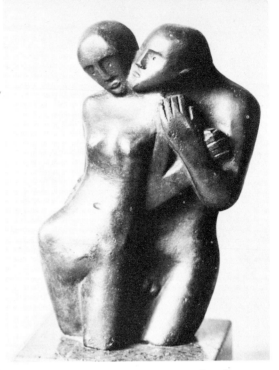

126 *The Juggler* (third state)
1961. Bronze (cast by the artist)

127 *Les Amoureux*
c.1932. Alabaster

1936, *Mexican Women*, *Mexican Idyll*, *At the Market Gates*, and one very animated example called *Pike-Fishing* based on a dramatic incident involving a 20-lb. pike on Loch Marlee when he was fishing with one of his students, Margaret Bruce, the year before. As always in the prints, he managed to describe very vividly the narrative of his subject, and yet to convert it into an apparently simple and spontaneous pictorial statement. Among those from 1939 were the rhythmic *Bathers*, *Plaza Gardens*, and *Montezuma's Fish*, all of which show him at his best.

67, 72, 77

The oils included in the Zwemmer exhibition were mostly at least six years old – for example *Ox Wagon*, *Dos Charros* and *Tehuantepec*, many of them with the very beautiful and characteristic frames which Underwood had been carving and painting since the 'twenties in an attempt to carry the rhythm of his pictures beyond the hard edges of the canvas. There were enthusiastic reviews in *Apollo*, *The Times* and most of the dailies, but most attention was rightly paid to the bronzes. Eric Newton used the opportunity to try to explain his excitement and appreciation of the sculpture in a long piece he wrote for the *Sunday Times*, rather passing over Epstein and saying that Underwood's *June of Youth*, in bronze and with inlaid silver nipples and navel, was one of the most expressive pieces of modern sculpture he knew. As well as this, the exhibition included *Syncopated Rhythm*, the alabaster *Les Amoureux* and the little bronze *Juggler* which had started life in 1935 with a chased ball on each hand and on his forehead but by 1939 was swinging clubs.

109

127

126

172

Newton had first noticed, and been deeply impressed by, the *June of Youth* while it was still a terracotta, before casting, in 1937, and had deliberately sought out and praised enthusiastically some drawings by Underwood in his *Guardian* review of the Royal Academy summer exhibition the same year. Underwood's relationship with the Academy, as a reactionary body in the 'thirties and 'forties, was a predictably uneasy one. On more than one occasion before the war he was irritated but not unduly distressed to find that, having been persuaded by some of the more liberal associates to submit work, it was invariably rejected, and in April 1938 he published a letter in *The Times* suggesting, instead of the usual loan exhibitions in the winter, a kind of Salon de Refusés for newer artists (a policy eventually adopted at Burlington House with the new sculpture show in 1971). As it happened, preparations for the 1939 winter exhibition – the Art of Greater India – were cancelled on the outbreak of war, and anyway it was argued that, without a government grant, potentially unfashionable exhibitions of new work would not be a practical proposition.

Nevertheless, from outside the Academy he saw no reason for avoiding categories that were traditionally its own preserve. In 1937 he made an unimportant but interesting excursion into portraiture in order to try to demonstrate that, even now, the principles of good sculpture were not irreconcilable with a public image of royalty. That such sniping at academic portraiture may have been slightly cynical is suggested by the fact that the bust he exhibited at the Fine Art Society in May 1937 had started off with the head of Edward VIII and changed, with the abdication, to that of George VI, but it was a convincing likeness and a well-conceived bronze in its own right.

In general, Underwood had come to fight shy of anything but family portrait sculpture for exactly the reasons that he did so in painting. There is an

128 *Three Months* 1945. Bronze

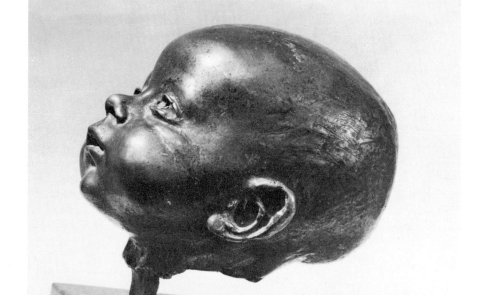

exquisite study of a baby's head and a sensitive portrait of Mary from the 'forties, but just as New York sitters had ended by declining to buy commissioned oil paintings, there had also been moments – for instance with a head of Sidney Burney – when his refusal to abandon artistic integrity in favour of flattery had resulted in an unpleasant atmosphere and the inevitable loss of sales: the portrait artist's perennial dilemma. Against this background, and entirely according to his own lights, he made a 2 ft. 10 in. bronze column, very erect and stiff, in which beneath a portrait head of the king he incised all surface detail, comprising the points of an admiral's uniform and decorations, in a rigid pattern that did not interrupt the form.

This was one kind of reaction to the existing order, and the press picked it up gratefully: another, which had more to do with 'thirties design and its search for the best adapted ideas for mass production, he tried in private. His instinctive preference for the handmade, a glance over his shoulder at the Arts and Crafts Movement of the 1880s from a period dominated by the Design and Industries Association, had led him to think briefly in 1937–38, about furniture. He made a chair in Italian walnut that succeeded in combining the basic requirements of a chair's function with the aesthetic principles of a piece of sculpture, his intention being to show the dangers and limitations of the Bauhaus notion that, in useful objects, function was a sole principle of beauty. In 1938, Moholy-Nagy wrote that each piece of truly contemporary work was constituted 'solely from the elements which are required for its function', a doctrinaire approach to fitness for purpose in design and architecture that has come increasingly under fire in the last decade.

Underwood's solution did not, admittedly, take into account necessary limitations like weight and stacking, but for a one-off prototype it is astonishingly tight, comfortable and stable, all qualities soon proved by sitting in it. It took the form of a standing animal motif derived from Egyptian tomb furniture, with twin deer for the arms and legs, their upturned heads for hand-rests, and the figure of a hunter similar to the 1922 Carrara marble relief incised into the backrest back and front. To weave the covering for the seat he constructed a loom, with the help of his student Margaret Bruce, and dyed and wove a fabric in soft browns and reds. The whole undertaking was extremely laborious and time consuming. There was no wide market for handmade furniture with the increasing use of plywood and veneers, and it is as though the thinking of Gimson and Ambrose Heal found late expression in a strange hybrid comprising something of English handmade cottage furniture and something of African carving and Indian weaving. There was a tentative commission for six more chairs of the same type but Underwood could never contemplate making another, though he did make a small bone-inlaid table. The loom, so laboriously constructed, was used only once or twice more and then broken up. It was not, however, a wasted exercise, in that it is central to his belief that practical experience in any direction is worth a lifetime's theory, an attitude more than borne out later in his knowledge of casting.

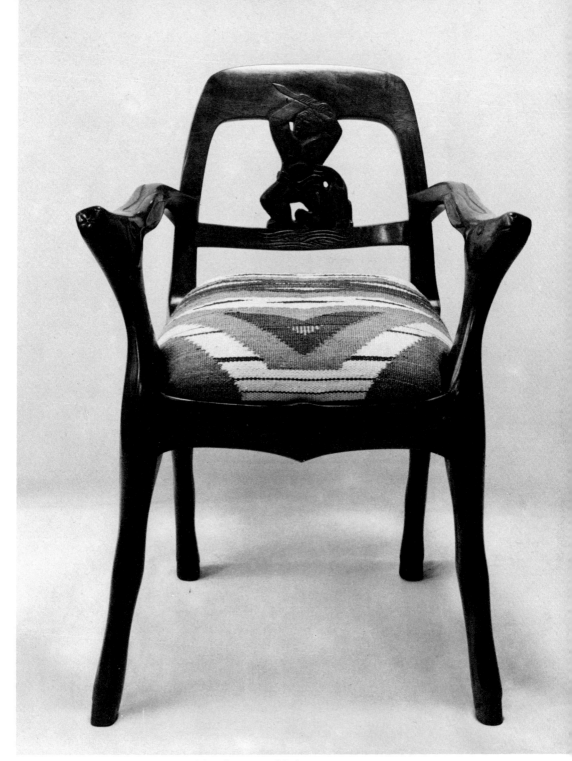

129 Chair 1938. Italian walnut and hand-woven fabric

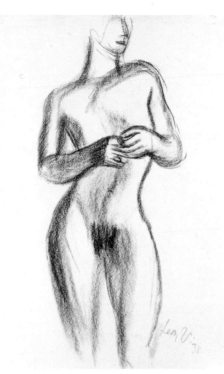

130 Life drawing *c.*1938. Black conté crayon

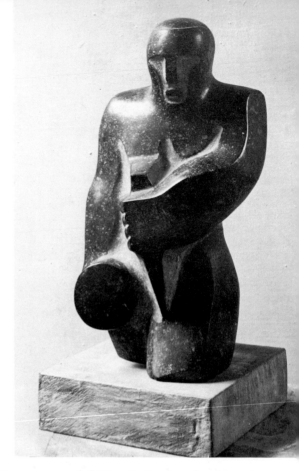

131 *The Sculptor* 1939.
Irish black marble

Ironically, with the 1939 Zwemmer exhibition indicating that his print-making and sculpture was not only increasing in momentum but beginning to regain a public lost when he went to America, war was declared. In no time he was frittering away a second spell in camouflage, this time attached to the Civil Defence department at Leamington Spa, with almost no opportunities for getting on with his work. The last major sculpture before the war is, significantly, *The Sculptor*, a massive and powerful figure in Irish black marble in which the head is drawn down into the shoulders and all the forms block in on one another, the weight of the buttocks balanced by the heavy head of the mallet and the deliberately phallic and potentially productive chisel held against the body in front.

131

His time in camouflage from 1939 to 1944 marks the end of the spate of activity directly inspired by Mexico, and finds its logical conclusion to Underwood's line of thought in Africa. Like the First World War, it is a bridge passage during which he could work little but thought much about his direction and philosophy. The effect of so long an enforced stop was to place a barrier or dam across his output, and the weight of ideas that had built up behind it by the time it was removed in 1944 was formidable.

There are several parallels between this and the period 1914–17. Again he made watercolours whenever there was an opportunity, comparable to a series of London Squares from the First World War but this time very much freer and more lyrical. He used his army car and petrol allowance on illicit sketching expeditions, painting empty landscapes with not a uniform in sight: their subjects are trees, grass, water and reflections, the sky. They are as though he was breathing deep lungfulls of fresh air in reaction to the business of camouflaging acres of factory roofs, and of fatuously painting bomb craters on pieces of hessian that were strategically placed round airfields to make them look, from the air, as though they were too pitted on which to land. His watercolours and the presence of other sympathetic artists in camouflage, like his friend the sculptor Eric Schilsky, were his only compensations.

He was, however, drawing in shorthand much of what he saw. None of the notebooks used for this survive but it is possible to get an idea of his style by looking at the life drawings of the period immediately before the war. It is 130, 135 extraordinary to realize the importance he still attached to life drawing in 136 1938–39 in his own work. Finding it impossible to get models and very expensive to heat the studio at Girdlers Road in the winter of 1938, he began to teach

132 *The Thames at Long Wittenham* 1935. Watercolour

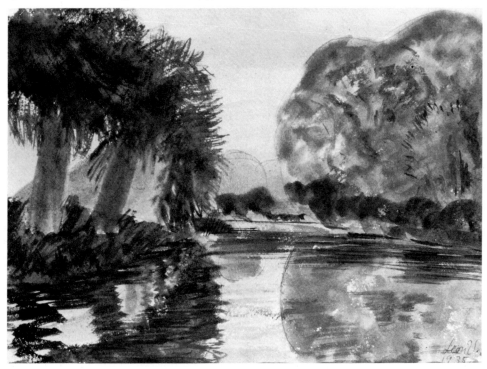

at the Hammersmith School of Art in order to make use of the models there. Between instructing his students on the weekly visits he was able to draw rapid studies of his own, usually in a single writhing line that directly and accurately establishes the tension and balance of a figure while suggesting its volume almost magically. There are folios full of these. Most are on very thin paper, some with several drawings to the page and also on the reverse. Occasionally they are packed with further information about volume by the use of broad washes. Almost in spite of themselves, the results have decorative qualities quite independent of the information they were intended to convey. There is every reason to suppose that any drawings Underwood made during the war were in the same vein.

A second clear similarity between this period and 1914–17 is another invention. Using the glasshouse at Greenhill, the house he rented for himself and his family near Leamington Spa until 1946 (and which appears in many of the watercolours), he developed a photographic means of building up a scale model to calculate range and angles of fire. The principle was that two aerial photographs of the same piece of ground, taken from two separate angles, were

133,134 Life drawings c.1935. Pencil and sanguine

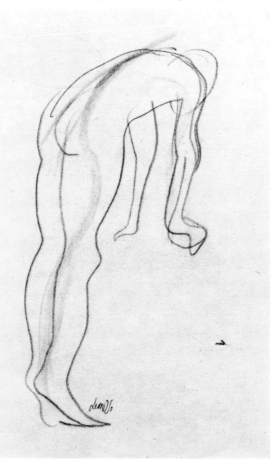
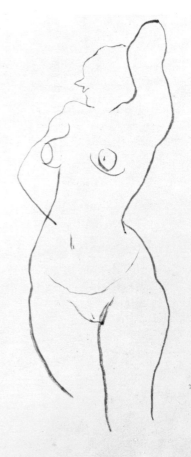

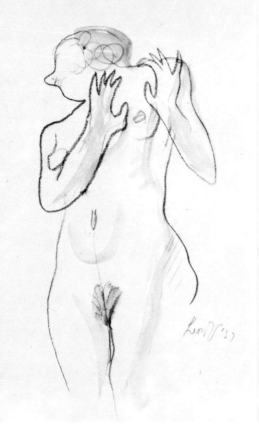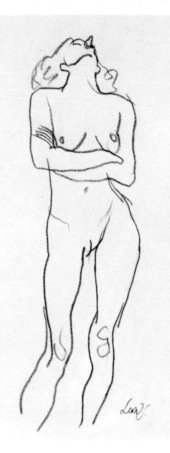

135,136 Life drawings c.1937. Conté and sanguine

projected on top of each other. One had its dark areas replaced with green, the other with magenta. When these two images overlapped on a slab of modelling clay containing titanium oxide they could be focused backwards and forwards to establish relative heights and depths, which could then be modelled into corresponding relief. The clay model could then be cast in plaster and a single monochrome image projected on it to provide an accurate scale model of the area. Underwood demonstrated his completed idea to a committee from the cartographic department in early 1944, but its adoption required that he adapt the invention to a more easily manageable and mobile form within six months, which he was unable to do. Like the repeating mortar of 1917, it was rejected, but that he was able to arrive at it in the first place is an indication of the extra-ordinary versatility of his mind, when need be, at a purely practical level.

The war and the shortage of materials did not prevent him from carving altogether, and the Mexican idyll finds its last expression in a sculpture 14 inches high completed in 1944, called *The Fishwife*. Related to the colourprint 139 with the same title of 1939, it is made of American black walnut and shows a woman with a broad basket on her head across which lie two inlaid ivory fish.

137 *Mask (Apollo O'erclouded)*,
incomplete, 1933. Bronze
(cast by the artist)

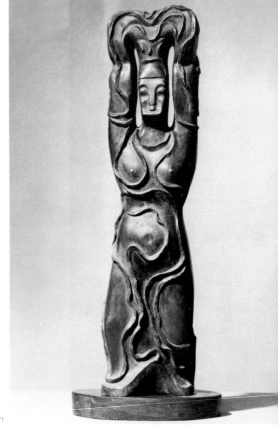

138 *Water Carrier* 1971. Bronze

Like Gaudier's *Dancer*, there is a turn in the lower half of the body as the figure gracefully descends a step, but with the difference that her shoulders and head remain taut and erect to support the level basket. The twist of her pelvis and legs is continued into the stepped base which begins slowly to turn as well.

But the most important development, equivalent to the *Not in Anger* monument of the First World War for which he drew plans and a watercolour in 1943, was an idea far larger and more far-reaching. Some drawings from 1937 show that it was already taking shape in his mind before the war as a gigantic male figure, suggestive of resurgence, and tentatively entitled *Wake Up, England*. In a politically orientated period, it is the only reference in Underwood's work to his imagery as a reaction specifically to what was happening in Europe instead of as a generalized ideal. With time to think, this idea intensified until in his imagination he saw an ecstatic figure embodying all the old optimistic impulses and symbolism that had been part of his stock-in-trade since he first saw *Glad Day* almost forty years before. It became symbolic of the rebirth of a shattered continent, destroyed but bursting full of fresh energy and hope. He rechristened the idea *Phoenix for Europe*.

He was not able to get to grips with it in his studio until 1951, and the figure was not finally completed and cast until 1969. It is now in an edition of three, one of which has the most sympathetic setting out of doors of any sculpture

125

by Underwood. It stands overlooking a pool in an Essex garden, against a background of napped-flint walls and open farmland. A god-like male figure, it is fringed with flames both round its backward-tilting head and the top of its truncated thighs. Despite its great weight and the extreme solidity of the forms, it gesticulates powerfully in an upwards direction as though to flicker and dance. There is a tension between the airborne gesture of the hands and the way in which their mass seems to swing on the forearms like weights on the beam of a crane. The features of the face are simplified and formalized, the eyes closed in ecstasy, suggesting the spirituality of a mask. From the fringe of flames where the figure tries to break free from its base, its erect penis comes upward and forward like an ascending bird.

The symbolism suggests equivalents in African tribal carvings, and before the war was over Underwood was beginning to feel that his researches into primitive art in Europe and Mexico led deeper into questions about abstraction and belief that could only be resolved in Africa. The journey through West Africa in 1944 is the culminating influence on his work and marks the beginning of a new phase, distinct from his achievements up to 1939, that has occupied him up to the present day.

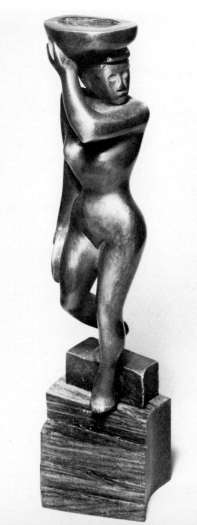

139 *The Fishwife* 1944. Bronze

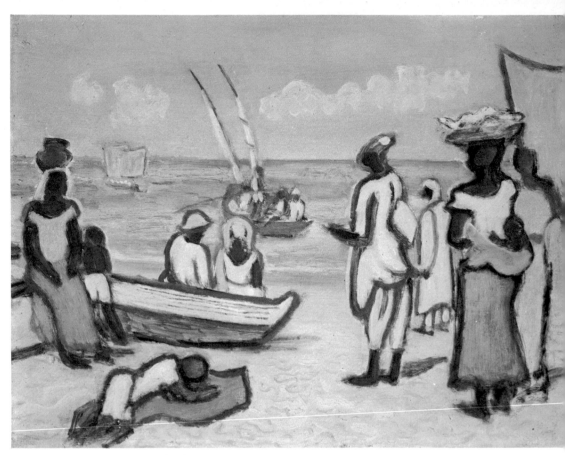

140 *Waiting for the Ferry, Gambia* 1945. Oil

In order to get to Nigeria, Underwood succeeded in persuading the British Council, via the Home Office, that it was important that Africans should understand the significance of their own tribal art in Western culture. Mainly on the basis of a public relations exercise it was agreed he should leave in May 1944, with an open air-ticket, to tour schools, colleges and museums in West Africa and to lecture to them about the influence of African art in Europe and America. In the event, although there were isolated instances where an attempt at an artistic renaissance was being based partly on the revival of traditional forms, he found that Africa was already more interested in European art than in its own. The drug that in Paris in 1907 had seemed a primitive cure for all aesthetic ills now worked in the opposite direction. The traits of African art in Cubism having been judged by purely western aesthetic canons, instead of in relation to their background tribal culture, now flowed ironically in reverse. Without understanding them, Africans wished only to adopt the styles of western painting and sculpture, and the place of their own art within that development was not yet a source of national pride.

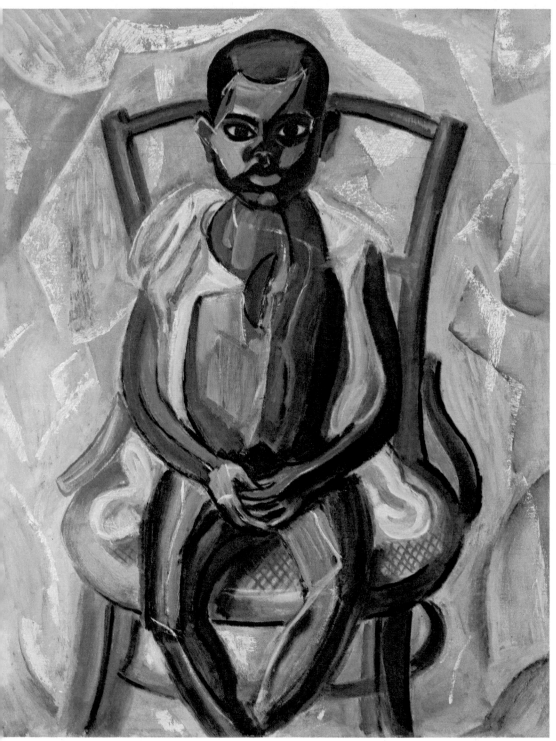

41 *Ivory Coast Gamin* 1945. Oil

With the breakdown of the tribal system and the introduction of European and Moslem religious thinking, tribal art was emptied of the beliefs that it existed to embody; and in this condition it was either regarded principally as ethnological data and its aesthetic qualities largely overlooked, or fostered at a very tired and debased level for the purposes of the tourist trade.

Whatever the attitude of Africans themselves, the journey provided Underwood with four months of travel and research in his own directions, and the opportunity to assemble a large collection of carvings, pottery and materials – twenty-five cases in all – that he shipped home but which the British Council declined to accept. On his return he was not only equipped to throw new light on the mysterious 'classical' bronze sculpture of Ife, but to discuss the abstract qualities of African art in general in relation to the society to which it belonged, and also in respect of his own theory of the cycle of style. At a time in 1945–50 when London had a long series of exhibitions about African art – at the Berkeley Galleries, at the ICA, at Zwemmers and those organized at the British Museum by the Anthropological Institute – he was publishing highly original views on the subject, notably in *Man* (January 1949) and *The Studio* (December 1948) and three influential books on separate aspects of African art that appeared in 1947, '48 and '49.

His somewhat oracular style was sometimes too much for reviewers, but if his thought in *Figures in Wood of West Africa* seems elliptical, that is because he was writing on at least three different levels: a purely technical discussion of the practical problems involved, a searching investigation of the social and spiritual stimuli that shaped African art, and thirdly the application of both those principles in contemporary art. At the opposite ends of this attitude were his own experiments in casting at Girdlers Road – from which he was able to prove to the British Museum, for example, that it was entirely wrong about the use of moulds for Mesopotamian arrowheads – and at the other a poetic view of belief, equated with the spirit of the dance (of syncopation, the same impulse that came out in black American jazz), as the essential force in primitive art, and hence as the missing element in contemporary art of the west.

It was with the last aspect at the forefront of his mind that he disembarked at Abidjan, on the Ivory Coast, in May 1944, and began to make his way east along the coast to Takoradi and Accra. Using the pavilion of the British Council in Accra as his headquarters he started to lecture and to show the slides he had brought with him from the British Museum, but finding there was little interest he hired transport and servants and began a series of journeys that ranged from Freetown and the northernmost territories of Sierra Leone in the west to Lagos and Benin towards the eastern end of the Guinea Coast.

He soon realized that the further he went north, away from Westernizing influences on the coast, the purer the traditional work he was able to examine and buy. Until he caught malaria and returned to hospital in Lagos in September he travelled by lorry, narrow-gauge railway and occasionally on foot to Kumasi, Tamali, Bo and Bunumbu and in Dahomey. He visited the pottery

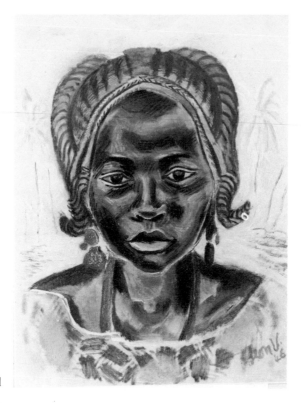

142 *West African Girl* 1946. Oil

school at Alaga, founded by Meyrovitz and run by Michael Cardew, where Africans were experimenting with ways of combining traditional with new techniques; and he spent some weeks with the Mende in Sierra Leone, studying the large black masks worn as helmets which were made for the Bundu women's initiation society. The Mende were of particular interest to him because both their social life and their art were dominated by powerful secret societies, and as well as masks they made beautiful carved wooden figures, *minserek*, used by the Yassi society in magical healing rites.

From Lagos he studied Gelede masks, which already included secular motifs absorbed from outside influences, and went to Kano where he discussed with Islamic teachers the problems of making woodblock illustrations incorporating specifically African imagery for modern school books. Everywhere he went he was struck by the dance as the direct expression of the people, and the vital significance of the mask as an integral part of the dance ritual – a transfer of all symbolic importance to the head in contrast to the European tradition, for example the Greek, of concentrating expression in the whole physique, the athletic body. In particular he looked at the Yoruba of Western Nigeria and eastern Dahomey, one of the most prolific sculpture-producing groups comprising several separate sub-styles directly related to the ancient religious art of Ife and the royal art of Benin.

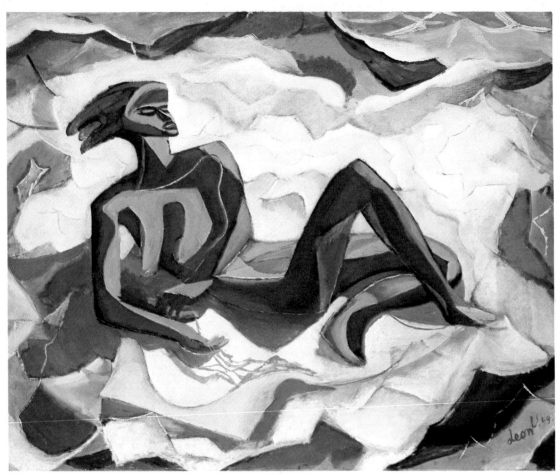

143 *Birth of Venus Africana* 1950. Oil

The conclusions he drew are typically practical in technical respects but at the same time poetic. For instance his view of the dance, and especially the rhythmic rocking of the Yoruba, is romantic: 'the rippling thrust of a thousand corn seedlings breaking through surface soil', with the implication of social rejuvenation very similar to the one he had recognized in the Mexican market place. But in general his conclusions can be summarized by saying that he found tribal art to be part of a cultural pattern essentially dependent on commitment and belief, a means by which tribes expressed their internal solidarity and identity within a mature and complex structure static enough to be outside the normal 'early formative' and 'late degenerative' phases through which the art of major civilizations evolves.

The principle, he found, was of synthesis as opposed to European analysis. What to European eyes is abstract form, in African sculpture is a meaningful and instantly recognizable language to the tribe: the African carver is incapable

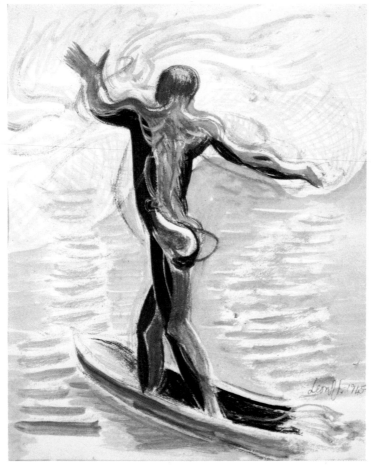

144 *The Cast-Net, Lake Bosumtwi* 1946. Oil

of free abstraction because he cannot use a shape without a meaning. Form depends entirely on urgent expression. The failure of Western art was its adoption of the form and its inability to simulate belief, typical of a culture in decline. Hence the high classical ideal, recurring once in Greece and once in the Italian renaissance, was the counterpart of the primitive element in that its powerful belief evolved a style, a real style as opposed to imitation and historicism which is mere virtuosity, a negative contribution.

In his three books Underwood looks at these ideas with particular reference to the apparently classical portrait style at Ife and the highly selective representation and gradual recession from European influence at Benin, including a discussion of the lost wax process and the problems of how and when bronze technology found its way into Africa from the Near East long after iron had been used for tools. All these are questions that still occupy him, but his realization that (except where there were outside influences as in the stone

145 *Pounding Fou-Fou* 1946. Oil

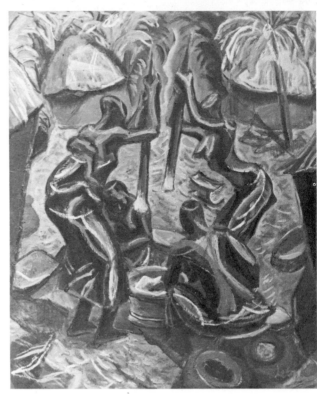

146 *Yoruba Dance* 1946. Oil

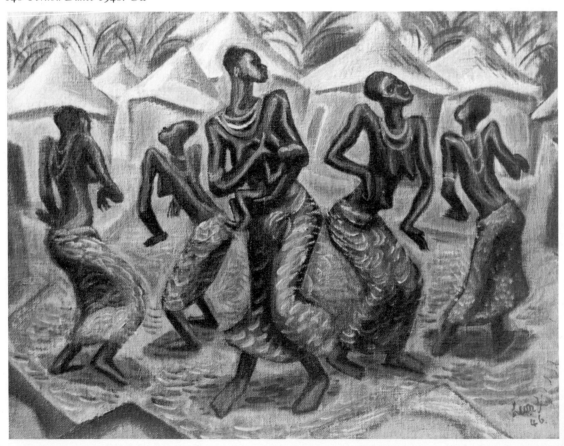

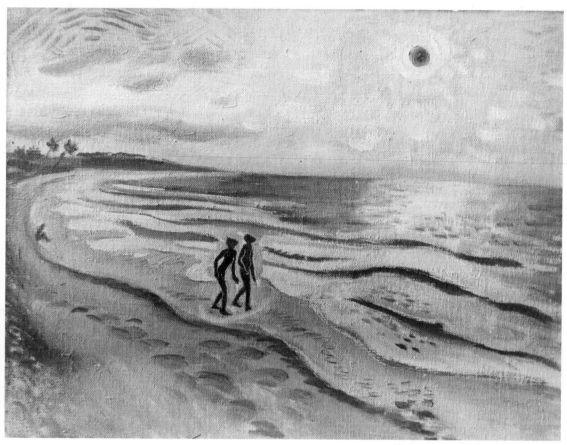

147 *Black Sun* 1949. Oil

figures of Sierra Leone, Benin bronzes, steatite figures of Essie or terracottas of Jemme) the African carver's knowledge of form was confined to its volume and surface, stimulated him to an increasingly dynamic exploration of sculptural space. In tribal sculpture, heads seldom turn or spines rotate. His own sculpture of the 'fifties and 'sixties is often on a violently spiralling axis and more about space than volume – as Eric Newton described it, it is more than half air.

He arrived home from Africa in October 1944 with an enormous collection of African art and a great many drawings and watercolours, including some superb watercolour sketches done while he was waiting for his aircraft three days at Alaga. His views on the place of belief in sculptural form were now so sufficiently clarified that he was ready for a new explosion of activity as soon as the war was over.

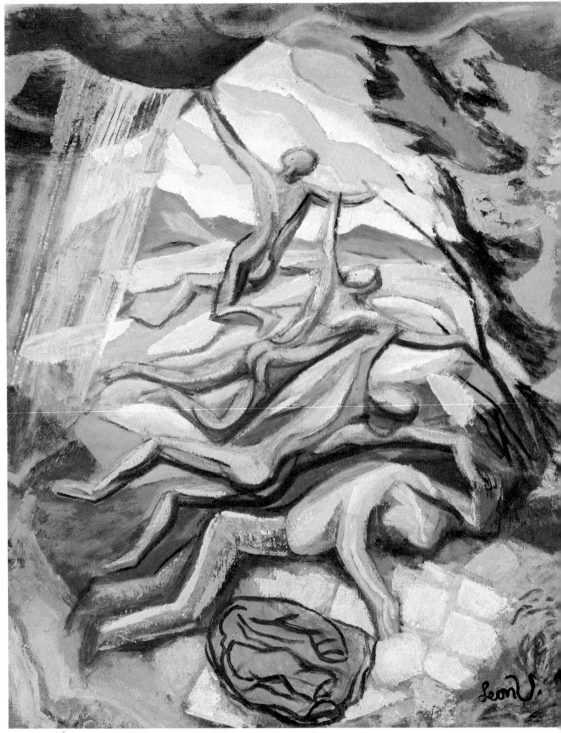

148 *Apotheosis of a Lakeland Poet* 1952. Oil

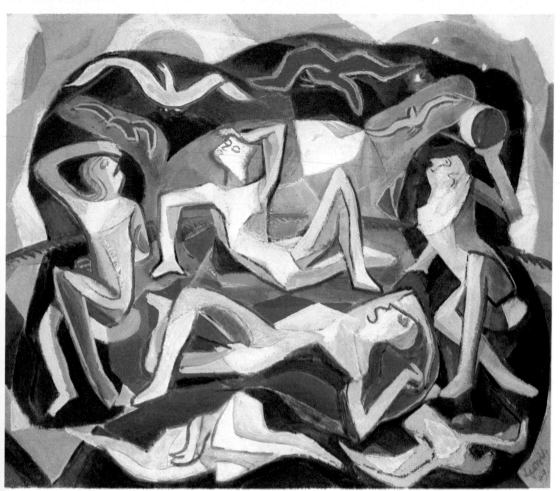

149 *Men and Birds* 1953. Oil

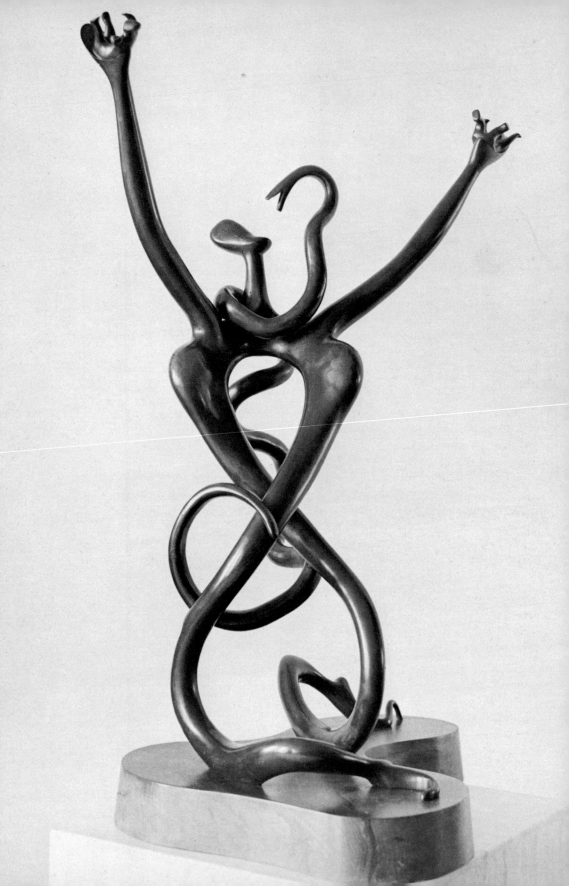

12 Late bronzes

When the Second World War ended, Underwood was fifty-five. There is a danger, because of changes in his work since then accompanied by a shift in taste that has left him even more isolated than before, that some critics will see him principally as a pre-war figure. Certainly there are senses in which his work in the 'twenties and 'thirties can be judged as an integral part of developments in art, even where it is in reaction, and in the early part of that period he and Moore were thrashing out a new set of formal idioms comparable to the way in which Picasso and Braque had experimented with the theory and practice of Cubism twenty years before. Since 1945 this has not applied. Underwood's increasing exuberance in bronze occasionally seemed elaborate and contrived, and his sometimes very literal dependence on ideas has led some people to feel that such statements were naïve. Nothing made critics in the 'sixties more uneasy than the suspicion that a work of art might have a soft centre because at first glance it was both romantic and literary.

Such judgments about Underwood's sculpture could not be further from the truth. Fortunately there have always also been critics who recognized only too clearly that although the work is frequently dependent on verbal imagery and intellectual ideas, it functions effectively through violently dynamic form, which in its own way is a vivid reflection of twentieth-century life. This dynamism, the rocket-like lift-off of a sculptural idea, meant that he largely abandoned carving in the late 'forties in favour of modelling and bronze-casting, a technique that enabled him to wrap paper-thin material round space and to send it flickering upward – a quality somehow achieved without weakening the basic structure of the form.

He had begun casting in the garden at Girdlers Road in 1937, with the help of his student Philip Turner who provided a noisy ex-army blow-lamp and some moulds. By the time he had studied the Ife bronzes Underwood's knowledge of the subject had extended from making bronze-age tools to a sophisticated ability to cast even the largest and most difficult of his own sculptures in the studio with an assistant. (His prowess and reputation as a bronze caster resulted in his appearance, looking suspiciously clean and neatly turned-out, in an advertisement for a chemicals company in *The Times* in November 1958, with a caption that ran: 'Sculptor Leon Underwood demonstrates the casting of a bronze-age axehead'.)

< 150 *Vine and Serpent* 1948. Bronze

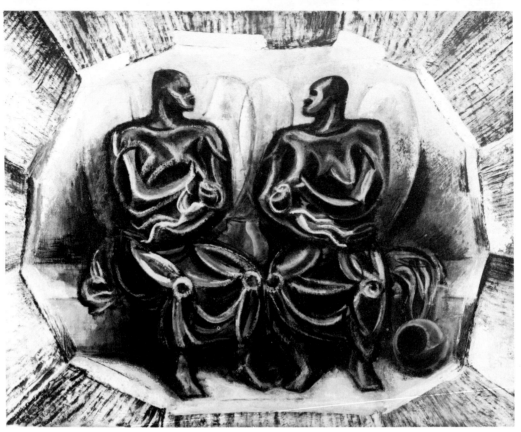

151 *Black Diamonds* 1950. Oil

From 1945 until the mid-'fifties this enthusiasm for bronze-casting ran parallel to his paintings and prints. The oils he made from notes taken in Africa share many of the compositional elements originating in the Mexican pictures of fifteen years before – for instance the market theme, women with burdens on their heads, mothers and children – but their treatment was now linked directly to the bronzes. As paintings and prints they began to be concerned almost exclusively with rhythm in space, and because all three facets of the work shared the same preoccupation, they began to converge in both manner and subject. Many of the African subjects of paintings that date from the late 'forties and early 'fifties are interchangeable with the prints, and both are not so much set down on a two-dimensional surface as cut out in three, and restrained only by the physical limitations of the media. They are the closest Underwood came to describing a totally convincing space on a flat surface, and as such they are logically superseded ultimately by the bronzes. Painting had, by the late 'fifties, for him become a superfluous activity.

His method of describing volume and mass is predictably based less on colour values than on an adaptation of his serpentine line. An examination of his life 153, 154 drawings from the same period indicates that planes and volumes are now described by amoeba-like boundaries that set up a strong rhythm both within

194

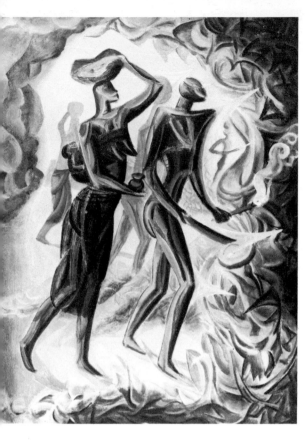

152 *Cultivation by Fire* 1950. Oil

153 Life drawing 1957. Conté
154 Life drawing 1952. Conté

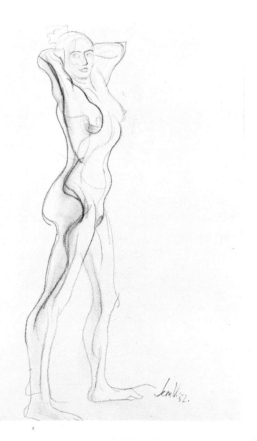

themselves and from one to another. Instead of the line disappearing over the horizon of a form and re-entering the picture-plane in another place, it meanders across a mass so near its front edge that it is permanently visible. It is as though a cube were established by drawing its nearest side and the remainder of it in section, or a sphere by a succession of receding and expanding concentric rings.

In the paintings and prints this results in a shorthand with instantly recognizable signs for various parts of the anatomy which recur. The most typical is the rounded w-shape of pendant breasts that is enclosed at the top by the collar bone and extends down the front plane of the arms to make a single area. In seated figures the plane comprising the top of the thighs and lap is treated in the same way. The net result of such a highly formalized system of drawing is to establish the figures so firmly that the rest of the canvas or sheet has to be made to accommodate them in the same language. The complete surface is broken down into small areas of concave space that lock one into another, their outside edges setting up a syncopated pattern that informs the whole. The line, as well as charting volume, very often has a cloisonné effect and by separating one colour from another intensifies their brilliance.

These are not easy pictures. When they fail they look like paintings of pieces of sculpture. In some of the most successful, like *Apotheosis of a Lakeland Poet*, they have a unity and exhilarating zigzag movement towards the top edge and back again that gives the impression that Underwood was running his brush affectionately over every surface, luxuriating in each little complexity and never missing an opportunity to order every facet in relation to every other, in space.

There is, however, one kind of painting from the same period that is more concerned with poetic observation than problems of pictorial space. Underwood was so fascinated by the perfect spiralling throw required to open the neck of a native fishing net on Lake Bosumtwi that he tried to draw it accurately, and rapidly, with startlingly good results. Equally there is a little beach picture of 1949 in which the blinding tropical sun is represented as a black scorch mark on the retina – a witty and effective conceit in exactly the tradition of Dufy's invention of white shadows of the 1930s. Pictures like this, however, look backwards to the Mexican landscapes rather than forward to the late bronzes.

While this transition was taking place, Underwood did not exhibit, with the exception of one show of old work at the St George's Gallery in April 1945. His only appearances in public were as the designer of the cover of the victory number of the *Listener* (for which he adapted the beautiful drawing of hands releasing a dove, called *Freedom*, of 1930), and as the author of articles and books about African art. In the summer of 1945 he discussed and showed the collection he had brought back with him the previous year on television. Although his sculpture was sometimes included in mixed exhibitions, like the one including bronzes by him, Gaudier and Moore from the collection of W. A. Evill that went on view to members of the Contemporary Art Society in January 1948, his work as a whole was not seen in coherent form until a one-man show at the Beaux Arts Gallery, Bruton Place, in the summer of 1953.

155 *Urgent Spirit* 1950. Bronze (cast by the artist) >

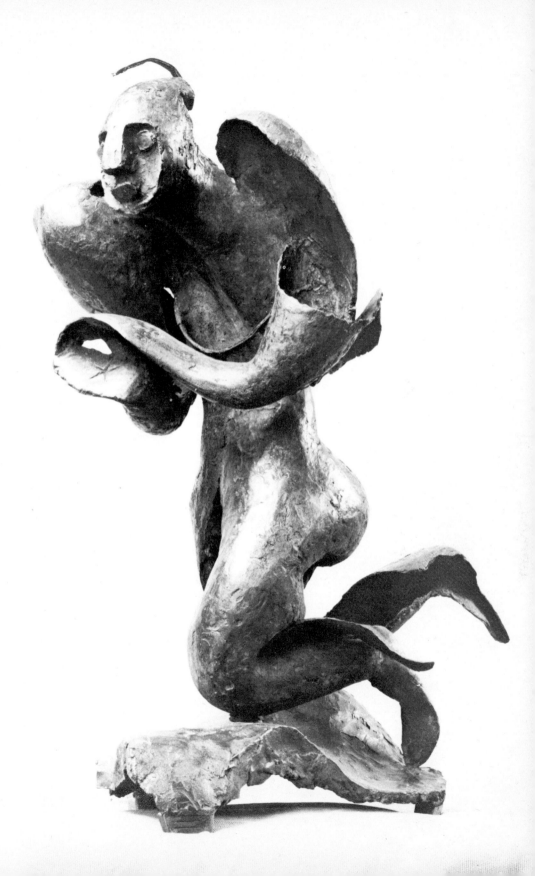

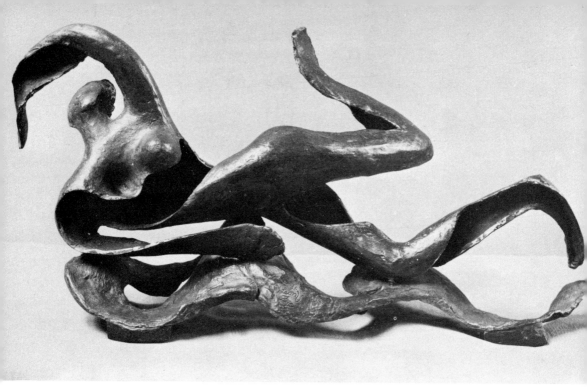

156 *Hill Rhythm* 1952. Bronze

157 *Water Rhythm* 1953. Bronze

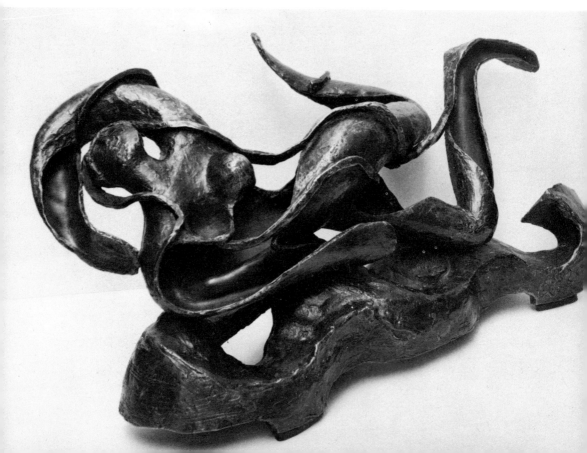

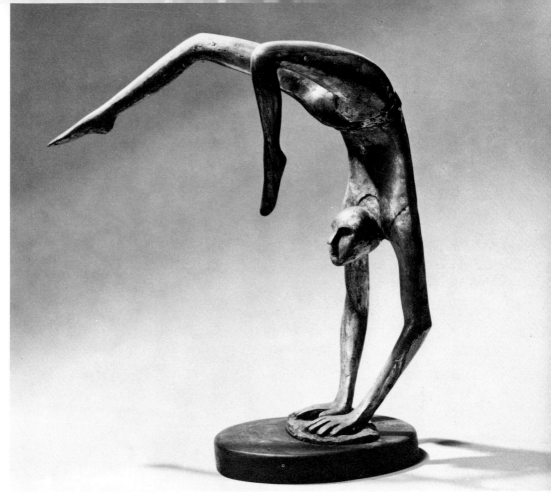

158 *Busker (The Clever One)* 1938–39. Bronze

This marks the beginning of the intermittent and increasingly enthusiastic reassessments of his achievement that have been characteristic of the London art establishment during the last twenty years. Because he had been working quietly by himself, critics were taken by surprise by Underwood's growing inventiveness, and in particular by the new ways he had evolved of opening the skin of his forms to describe their volume. *Water Rhythm* of 1953, and *Hill Rhythm* of the previous year, both first seen at the Beaux Arts Gallery, are related to the Harlem *Negro Rhythm* of 1934, but in seeking to express the way in which we recognize our own physical experience as part of a universal rhythm, Underwood made a bronze magically relieved of any downward drag despite the weight of its material.

157
156
106

He was more than ever at pains in his catalogue introduction to stress the importance of subject as the only valid source for intellectually determined simplifications, having argued in recent months with Herbert Read over an

exhibition, partly selected by him, under the title '40,000 Years of Modern Art'. All Underwood's researches had led him to the conclusion that a society only produced a valid style by co-ordinating its spiritual needs with its intellectual gains, and that a dependence on the subconscious – Read's 'art of internal necessity' – was a negative and pessimistic attempt to fill a vacuum left by subject with 'decorative' abstraction. Hegel, he pointed out, had expressed the cycle of renewal as thesis-antithesis-synthesis, and he considered that the phase of antithesis (without subject) was reaching its lowest point. He quoted Schweitzer: 'The one serviceable world-view is the optimistic-ethical'. The critics in general took his point and there was a spate of good reviews through-out May and June, most of which discussed his philosophy as embodied in a

158 bronze in the exhibition, *The Clever One* (begun in 1938), showing an artist walking on his hands like an acrobat – in other words earning his living and applause purely from a display of technique and virtuosity without belief.

102 There were almost a hundred items in the exhibition, from *Flux* of 1924 to *Dance of Substance and Shadow* and *Abominable Man* of 1953, providing a clear idea of Underwood's development and an opportunity for intelligent reassessment. But before looking at the reaction to this exhibition in relation to two subsequent shows at the Kaplan Gallery in 1961 and 1963, and another in New York in 1962, it is worth looking briefly at the application of his studio principles on a larger scale in a series of commissions for public buildings undertaken by him in the 1950s and in 1960–61.

The technical expertise and initiative that Underwood brought to his commis-sions was formidable but, except in the case of the bronze sculpture made
162 for an LCC housing estate off the Finchley Road in 1960, they have little real connection with his preoccupations at the time and do not compare favour-ably with the rest of the work. Since the War Museum paintings in 1919 he had not been at his best when inhibited by the need to produce a work of art for a specific audience, and the LCC sculpture perhaps succeeds because it already existed as a maquette (in the first Kaplan exhibition) before ever it was adapted to suit the Hilgrove site.

Like many attempts to animate the outside walls of new blocks then and
160 now, the relief in beaten lead he did for the Commercial Development Building, in Old Street, E.C.1, is placed too far up the wall to read properly without the opportunity to see it from a distance. A column of three figures, holding imple-ments to denote three stages of industry, it embodies the strongly rhythmic line of the life drawings and African pictures in bas relief and was cunningly cast by Underwood in a process he invented himself. He began by beating a fifteen-foot piece of sheet lead into a mould and backing it with concrete. On removing the mould when it had set he could retain the relief and its reinforce-ment intact ready for setting in the wall, but the result is so heavily stylized and so cramped that it does not function effectively as a piece of sculpture in its own right or simply at the level of a decoration. It was completed in 1955.

Similar criticisms apply to his mural of the previous year on an eight-hundred-foot-square wall in the Shell Petroleum canteen in St Swithin's House, E.C.4. 159 It was a colossal undertaking technically, involving syrupite on expanded metal panels built out in front of the wall itself for insulation, the use of a large scaffold and a great many thousand eggs to provide a suitably durable tempera base. It was, however, a decorative scheme: the subject was London parks, to compensate to some degree for the tedium of the city environment. It does not carry any real meaning apart from its intention to bring sunlight and green grass into the room, and the result is an expansive and accomplished exercise in Underwood's skill as a draughtsman and composer that amounts to no more than metaphorically walking on his hands. The danger of a decorative project on this scale is that the way in which figures are formalized begins to look like a cliché, and the overall effect is highly mannered. Even at this level, the project could be interesting as a specimen of taste – Underwood was also responsible for other parts of the room – and almost a collector's piece as an example of 'fifties decoration as heavily flavoured as any cinema lounge from the 'thirties. Time will tell, but such a room has no point of contact with his direction or philosophy.

There is, however, one neat trick that shows how inventive he remained despite the canteen's limitations. High above the multi-coloured chairs, for gaiety, he decorated the plaster dado with figures in bas relief – suggesting games, sports and outdoor activities. They look convincingly modelled from below but in fact they are in reverse, with all their surfaces concave, lit from underneath with neon tubes. The shadows cast are consequently on the underside of each shape, tricking the eye effectively into reading them as positive rather than negative and at the same time disposing of the problem of black dust settling along top edges and contradicting the form, as so often happens in bas relief.

Dating from 1955 and equally typical of Festival of Britain architecture and decoration, though this time ecclesiastical, are the murals and stained glass he made for the Church of St Michael and All Angels at New Marston, 161 near Oxford. The church, the first to be consecrated in the Oxford diocese after the war, is a simple sand-lime brick building on a traditional plan by Lawrence Dale, with a squat brick tower at the east end balanced by a slender off-set campanile. During the summer of 1955, helped by Eric Wood, Underwood painted a large reredos, again using egg tempera, and a smaller mural for the Lady Chapel. Despite the precautions he took in sealing the walls, the colour has lost its pitch and, in the reredos particularly, has retreated from crimson and cobalt towards a more sombre middle ground dominated by ochres and indian reds reminiscent of Florentine frescoes. The blaze of colour intended to be emitted from above the altar into all parts of the church has been lost, and only the enormous converging gesture of six heavily stylized angels with flickering drapery, wings and limbs remains. As a full-blown design to animate the wall and impose a mood, perhaps the composition is successful, but individual

elements like the features of the angels and the balancing figures of the donors below have not worn well.

Above, and now effectively cancelled-out by a wooden crucifix suspended in its line of view, is an elliptical window in which Underwood depicted Christ in Majesty hovering over the Oxford skyline. Although the stylized drawing, which extends here to his use of leading, is recognizably Underwood's, the concept – perhaps dictated by the spirit of the building – is traditional and dependent on what is really a medieval formula, without any attempt to exploit the emotional possibilities of coloured glass as explored this century, for instance, by Rouault and Matisse. Although he quickly applied himself to the principles of making stained glass, and constructed the window alone, its weakness as a design may be that normally the whole function of Underwood's line is to establish a form in depth whereas the function of the leading is here to hold it flat on the surface. The effect is to diffuse the drawing, while the concept is too predictable and the colour too anaemic to avert an uncomfortably mannered piece of high 'fifties design. By the rigorous standards applicable to the remainder of his work, neither the New Marston nor the St Swithin's House project deserve to be taken into detailed account.

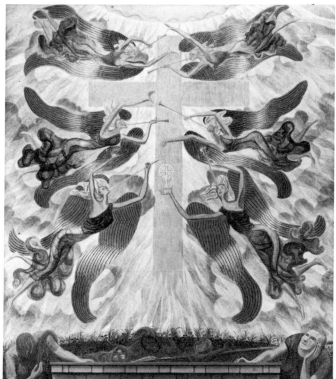

159 *London Parks* 1954.
Tempera mural,
St Swithin's House, E.C.4

160 *Industry* 1955.
Lead and concrete

161 Altarpiece 1955. Tempera.
Church of St Michael and
All Angels, New Marston

Fortunately, as a commission, the Hilgrove Estate bronze is in line with Underwood's own work of the early 1960s and sprang directly from it, with correspondingly happier results. It continues, on a larger scale than usual, his investigation of weightlessness in metal sculpture, with a group of two running figures, six feet wide and 4 ft 6 in. high, set on a Brescia marble column nine feet tall which began shell-pink but has weathered and oxidized to blue-green. It stands on a lawn among pleasant trees, of which the branches complement its spiky stick-like silhouette in winter, overlooked by a housing estate of tall blocks by Louis de Soisson that range downhill on a sloping site from Finchley Road. Commissioned in March 1960 on the recommendation of the Arts Council, *The Pursuit of Ideas* vividly symbolizes the way in which thought develops by ratiocination, one line of reasoning linked to, and leading to, another – not perhaps, for Underwood's purposes, so much by firm logic as by leaps of the imagination. He would say that ideas run after one another to propagate, to breed others.

The lateral movement is further emphasized in the original maquette by an undulating horizontal line cut in the base, but it remains a dynamic sideways and upwards drift even when mounted on the fierce vertical of a column. The weightlessness is achieved very skilfully by using the leading foot of the front figure as a pivot to take the balance of the second by linking its legs, piercing them at calf and thigh. To keep the weight forward and to distribute it symmetrically above the pivot, the back figure overlaps the front and both their arms are elongated forwards. This in turn results in the most effective purely sculptural consideration which is the play of space between the two, the underside of the top figure opened-out to accommodate the curved back of the one below, a formal exercise that gains from the piece being above head height, and which adds to its interest from back and front in what would otherwise be a design consisting of only two sides.

The fact that this was comparatively strong meat for a new housing development led to a certain amount of criticism of the LCC for failing to spend the money on something more useful, like a children's playground, but a cartoon in *Punch* in January 1964 quickly put this into perspective by showing Underwood's sculpture in use as a climbing frame.

Significant subject matter, like *Ideas*, combined with just such inventive solutions to the problems of defying gravity in bronze are typical of the late work. It has thrived on Underwood's home ground and made only periodic appearances in public, and the comparative failure of some of those works commissioned specifically for public consumption should not be allowed to detract from its importance.

By 1960 Underwood's alternative philosophy had hardened, like his bronzes, into something of a paradox. Remembering his effect as a teacher, at the RCA and Brook Green in the 'twenties and 'thirties, reviewers began to refer to him as the father of modern sculpture, and certainly he had been more than merely

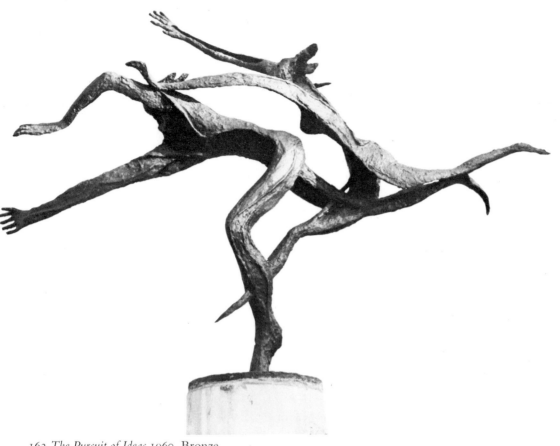

162 *The Pursuit of Ideas* 1960. Bronze

instrumental in evolving an important part of its formal language. He, on the other hand, saw the use to which that idiom was put as representing the lowest possible point in a style cycle, because of its lack of purpose, and wished to be entirely disassociated from it. He has a significant place in the modern movement himself, and yet he will say categorically (for instance to the critic on the *Evening Standard* in 1961): 'Modern art is decadence. Of course you must cut away the old crops and compost them, but you must also grow something new. We have produced a generation of iconoclasts.'

As a builder, a reconstructor, in his seventies he produced an extraordinary burst of fresh activity in bronze with starting points in the Old Testament, in classical mythology and poetry, usually with an unrestrained optimism. The bird theme, the shape he had first pierced from side to side in the *Lark* of 1934, 99 finds its way home as a dove with an olive leaf, in *Dove's Return*, 1962. Such 103 optimism becomes a part of a tremendous joie de vivre, epitomized by *Piping Down the Valleys* (1961) from Blake's *Songs of Innocence*, but where his concern 119

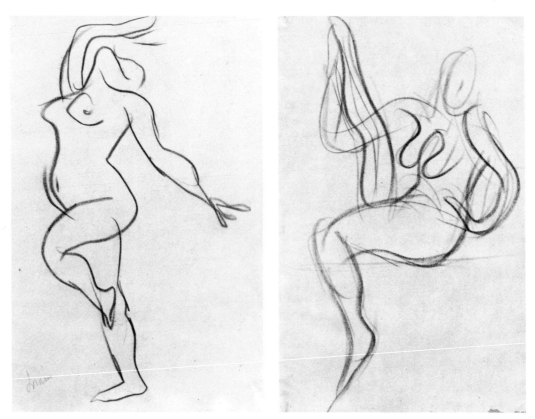

163, 164 Drawings *c*.1955. Charcoal and conté

with the humanist tradition leads him to comment on birth, life, love and
death he produces shockingly sharp images for futility or grief as well.
Archaeology (1962) is a good example. Underwood's own life-long researches
into ancient art and technology had succeeded only in informing him more
fully about the needs and responses of himself and his contemporaries: human
nature, to that extent, is inescapable. The archaeologist of the sculpture, kneel-
ing to dig in his own element (clay or bronze), has unearthed his own face. It
is only when you turn the sculpture round that you realize he is faceless and
looks at it with an empty head. The idea is vivid but the form also is convincing,
in that the hollow bronze skin suggests a volume, a concave shape effectively
played off against the convex of the mask. The danger of a sculpture of this
kind is that the idea will dominate the form, a possibility that first became
apparent with the idea for *Not in Anger* in 1918, but in almost every case the
work gains from the two aspects being held in tension.

There are very many successful examples: *40,000 Years* is an attenuated
pregnant figure sharply compressed by surrounding space in the manner of a

167

168

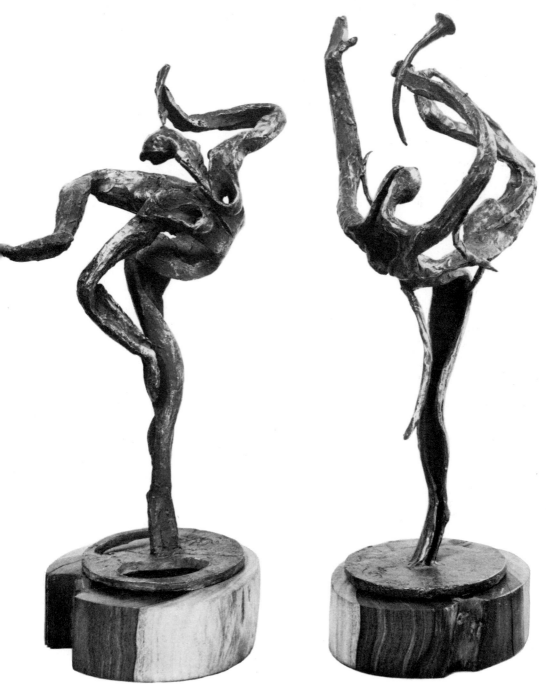

165,166 *Heralds* 1957. Bronze

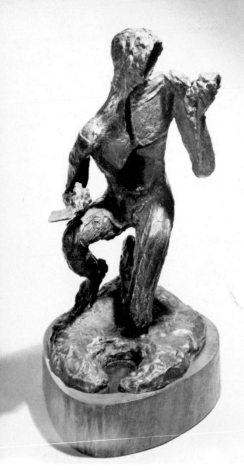

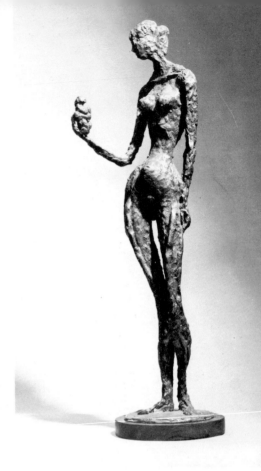

167 *Archaeology* 1962. Bronze 168 *40,000 Years* 1960. Bronze

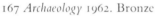

Giacometti, her outstretched arm supporting the 'Venus' of Willendorf. The subject of pregnancy is treated to a similar comment on its perenniality as the archaeologist, the formal play in this case being between the relative sizes of an extremely squat bulky figure and a tall slender one. Compositional elements are balanced like this, in complementary single elements or in rhythmic and far more complicated groups, in order to emphasize an idea. The screen pattern of pierced forms used first in 1959–60 for *Tyger, Tyger* is expanded into *Lifesection* (1960), a group that will work either way up as representing a number of figures, both elevating and trampling two others. The sensation is very strong both of compression and expansion with the human spring in the middle retaining the stasis, but it also vividly evokes both a picture of society in general as well as the ups and downs of an individual psyche within it. The elation of the uppermost figure and the hopeless depression of the lower are instantly identifiable. And with this the *Juggler* in its third state of 1961 is at once recognizable as a satirical representation of the management of human affairs.

170
169

126

208

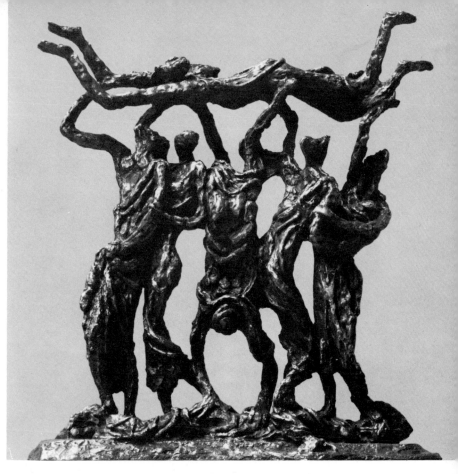

169 *Lifesection* 1960.
Bronze

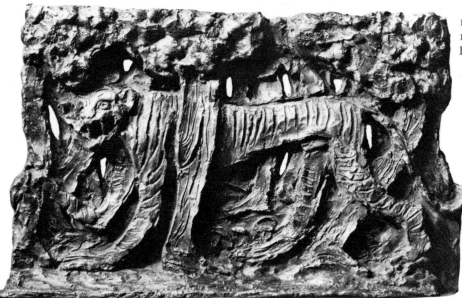

170 *Tyger, Tyger*
1959–60.
Bronze relief

Two formal solutions recur most often. The first is a kind of mirror image or reflection that Underwood utilizes to stress the two aspects of an idea, the duality of human nature, positive and negative, rise and decline, thesis and antithesis. A good example is *Selfencounter* of 1960. Two figures are shown at the instant of recognition, they are separate but close enough together that they share a common rhythm. It is a device that Rossetti used frequently, both with the *Doppelgänger* drawing of 1860 and later, to promote maximum tension: the moment when the spark jumps. Rossetti called his version *How They Met Themselves*. In Underwood's, the idea that we encounter ourselves in others (not necessary with the fatal overtones of the *Doppelgänger* legend), by a common overlap in intuition and intellect, is given an added – and topical – dimension by the fact that one figure has negroid and the other distinctly Aryan features.

The second solution has more to do with Blake, though significantly some of the most vivid examples come from the Rossetti manuscripts. *Joy as it Flies*, from Blake's *Eternity* is an example, in its second state of 1961. One figure, as though caught in the tug of a whirlwind, strains upward to catch another whose gesture and surface are a reverse curve of its own. The scale, weight and thrust of the smaller element set up a dramatic pull between itself and the larger, which threatens to leave the ground. The child in its cloud works in the same way in a later state of *Piping Down the Valleys*, and more earthbound

171

173

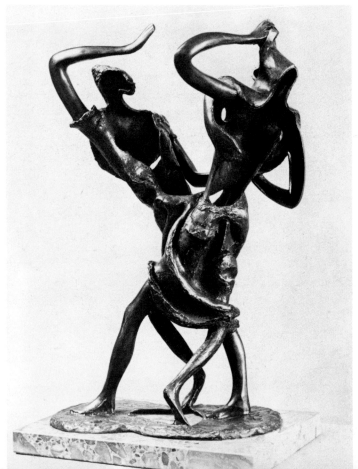

171 *Selfencounter*
1960.
Chased bronze

210

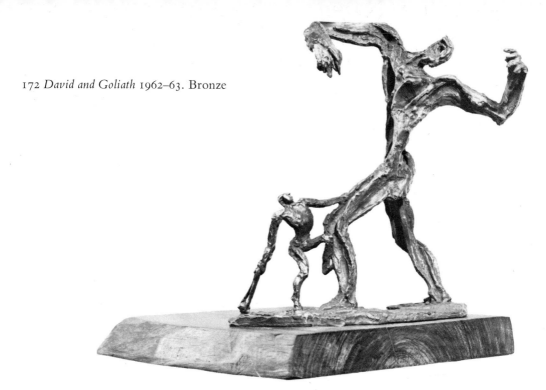

172 *David and Goliath* 1962–63. Bronze

173 *Joy as it Flies* 1961. Bronze

174 *Elijah's Meat* 1961. Bronze

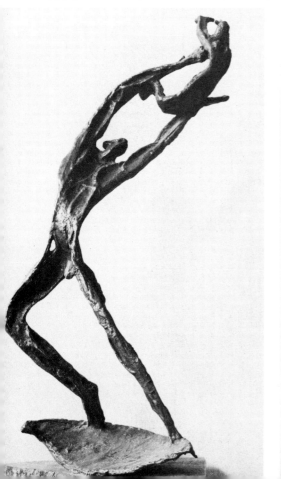

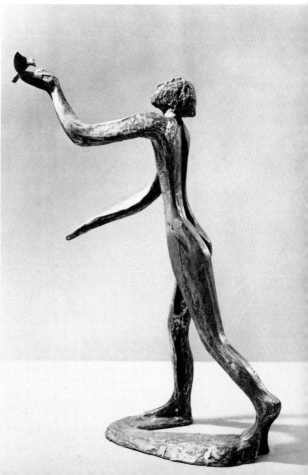

174 examples are the raven that lands on Elijah's hand in *Elijah's Meat*, and the Boaz,
175 arms aloft, whom Ruth stoops to lift up in the *Gleaner* (1961).
1 Although the beautiful upward gesture of *I Believe*, of 1957, which starts where the toes of the back foot touch the base and moves eloquently into the air off the upturned palms of the hands, is typical of Underwood's whole expression, he is also capable of sculptures – referring back to the first Ancaster torso – that seem part of the earth itself. The inturned forms, slow movement
178 and dense mass of *Isaac and Jacob* (1962), for example, convey, in a poignantly Jewish way, the depths of grief.

 It is the upward gesture, however, that continues to occupy him – a thrust so vigorous that it can barely be restrained. There is a clear reference to psychology
179, 180 in the Laocoon of 1962 (and in an oil painting of the same subject of 1950), where mental preoccupations and shortcomings are symbolized by the terrible serpentine bonds. But invariably the spirit shakes itself free and goes shooting
177 into the air as sharply as the *Arrow* (1961) from Longfellow, or *Moses*
176 *Transcendent* of the same year, in which the figure breaks through the layer of cloud that hides God from the earth and continues soaring upwards.

 In a period when such an optimistic vision, and such insistence on ideas, have run in direct opposition to the established aesthetic, the recent sculpture has been extravagantly praised by the critics whenever it has appeared, but still without any genuine attempt to see it as a valid historical alternative. Such statements about man's condition are too grandiose, too oracular, to be easily digestible, especially when their meaning at any level can only be to question and undermine the position of all the major developments in European sculpture since 1930. In a period equally obsessed with specialization and historical accuracy, a poetic theory like Underwood's cycle of styles may lose its essential truth if forced to conform too rigidly to a chronology that has no place for the mystic and cares only for the facts. Without a grasp of this philosophy, to see his late sculpture as a species of Expressionism would be to recognize only an elaborate decoration of literary ideas, an embroidery in

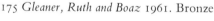

175 *Gleaner, Ruth and Boaz* 1961. Bronze

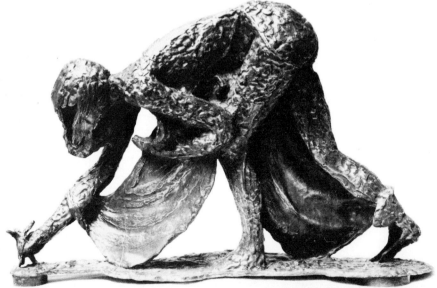

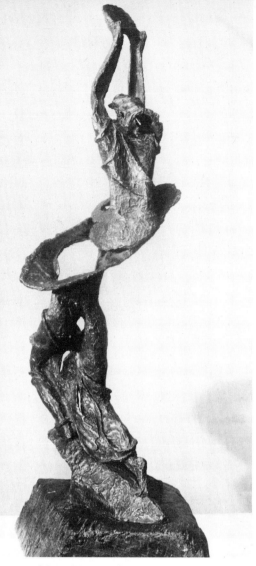

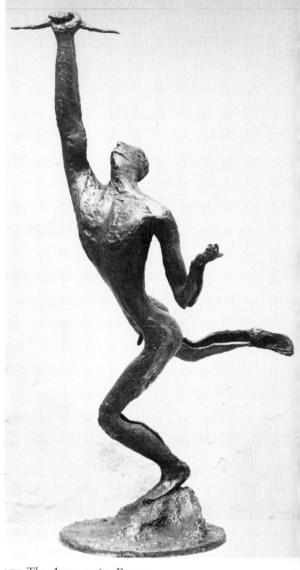

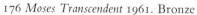
176 *Moses Transcendent* 1961. Bronze 177 *The Arrow* 1961. Bronze

bronze of sentiments and truisms. In reviewing an exhibition Underwood shared at Zwemmers in 1957 with Epstein, Moore, Hepworth and Marini, this point was touched on thoughtfully by John Bunting. Wondering why Underwood had received none of the honours accorded to the others, he wrote that his sculpture 'challenges thought like a proverb, and like a proverb it belongs to the future, when it grows to its full meaning.'

With the critical successes of the Kaplan shows in 1961 and 1963 and at the Aquavella Galleries in New York in 1962, the public again was made aware of his continuing liveliness and originality; and that his inventiveness shows no sign of slackening has been demonstrated more recently at the Minories, in Colchester, where there was an impressive retrospective exhibition in 1969.

To say that a full-scale re-assessment of Underwood is long overdue is merely to repeat what many observers, led by Eric Newton, have been saying since 1950. In 1953, Newton wrote (in his review of the Beaux Arts show): 'If the present exhibition is not thronged with visitors and if those visitors are not astonished to find in Underwood a great artist and a fine craftsman, there is no justice in this world.'

And as to Underwood himself, he continues to get on with his work. Since his eightieth birthday he has concentrated increasingly on revising some of his earlier ideas in bronze, rewriting and extending his books on African sculpture and, most important, working daily on his philosophical book about the cycle of styles in art, religion, science and technology that has occupied him for almost forty years, and of which a glimpse appeared in a pamphlet he published with the same title in 1961. Significantly, the prints and the maquettes for bronze sculptures most often attract attention at the moment, presumably because they embody the poetic idea without the resounding accompaniment of his full-scale formal vocabulary – the conceptual without the formal.

It has not been an easy journey. His independence has cost him and his family dear, a fact that he cheerfully acknowledges, when asked about survival, by saying: 'The ravens fed me' – but adding, nonetheless, that since ravens do not have watches they often came very irregularly.

European sculpture of the last forty years needs just such a thinker, just such an alternative vision. Underwood has succeeded in what he set out to do. It remains only for the art establishment, which he has scorned for so long, to swallow its pride and admit to the scope of his achievement.

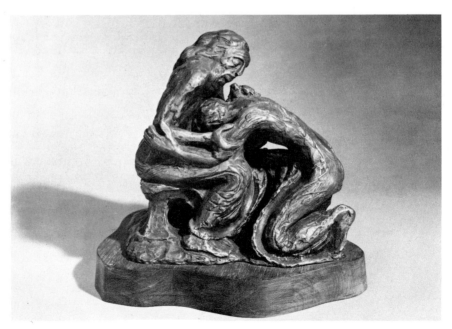

178 *Isaac and Jacob* 1962. Bronze

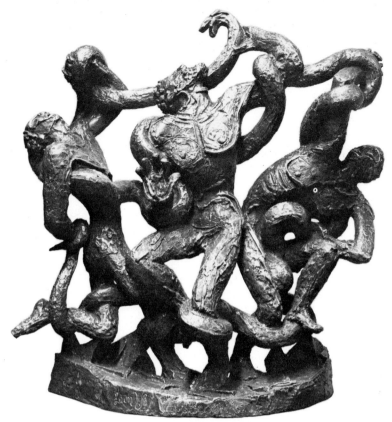

179 *Laocoon* 1962. Bronze

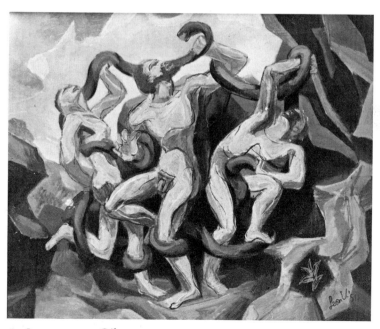

180 *Laocoon* 1955. Oil

Chronology

1890 December 25. Born in Askew Road, Shepherd's Bush, London, the eldest of three sons of Theodore George Black Underwood and Rose Underwood (née Vesey). The previous three generations of the Underwood family had all been antiquaries and numismatists. George had an antique and print shop in Praed Street, Paddington. Leon was christened at the church of St Paul, Hammersmith, in February 1891. At five, began to attend St Michael's Primary School, St Michael's Street, Paddington.

1904 January. Attended Hampden Gurney Church of England School, until December 1906 when he left to work in his father's shop.

1907 Saw Blake's coloured engraving *Glad Day* and was deeply affected by it. September, moved to Goose Green, Dulwich, and enrolled as full-time student at Regent Street Polytechnic under Percival Gaskel. Made first drawings at Old Metropolitan Music Hall, Edgware Road.

1910 October. Scholarship to the painting department of the Royal College of Art, where he became the student of Gerald Moira and E. C. Alston. Reacted strongly to Fry's first Post-Impressionist exhibition at the Grafton Galleries in November.

1911 Made brief visit to the Hague at Easter to decorate a lunette in the Peace Palace. Summer sketching expedition to the Lake District with Edward Armitage. Stayed at Walthwaite. Won Sketch Club prize at RCA. Began to investigate colour harmony and chromatics, and constructed screened easel to experiment with colour theory when painting in the open.

1913 After winning Sketch Club competition a third time, was failed painting diploma in September. December, joined Armitage in Dresden and went with him to Vilna, Poland. First visit, at Christmas, to Ravanica estate, Minsk.

1914 Painted landscapes and portraits in Poland. June, returned to London and re-sat painting diploma. Passed. Rejoined Armitage at Ravanica. On outbreak of war in August, escaped round Baltic via Finland and Sweden. Lived with Armitage at 43 Blenheim Crescent. November, enlisted in Royal Horse Artillery, Albany Street Barracks.

1915 Transferred to the 2nd London Field Battery, Woolwich, as First Lieutenant.

216

1916 January. To France. Gommecourt. Loos. Transferred to Camouflage Section, Royal Engineers, at Wymereux, under Girond de Sevolat. War drawings in *Illustrated London News*. Began frequent flying.

1917 January. Married Mary Colman. Submitted model and designs for repeating trench mortar to War Office. First carving, *Dove*, in Caen stone. Promoted Captain. Mentioned in despatches.

1918 June. Invalided back from France with severe gastro-enteritis. Recuperation at Ilfracombe. Wrote ballet, *Rickets*. Rented rooms in Aynhoe Road, London W.14, in September. Submitted trial drawings to Ministry of Information, Propaganda Section, in June, with a view to painting camouflage picture for the Imperial War Museum. Conceived *Not In Anger* sculpture project.

1919 April. Painted *Cpt. G. B. McKean, VC, MM* and *Erecting a Camouflage Tree* commissioned by Muirhead Bone's committee for Imperial War Museum. Both pictures, and many sketches made in France, in Camouflage Artists' Show at Burlington House in October. Sale of first works in New English Art Club exhibition. First son, Garth, born in July. Bought studio at 12 Girdlers Road, Hammersmith, in May. Began to carve pebbles. Enrolled for year's refresher course at Slade in September, and devoted himself almost exclusively to life drawing under Tonks. Founder member of Seven and Five Society.

1920 Watercolours made on holiday at Wolverton. Experimental stone carvings. Awarded premium in Rome Prize in June but refused to go to Rome. August, joined staff of RCA as assistant teacher of life drawing.

1921 January. Opened Brook Green School: among first pupils were Eileen Agar, Jessie Aliston Smith, Rodney Thomas, Blair Hughes-Stanton. Installed etching press at Girdlers Road and embarked on two years of constant activity in printmaking. Bought boat and made many studies of fishermen at Poole Harbour, Dorset. Began work on first major painting, *Venus in Kensington Gardens*.

1922 May. First exhibition at Knewstub's Chenil Gallery at 183 Kings Road, Chelsea. Campbell Dodgson began buying etchings for the British Museum, including the *Self-portrait with Landscape Background*. Family holiday at Ashurst, Kent, with the Knewstubs in July–September resulted in many watercolours, paintings and etchings. Began *Peasantry*. Daughter born November.

1923 June. Argued with William Rothenstein and resigned teaching post at RCA. To Paris and Iceland on Rome Prize grant. Trekked from Reykjavik to Husavik with Rodney Thomas and Blair Hughes-Stanton. Portraits and landscapes evolved to a more symbolic style. Began to think about channels of communication in primitive culture. Worked his way back from Iceland by trawler. Concentrated increasingly on collecting African carvings.

1924 May. *Venus in Kensington Gardens* exhibited for the first time in a show shared with Olive Snell and Ralph Chubb at the Alpine Club Gallery, Mill Street. Holiday at Birchington, embryo pebble carvings. Began evening class at Girdlers Road of RCA students including Vivian Pitchforth, Henry Moore

and Raymond Coxon. First cast of *Flux* by Parlenti. Ashurst *Mother and Child* awarded honourable mention at Carnegie Institute, Pittsburgh. Essay on Underwood by R. H. Wilenski in *Draughtsman*, from series on contemporary British artists edited by Albert Rutherston, published by Ernest Benn. The others were: Edna Clarke Hall, Henry Rushbury and Randolph Schwabe.

1925 Completed Mansfield sandstone *Torso*. July, painted in Dalmatia with a group of his students including Gertrude Hermes. Travelled in Italy. Abandoned Florence for Altamira in September and became deeply committed to theory of cycle of styles on seeing cave paintings. Exhibited watercolours at St George's Gallery, George Street, in October. Left for New York on the *Bremen* in December.

1926 Went to Palm Beach to paint murals but received no commissions. Returned to New York in May and began work as an illustrator for Brentano, John Day Company and on *Vanity Fair*. Opened a private drawing school on 8th Street West, Greenwich Village. Painted portraits. His own book of verse and woodcut illustrations, *Animalia*, published in November by Payson and Clarke. Joined by Mary Underwood in May and went to Penguin Island, Bay of Fundy. Showed *Animalia* prints at St George's Gallery in December, and at the Weyhe Gallery, Lexington Avenue, New York.

1927 April. Returned to England and went to Nanjulian, Cornwall, to write novel, *The Siamese Cat*, with woodcut illustrations. Delivered it complete to Brentano in New York in September. Watercolours of Cornwall. June, *Peasantry* sold in London for £200.

1928 January. Travelled down the south-eastern shore of Gulf of Mexico, up the rivers of Tabasco and over the Sierra Madre to the Pacific east of the Isthmus of Tehuantepec, with Phillips Russell, studying Mayan and Aztec art. Made great many Mexican drawings and paintings with a burst of enthusiasm for his new subject matter. *The Siamese Cat* published in April. Showed Mexican wood engravings and lino cuts at the St George's Gallery in December. Second son born in February.

1929 *The Red Tiger*, Phillips Russell's book about the Mexican journey, with illustrations by Underwood, published by Brentano in New York and Hodder and Stoughton in London. First of the major Mexican paintings, *Cortez* and *Montezuma*. Began Mexican colour prints. Showed watercolours at the Modern English Watercolour Society in March. Experimented with Surrealism, *The Fates*. Began to teach drawing one day a week at St Martin's School of Art.

1930 Completed *Marina's Remorse*. May, showed *Mexican Love Song* and the sculpture, *Fist*, at the first exhibition of Neo at the Godfrey Phillips Galleries, Duke Street; six Surrealist pictures, including *Casement to Infinity* and *At the Feet of the Gods*, at the National Society exhibition at the Grafton Gallery, which he angrily withdrew on the second day. Drew *Freedom*.

1931 June. Founded and published magazine, *The Island*, edited by Joseph Bard, with a statement by Gandhi and contributions by Underwood, Henry

Moore, John Gould Fletcher, Laurence Bradshaw, Ralph Chubb, Grace E. Rogers, Eileen Agar and Velona Pilcher. Four issues. Completed large elm-wood *Regenesis*.

1932 Carved *Cathedral* and published engraving and plans for it in *The Island*. November, organized and wrote detailed exhibition catalogue for exhibition of Primitive, Greek, Polynesian, African, Chinese and modern European sculpture, including his own Mansfield sandstone *Torso*, 1925, and *The New Spirit*, 1932, at the Sydney Burney Gallery, St James's Place.

1934 First pierced sculptures, on 'lark' theme. April, important exhibition of sculpture, paintings, drawings and engravings at the Leicester Galleries, Leicester Square, with an enthusiastic catalogue introduction by R. H. Wilenski. Published pamphlet, *Art for Heaven's Sake* (Faber and Faber) containing thoughts and aphorisms on the subject of art and technology. Carved plaster model for *Herald of New Day* acquired by Victoria and Albert Museum and since transferred to Tate Gallery. Completed Carrara marble *Mindslave*, and began *African Madonna* in lignum vitae. Experimented with inlaid line in sculpture.

1935 November. Showed paintings and sculpture, including *African Madonna*, at Beaux Arts Gallery, Bruton Place. *Juggler* (first state), *Negro Rhythm* and completed *June of Youth*.

1936 March. *Black Madonna* arrived in Johannesburg on way to English Church Native School, Rosettenville, and caused uproar. Exhibited paintings and sculpture with the National Society in February. October, designed and engraved new symbol for *The London Mercury*.

1937 Completed chased bronze portrait of George VI. Showed bronzes, including *New Spirit*, at the Royal Institute Galleries, Piccadilly, in February. Drawing *Wendy* in Royal Academy Summer Exhibition. *George VI* on show at Fine Art Society, New Bond Street, in May.

1938 Began to carve chair in Italian walnut, and constructed loom at Girdlers Road to weave fabric for seat.

1939 Started Irish marble *Sculptor*. Made last of big colour prints on Mexican themes. Successful exhibition of prints, paintings and recent sculpture at Zwemmer Gallery, Litchfield Street.

1940 Joined Civil Defence camouflage unit at Leamington Spa, and began a long series of landscape watercolours.

1941 Rented Greenhill, near Leamington Spa, and started work on an invention by which he was able to construct a relief model of terrain by means of superimposed projected photographs. Spent much time flying.

1944 Completed small inlaid carving, *Fishwife*. From June to October, travelled extensively in west Africa, lecturing for the British Council and assembling a large collection of carvings, pottery and textiles. Made many African drawings and watercolours.

1945 August. Designed cover for victory number of *The Listener* (a variation on the *Freedom* drawing of 1930). Last full-scale exhibition, at St George's Gallery, until 1953. Began to devote himself increasingly to bronze-casting experiments and writing on African art. November, discussed collection of African art on television.

1946 First oil paintings on African themes using fragmented method of suggesting space.

1947 *Figures in Wood of West Africa* published by Alec Tiranti.

1948 *Masks of West Africa* published by Tiranti. *Mindslave* in LCC open-air sculpture exhibition, Battersea Park, in May. *Unknown Warrior* at Society of Scottish Artists, Edinburgh, in October. December, article under the title 'Abstraction in African and European Art' published in *Studio*.

1949 *Bronzes of West Africa* published by Tiranti. January, wrote a long article with William Fagg for the Royal Anthropological Society's journal *Man*: 'An Examination of the So-called Olokun Head of Ife, Nigeria'.

1953 May. Showed African sculptures, drawings, paintings and prints for the first time, at the Beaux Arts Gallery, Bruton Place. His catalogue essay, under quotations from Einstein and Hegel, was an attempt to justify optimistic subject matter and uphold his cycle of style theory after a disagreement with Herbert Read.

1954 Painted tempera mural, *London Parks*, for Shell canteen, St Swithin's House, St Swithin's Lane, E.C.4.

1955 February. Invented a method of casting his relief panel in beaten lead for exterior wall of Commercial Development Building, Old Street, E.C.1. June, began stained glass and two tempera murals for church of St Michael and All Angels, New Marston, Oxford, consecrated in September.

1957 August. Experiments in bronze casting disproved British Museum theory about the casting of Mesopotamian axe heads. Showed sculpture at Zwemmer Gallery with Epstein, Moore, Hepworth and Marini, in June. Slit forms became more pronounced in bronzes. Completed and cast *I Believe*.

1958 Published 'Bronze Age Technology in Western Asia and Northern Europe' in *Man*, nos. 13, 39 and 64. Made bronze crucifix and candlesticks for Ampleforth Abbey. Crucifix reproduced on the cover of *Crucified and Crowned* by William Barclay (SCM paperback).

1959 *Mindslave* at the Antwerp Biennale in May. Showed *Lot's Wife* at Smithsonian Institute, Washington. Stopped painting entirely in order to concentrate on sculpture.

1960 Pamphlet *Colossal Bronze Sculpture of Assyria* published by Royal Society of British Sculptors. July, showed bronzes in 'Artists of Fame and Promise' exhibition at Leicester Galleries. Commissioned by LCC in March to make bronze group, *The Pursuit of Ideas*, for Hilgrove Estate, N.W.6. Renewed burst of bronze sculptures on optimistic themes with opened surfaces.

1961 March. Important one-man exhibition of sculpture, paintings and prints at Kaplan Gallery, Duke Street, with catalogue introduction by Eric Newton in which he pointed out similarities between Underwood's and Moore's formal experiments in the 1920s. New bronzes included *Selfencounter, Lifesection* and *Forty Thousand Years*. Pamphlet *The Cycle of Styles in Art, Religion, Science and Technology* published by Royal Society of British Sculptors.

1962 Increasing dependence on psychological comment in sculpture, with hollowed forms and roughened bronze skin. Completed *Archaeology* and *Gleaner*. Comprehensive one-man exhibition at N. M. Acquavella Galleries, East 57th Street, New York, in October.

1963 April. Second one-man show at Kaplan Gallery including recent bronzes on biblical themes, notably *Moses Transcendent, David and Goliath* and the more massive and static *Isaac and Jacob*.

1964 May. *Totem to the Artist*, 1934, shown in Royal Academy summer exhibition and purchased under terms of the Chantrey Bequest. Made honorary member of Royal Society of British Sculptors.

1966 Renewed work on philosophical book in three parts under general title of *Cycle of Styles*.

1968 Completed bronzes, *The Chosen*, and began *Weightless Rhythm* and *Neighbours*. *New Spirit* and *Political Prisoner* sold at Christie's in July.

1969 August. First important full-scale retrospective at The Minories, Colchester, organized by the Victor Batte Lay Trust. Catalogue essay by Sir John Rothenstein in which he discussed Underwood's output and philosophy in the context of his period. The result was a general critical re-awakening. April, *June of Youth* sold at Christie's and *The Sculptor* and *Birth of Eve* at Sotheby's. Showed sculpture at the Archer Gallery, Grafton Street.

1971 June. Drawings, including chalk and pencil studies for *Venus in Kensington Gardens* at Agnew's, Old Bond Street, and paintings 1922–52 at Archer Gallery. Exhibition of Mexican paintings and colour prints, with some later sculpture, at Kemp Town Gallery, Brighton.

1972 January. Drawings 1921–59 shown at Archer Gallery.

1973 October. One-man show of small bronzes and wood engravings at Agnews.

Index

Numerals in *italic* refer to illustrations